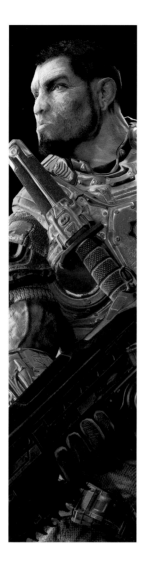
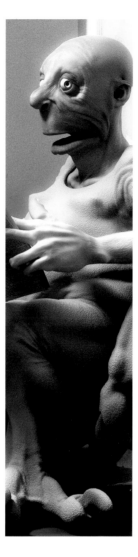

CHARACTER MODELING 2

d'artiste

DIGITAL ARTISTS MASTER CLASS

d'artiste™

Published
by
Ballistic Publishing

Publishers of digital works for the digital world.

Aldgate Valley Rd
Mylor SA 5153
Australia

www.BallisticPublishing.com

Correspondence:
info@BallisticPublishing.com

**First Edition published in Australia 2007
by Ballistic Publishing**

Softcover/Slipcase Edition ISBN 1-921002-35-2
Limited Collector's Edition ISBN 1-921002-38-7

Managing Editor
Daniel Wade

Assistant Editor
Paul Hellard

Art Director
Mark Snoswell

Design & Image Processing
Lauren Stevens

d'artiste Character Modeling 2 Master Artists
Kevin Lanning, Timur "Taron" Baysal, Zack Petroc

Printing and binding
Everbest Printing (China)
www.everbest.com

Partners
The CG Society (Computer Graphics Society)
www.CGSociety.org

Also available from Ballistic Publishing
d'artiste Digital Painting ISBN 0-9750965-5-9
d'artiste Character Modeling ISBN 1-921002-11-5
d'artiste Matte Painting ISBN 1-921002-16-6
d'artiste Concept Art ISBN 1-921002-33-6

Visit www.BallisticPublishing.com
for our complete range of titles.

Cover credits

Marcus Fenix UE3
Lighting, set up and overall shot:
Jerry O'Flaherty, Lancer weapon
concept: James Hawkins,
Lancer weapon model: Pete
Hayes, Lancer weapon skin:
Chris Perna, Maury Mountain,
Character concept: James
Hawkins, Character model:
Kevin Lanning, Character skin:
Chris Perna, Character pose:
Aaron Herzog, Jay Hosfelt
*[Front cover: d'artiste
Character Modeling 2
Softcover edition]*

**Gears of War
© 2006 Epic Games, Inc.
All Rights Reserved.**
Gears of War, Marcus Fenix
and the Crimson Omen are
either trademarks or registered
trademarks of Epic Games, Inc.
in the United States and/or
other countries.

Leading the Horde
Maya, mental ray, Body Paint 3D,
Photoshop
Peter Zoppi, USA
*[Back cover: d'artiste Character Modeling 2
Softcover edition], 72*

Yatoer, the bus stop boxer
Maya, mental ray, ZBrush, Photoshop
Loïc Zimmermann, FRANCE
*[Cover: d'artiste Character Modeling 2
Limited Edition cover]*

/ BALLISTIC /

Daniel Wade
Managing Editor

Paul Hellard
Assistant Editor

Welcome to the fifth book in our Digital Artist Master Class series. **d'artiste: Character Modeling 2** showcases the work and creative prowess of acclaimed character modelers: Zack Petroc, Kevin Lanning, and Timur "Taron" Baysal. These three Master Artists have worked on a remarkable number of high-profile movie and game projects including: 'Sky Captain and the World of Tomorrow'; 'John Carter of Mars'; 'D.O.A.'; 'Gigantic'; 'American Dog'; 'Syriana', 'Reeker'; 'The Dust Factory'; 'Gothika'; 'Spy Kids 2: Island of Lost Dreams'; 'Impostor'; 'Megiddo: The Omega Code 2'; 'Dracula 2000'; 'Battlefield Earth'; 'Dogma'; and 'Gears of War'.

In **d'artiste: Character Modeling 2**, each Master Artist presents his character modeling techniques through a series of tutorials which start with the idea and step through the process of bringing the idea to fruition. The book is broken into three sections based around each Master Artist. Artists' sections include a personal gallery, the artist's work and thoughts in their own words, a large tutorial section, and an invited artist gallery featuring character work from some of the most talented character modelers in the world.

The d'artiste imprint (pronounced dah-tee-st) means both 'of the artist' and 'digital artist'. Each d'artiste title features techniques and approaches of a small group of Master Artists. The focus of d'artiste series is not limited to just techniques and technical tricks. We also showcase galleries of the artist's personal work and a gallery of artwork created by invited artists. Along with artist interviews this gives the reader a comprehensive and personal insight into the Master Artists—their approaches, their techniques, their influences and their works.

Ballistic Publishing continues to expand the d'artiste series to encompass all aspects of digital content creation. The d'artiste series already includes: Digital Painting; Character Modeling; Matte Painting; and Concept Art. Look for new d'artiste title announcements on the Ballistic Publishing web site: www.BallisticPublishing.com

The Editors
Daniel Wade and Paul Hellard

KEVIN LANNING

TIMUR BAYSAL

ZACK PETROC

d'artiste™
DIGITAL ARTISTS MASTER CLASS

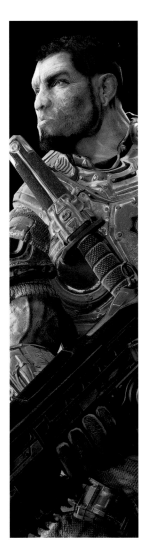
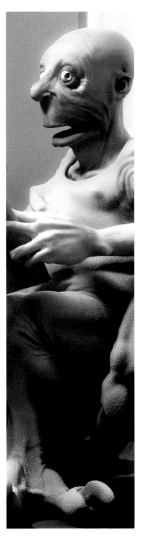

CHARACTER MODELING 2

Kevin Lanning
The artist6

Tutorials
High-poly workflow20
Low-poly workflow34
Rip and process workflow . .42

Invited artist gallery50

Timur "Taron" Baysal
The artist76

Tutorials
Box modeling90
ZBrush and texturing96

Invited artist gallery108

Zack Petroc
The artist126

Tutorials
Character creation142
Workarounds162

Invited artist gallery170

KEVIN LANNING

Kevin started creating art at a very early age drawing and sculpting. He received a half-ride scholarship at the Art Institute of Dallas graduating with a Degree in Computer Animation. Thanks to online exposure Kevin received commission work including character art for several commercials. This led to his discovery by Epic Games where he was hired as a full-time artist to create art assets for their next-gen game technology Unreal Engine 3. For the past four years Kevin has been working as a Character and Creature Modeler at Epic Games. His most recent work can be seen in Epic's blockbuster hit for the Xbox 360, 'Gears of War'.

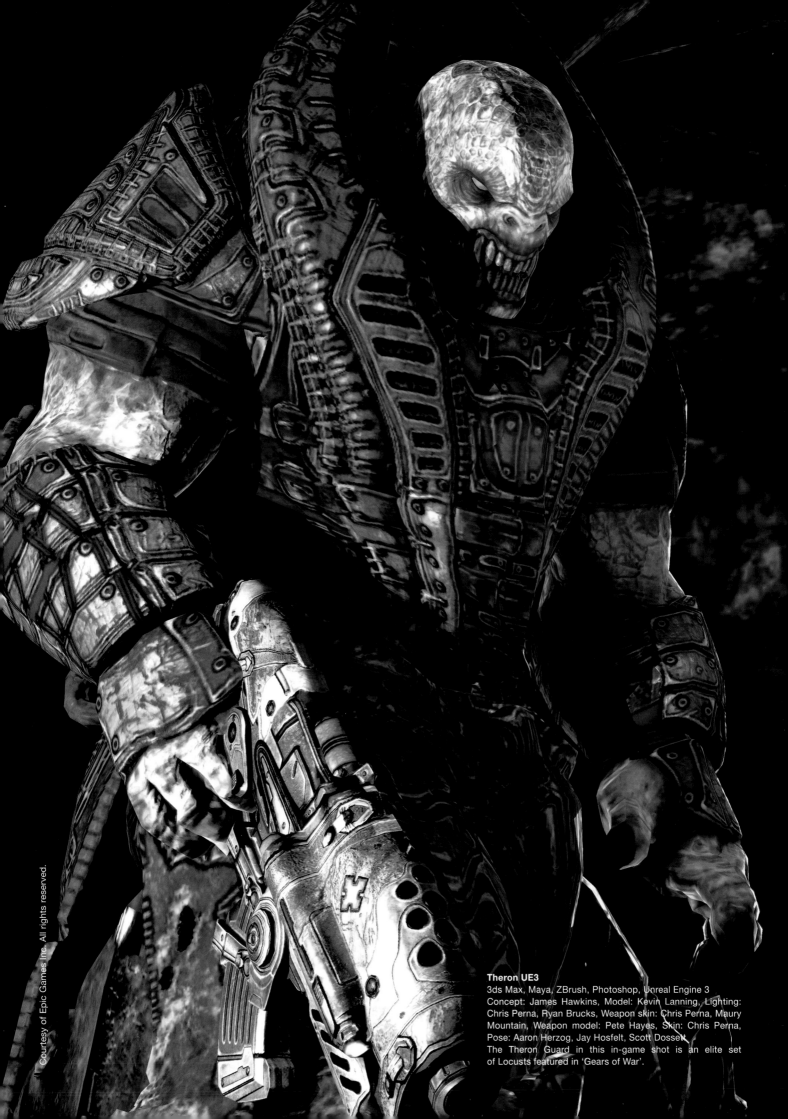

Theron UE3
3ds Max, Maya, ZBrush, Photoshop, Unreal Engine 3
Concept: James Hawkins, Model: Kevin Lanning, Lighting:
Chris Perna, Ryan Brucks, Weapon skin: Chris Perna, Maury
Mountain, Weapon model: Pete Hayes, Skin: Chris Perna,
Pose: Aaron Herzog, Jay Hosfelt, Scott Dossett
The Theron Guard in this in-game shot is an elite set
of Locusts featured in 'Gears of War'.

CONTENTS

**Kevin Lanning
Gallery**

12

**Kevin Lanning
Tutorials**

20

**Kevin Lanning
Invited Artist Gallery**

50

Beginnings

From as far back as I can remember, I have always enjoyed the freedom that comes from art. Art kind of runs throughout my family; my mother and grandmother are both traditional painters, and my brother Sean is currently a Senior Graphic Designer. Throughout my childhood, I would spend countless hours drawing and sculpting monsters from cartoons and comics. My mother being an artist herself constantly enrolled me into every art class she could find. Art became my favorite subject throughout high school and with the help of a pad, pencil, and a set of ear plugs every class quickly became art class, in one way or another.

Education

I've been rather fortunate to have two parents who have been extremely supportive in my pursuit of this career. I knew from very early on that I wanted to become an artist, and they helped me in my pursuit every way they could. Up to this point in my life, I had focused solely on traditional mediums, so attaining the knowledge needed for today's digital realm became a priority. After High School, my brother and I decided to attend the Art Institute of Dallas. I studied there on a half-ride scholarship won from a portfolio competition for around two-and-a-half years focusing on character modeling. The attendance of figure drawing and 2D animation classes served to be very rewarding in the amount of knowledge that was gained in regards to human anatomy and motion. I still find myself attending local figure drawing classes from time to time to relax for a bit. It's amazing how fast you can lose the ease and quality of your drawing skills when they're not exercised daily. I'm constantly humbled by the amount of raw skill and talent some artists have with this medium.

Digital

As for 3D application-based studies, these classes demanded a large amount of self-teaching. I've seen quite a few artists become overwhelmed by the complexity of application interfaces and with the amount of procedures involved in certain tasks. However, as one of my professors put it: "The moment one is truly free to begin creating art digitally, is when the tools become transparent to the user." That saying resonated with me for some reason, so I went out and bought as many books as I could find on the applications and buried my nose into them for months. After spending the time to learn the applications, I gained a huge understanding for the creation process involved that was previously incomprehensible to me. From that moment on, I began focusing on the creation of character models. There is a certain love I have acquired for the process of digitally sculpting a character or creature.

General RAAM UE3
3ds Max, Maya, ZBrush, Photoshop, Unreal Engine 3
Concept: James Hawkins, Model: Kevin Lanning,
Lighting: Chris Perna, Skin: Chris Perna, Pose: Aaron
Herzog, Jay Hosfelt
General RAAM in this in-game shot is the military
leadership of the Locusts featured in 'Gears of War'.

Career start

Once I graduated from the Art Institute, I began working with several friends from school on small side projects and helped out in the creation of a digital library that was to be sold online. This was quickly placed on the back burner after a good friend of mine Peter Hayes suggested I post some of my work online. With the exposure of my work, came opportunities of contract work within the industry. I was contacted by Floyd Bishop at Ice Pond Studios to do some character work on a 'GI JOE' commercial they were subcontracting for. I had a blast working on that project. In my eyes, this was the first real production work that I had done. This quickly erased any self-questioning I had on whether I had made the right decision to become an artist. I remember having a strong feeling that all

of the hard work and dedication put into my studies was about to pay off, and it was. Shortly after finishing the contract work for Ice Pond Studios, I received an email from Epic Games Lead Designer, Cliff Bleszinski who was browsing the forums on CGTalk.com and came across my work. I was given an art test that day and flew out to Raleigh, North Carolina at the end of that week for an onsite interview. I remember being totally blown away by the quality and creativeness of the concept that was given to me for the art test. It was one of those pieces that I couldn't get enough of and really enjoyed working on. From the moment I walked into Epic's headquarters for the interview, I knew that this was where I wanted to work. After a day of meeting the team and being completely amazed by the quality

of work and the professionalism held within the studio I sat down with Cliff for a final chat. I accepted a full-time job with them that night and have been happily employed with Epic for the past four-and-a-half years.

Tools

The tools I use vary from day to day. I use 3ds Max as my main 3D application and jump around from Mudbox and ZBrush for detailing. There is a great deal of artistic freedom that comes from the use of these applications. The abilities we have today to digitally sculpt characters in 3D is just awesome. However, the most rewarding stage is when everything comes together using Unreal Engine 3 for the in-game implementation of the final assets. The amount of detail and realism this tool allows an artist to put into today's games is unbelievable.

Working at Epic Games

I started out sharing an office with Lead Artist, Chris Perna for my first two years at Epic. Those years were a huge learning phase for me as an artist new to the video game industry. The amount of knowledge that is forced upon you when working with such an intense team is amazing. Looking back on those early years, I can clearly see just how much artists like Chris and Shane Caudle (among many others) mentored me in my growth as an artist both visually and technically. By surrounding yourself with nothing but talent you're forced to grow. By picking the brains of Animators such as Aaron Herzog, Jay Hosfelt, Scott Dossett, and Chad Schoonover I've gained a ton of tips and tricks that I continue to use daily in my process of creating character models. I've also been rather fortunate to have worked with

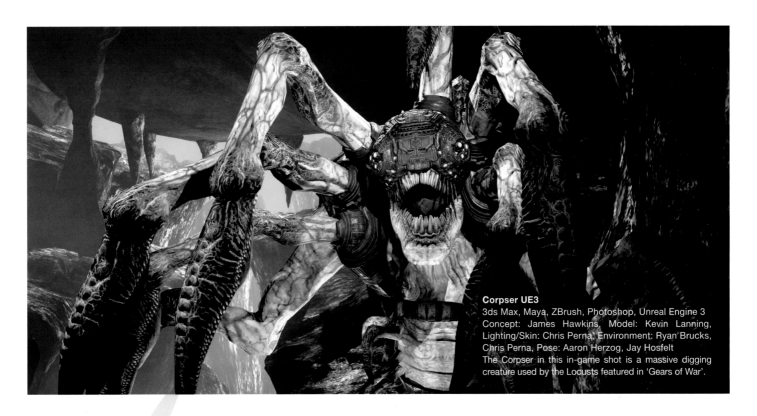

Corpser UE3
3ds Max, Maya, ZBrush, Photoshop, Unreal Engine 3
Concept: James Hawkins. Model: Kevin Lanning,
Lighting/Skin: Chris Perna. Environment: Ryan Brucks,
Chris Perna, Pose: Aaron Herzog, Jay Hosfelt
The Corpser in this in-game shot is a massive digging
creature used by the Locusts featured in 'Gears of War'.

such an awesome Art Director as Jerry O'Flaherty, and some really top-notch artists like Peter Hayes, Danny Rodriquez, Paul Jones, James Hawkins, Chris Wells, and many more that are too numerous to list. There is always something that can be learned from someone no matter how new they are or what their discipline may be. Keeping an open mind to that is key to personal growth. The majority of my time here at Epic has been spent working on character and creature models for 'Gears of War', with the exception of work on content for tech demos of Unreal Engine 3. Working on 'Gears of War' has been a dream come true. The typical process for character production starts like most places, with the initial idea and is then visualized into a concept. From there we begin modeling the high-poly

model, and then the low-poly after. The model is then ripped and processed to generate the normal maps. Once this portion of the pipeline is complete, it is handed off for final texturing and character rigging. The amount of teamwork involved in the character pipeline is huge. There truly is no one person that makes everything. Every model is either touched by a designer, artist, animator, or a programmer before completion. This pipeline works very much like an assembly line. I honestly couldn't ask for a better job; I get to spend my day making sick monsters and characters.

Breaking into games
My advice is to be persistent. Get your work where people can see. Posting on sites like CGTalk.com, ZBrushCentral.com, and the Mudbox forums is a great way to get your work exposed to

industry vets. With the quality of game art approaching that of movies, having a background in traditional art is a huge plus. It's the artist with the application knowledge and a solid foundation of traditional art that employers are seeking. My last piece of advice would be to direct 90% of your focus on one discipline. Becoming a jack-of-all-trades is certainly an added plus, however, most employers are searching for someone that can take ownership of one aspect of the pipeline. Find what area you have a passion for and master it.

Changes
With technology driving today's games evolving, so is the process of making assets for those games. As with past years we'll continue to see breakthroughs in the graphics of games. The amount of detail and time

being poured into game assets are shining through in the final product. The quality of games using technology like Unreal Engine 3 is quickly moving towards the look of blockbuster movies. I see more respect being given to this industry as an art form in general. The games being put out today have become these huge cinematic experiences that consumers have been waiting for. It truly is an exciting time to be a part of this industry.

Future plans
After the privilege of working on 'Gears of War', I'm honored to continue working at Epic Games. I've gained many friendships here and am working with one of the finest teams in the industry. As far as my personal life goes, I'm anxiously awaiting the arrival of my daughter Avry Grace Lanning due April 14th of this year.

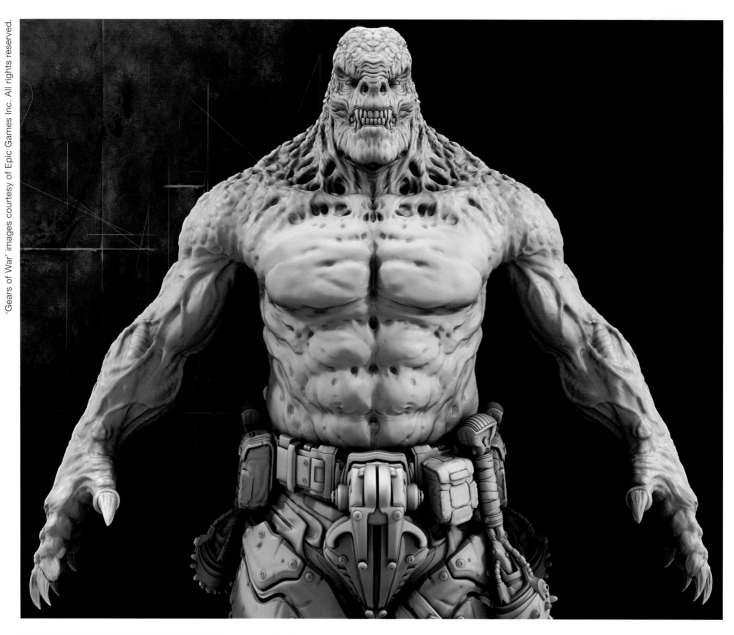

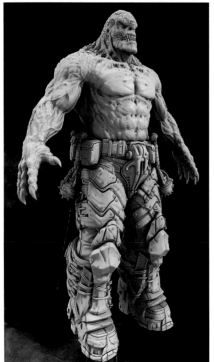

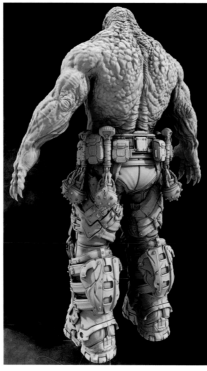

Grenadier HP
3ds Max, Mudbox, Photoshop
Character concept: James Hawkins
Character model: Kevin Lanning
Weapon model: Peter Hayes
The Grenadier is a grenade-wielding variation of the Locusts Drones featured in 'Gears of War'. These sets of images are renders of the high-poly model.
[left series, above]

General RAAM HP
3ds Max, ZBrush, Photoshop
Character concept: James Hawkins
Model: Kevin Lanning
General RAAM in this close-up render of the high-poly model is the military leadership of the Locusts featured in 'Gears of War'.
[right]

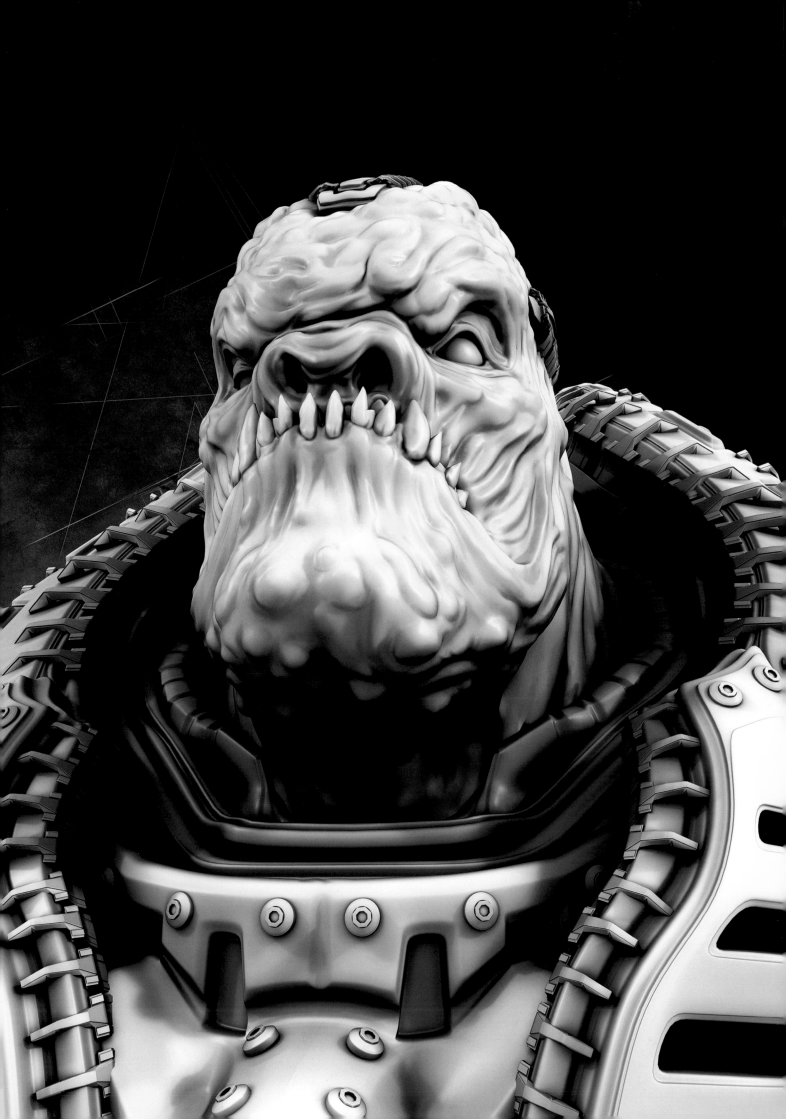

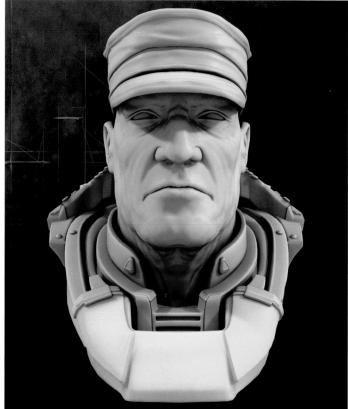

Damon Baird HP
3ds Max, ZBrush, Photoshop
Character model: Kevin Lanning
Baird in this close-up render of the high-poly model is a member of the Delta Squad featured in 'Gears of War'.
[top]

Marcus Fenix HP
3ds Max, ZBrush, Photoshop
Character concept: James Hawkins
Model: Kevin Lanning
Marcus in this close-up render of the high-poly model is a member of the Delta Squad and the main character featured in 'Gears of War'.
[above]

Augustus Cole HP
3ds Max, ZBrush, Photoshop
Character concept: James Hawkins
Character Model: Kevin Lanning
Gus in this close-up render of the high-poly model is a member of the Delta Squad featured in 'Gears of War'.
[top]

Colonel Victor Hoffman HP
3ds Max, ZBrush, Photoshop
Character concept: James Hawkins
Model: Kevin Lanning
Hoffman in this close-up render of the high-poly model is a member of the Delta Squad featured in 'Gears of War'.
[above]

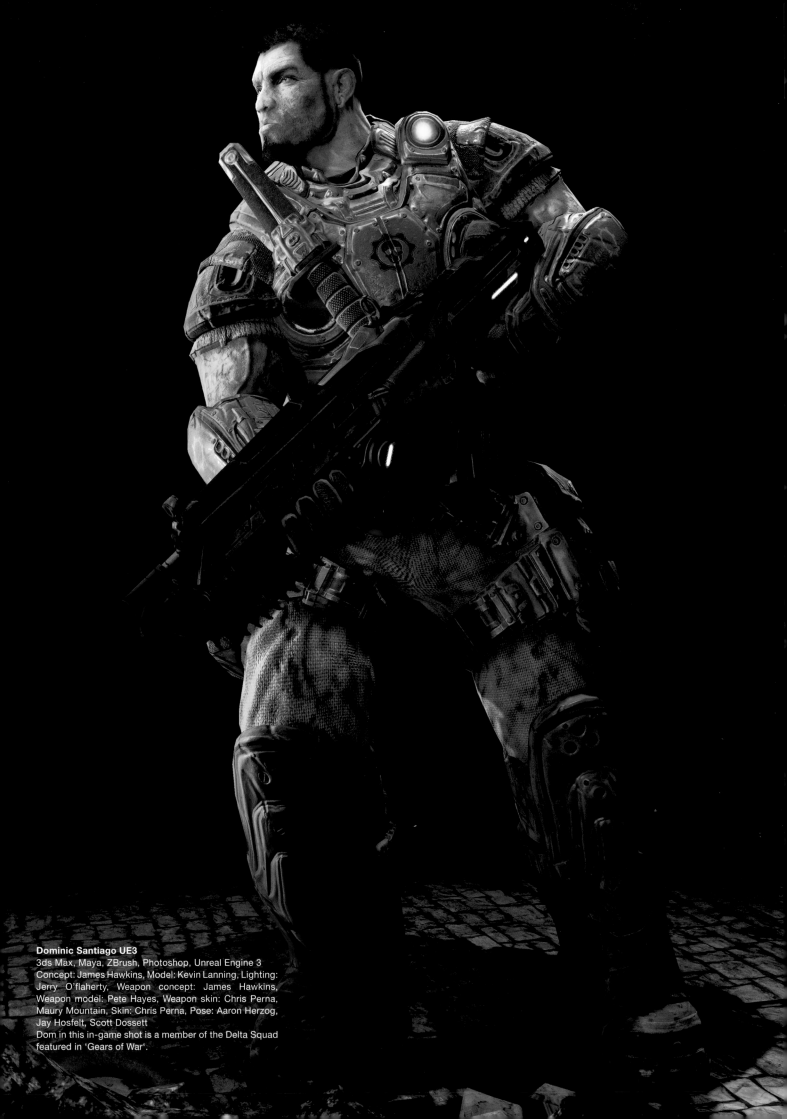

Dominic Santiago UE3
3ds Max, Maya, ZBrush, Photoshop, Unreal Engine 3
Concept: James Hawkins, Model: Kevin Lanning, Lighting: Jerry O'flaherty, Weapon concept: James Hawkins, Weapon model: Pete Hayes, Weapon skin: Chris Perna, Maury Mountain, Skin: Chris Perna, Pose: Aaron Herzog, Jay Hosfelt, Scott Dossett
Dom in this in-game shot is a member of the Delta Squad featured in 'Gears of War'.

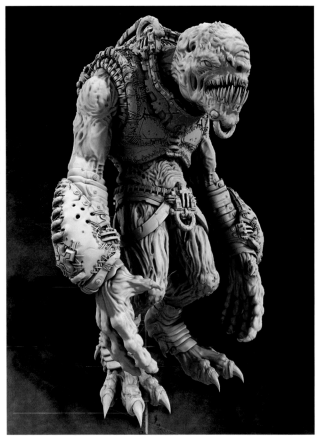

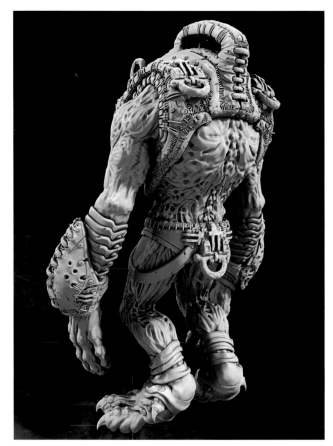

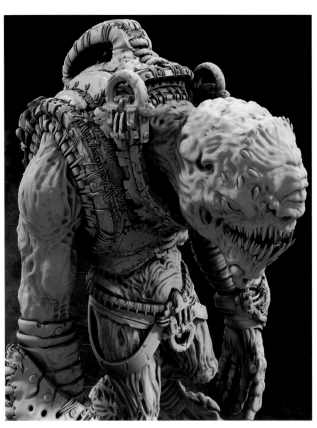

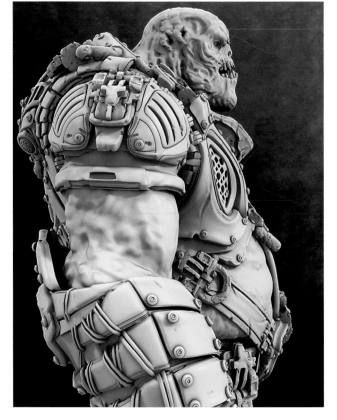

Wretch HP
3ds Max, ZBrush, Photoshop
Character concept: James Hawkins
Model: Kevin Lanning
The Wretch is a fowl creature used by the Locusts featured in 'Gears of War'. These sets of images are renders of the high-poly model.
[top, top right, above]

Boomer HP
3ds Max, ZBrush, Photoshop
Character concept: James Hawkins
Model: Kevin Lanning
The Boomer in this close-up render of the high-poly model is the largest variant of the Locusts featured in 'Gears of War'.
[above]

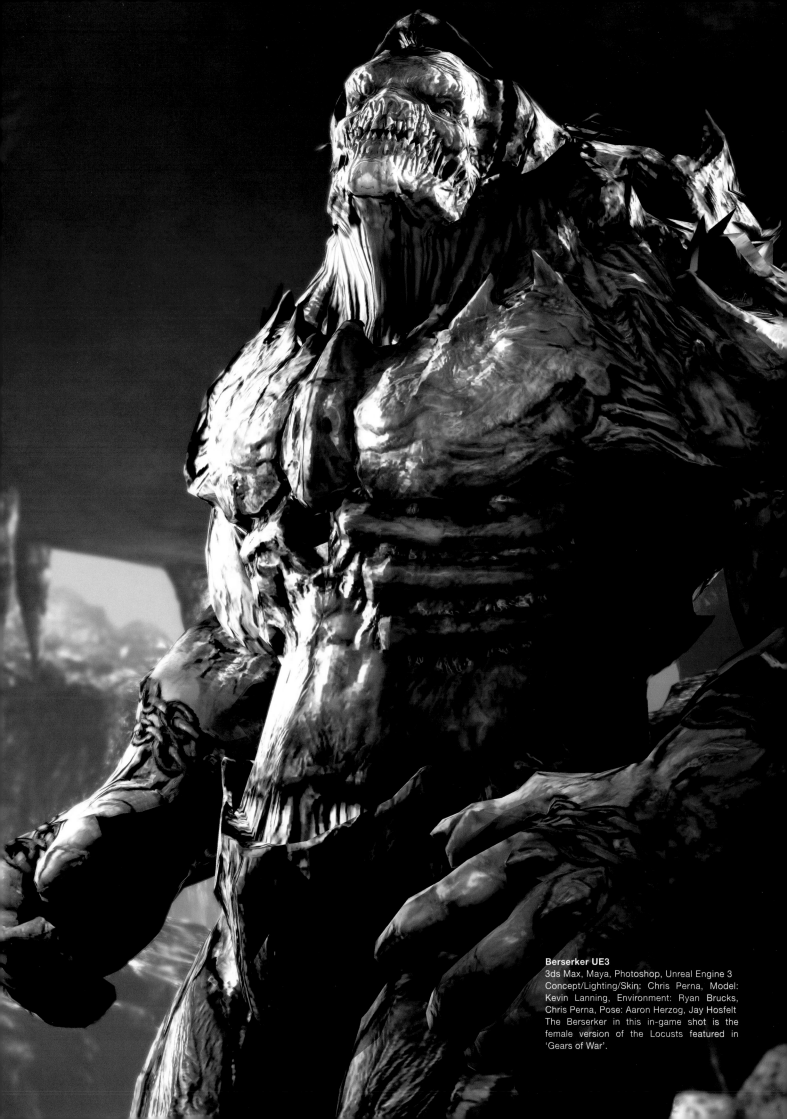

Berserker UE3
3ds Max, Maya, Photoshop, Unreal Engine 3
Concept/Lighting/Skin: Chris Perna, Model:
Kevin Lanning, Environment: Ryan Brucks,
Chris Perna, Pose: Aaron Herzog, Jay Hosfelt
The Berserker in this in-game shot is the
female version of the Locusts featured in
'Gears of War'.

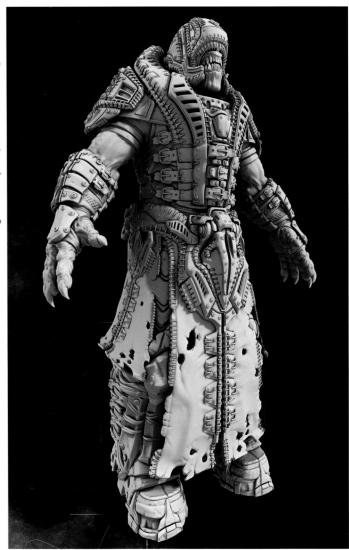 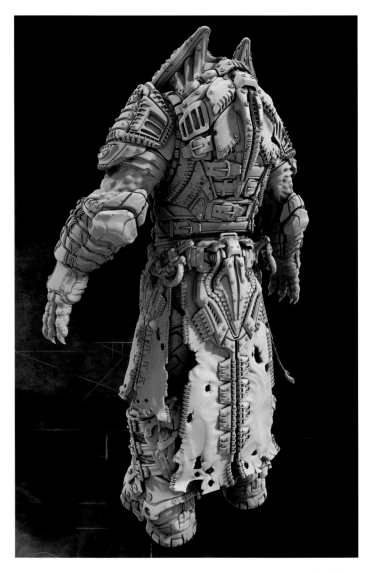

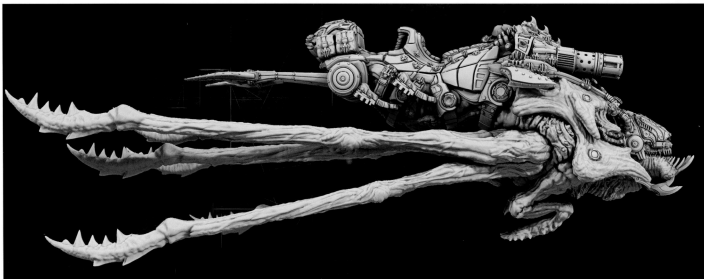

Theron Guard HP
3ds Max, ZBrush, Photoshop
Character concept: James Hawkins
Model: Kevin Lanning
The Theron Guard is an elite set of the
Locusts featured in 'Gears of War'.
These sets of images are renders
of the high-poly model.
[top, top right]

Reaver HP
3ds Max, ZBrush, Photoshop
Character concept: James Hawkins
Model: Kevin Lanning
The Locust Reaver in this high-poly
model render is the choice creature
used for transportation by the Locusts
featured in 'Gears of War'.
[above]

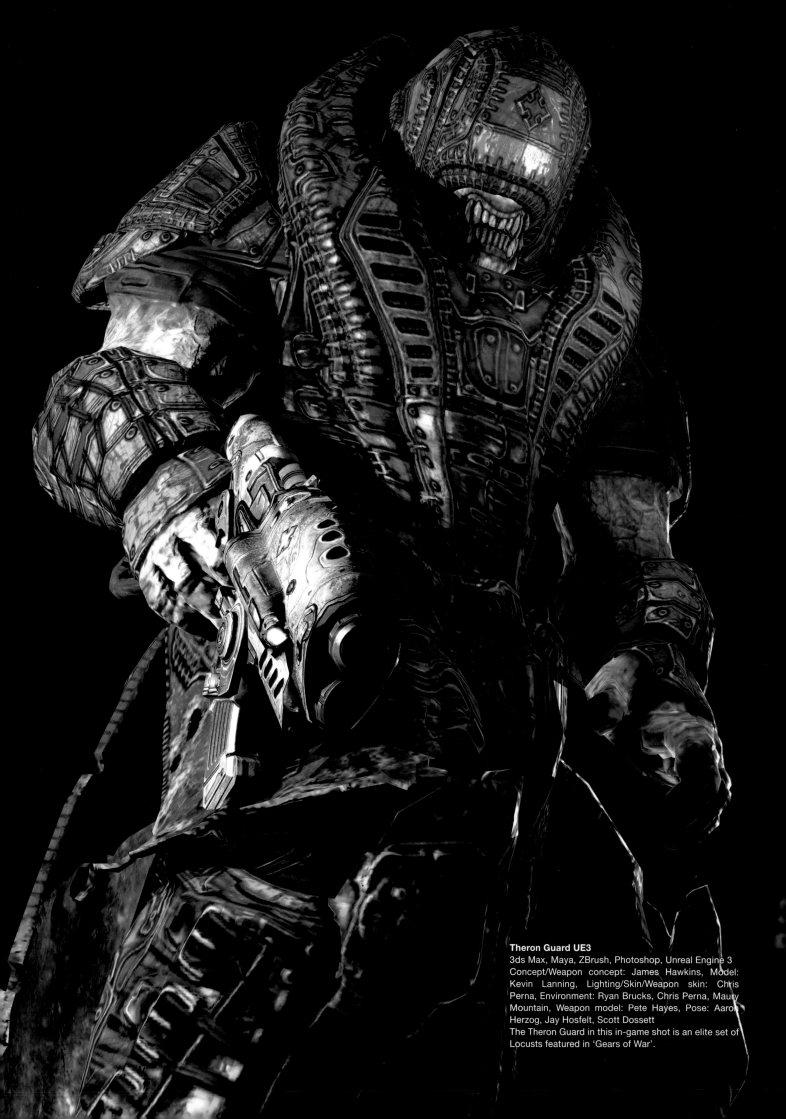

Theron Guard UE3

3ds Max, Maya, ZBrush, Photoshop, Unreal Engine 3
Concept/Weapon concept: James Hawkins, Model:
Kevin Lanning, Lighting/Skin/Weapon skin: Chris
Perna, Environment: Ryan Brucks, Chris Perna, Maury
Mountain, Weapon model: Pete Hayes, Pose: Aaron
Herzog, Jay Hosfelt, Scott Dossett
The Theron Guard in this in-game shot is an elite set of
Locusts featured in 'Gears of War'.

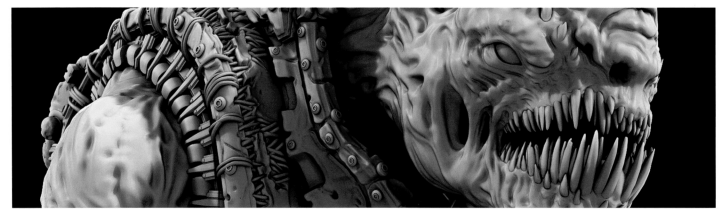

GEARS OF WAR: HIGH-POLY WORKFLOW

Next-gen games

As the technology driving today's games has evolved, so have the steps involved in producing the characters made for those games. This set of tutorials is geared towards covering the overall pipeline in creating characters for next-gen games at Epic Games. This generation of game engines has allowed artists to put in a stunning amount of detail and realism into the characters. Here we'll start with a look at a few character concepts from our recent Xbox360 title 'Gears of War' and walk through the process of creating uber detailed characters utilizing tools like 3ds Max, Mudbox, Zbrush, and Unreal Engine 3. Demonstrating the pipeline used at Epic Games to take a character from concept to in-engine retaining a maximum amount of the detail injected into the high-poly 3D model.

Working in a team

The amount of teamwork and dedication involved in creating the characters for Gears of War from concepts, models, textures, and animations has amazed me throughout my time of working at Epic. I'll be sitting at my desk cranking on a model and someone will pop their head in to chat about a new creature or character idea the Leads have. This is usually the starting point of a new character that will trickle down into the production pipeline. Once the initial idea has been approved by the Leads, James Hawkins (Concept Artist) will begin churning out some initial designs being directed by Jerry O'Flaherty (Art Director). This is when the team starts getting rather excited to try to create the sickest thing possible. It's the greatest feeling to be able to collaborate on ideas with Jerry, James, and Chris Perna (Lead Artist) as well as others at this stage of production. Just when you think you're working on the coolest thing ever, you get a sneak peek at what's coming next and can't wait to dig into it. After the concept has been finalized, it is then passed down the production pipeline for the modeling to begin.

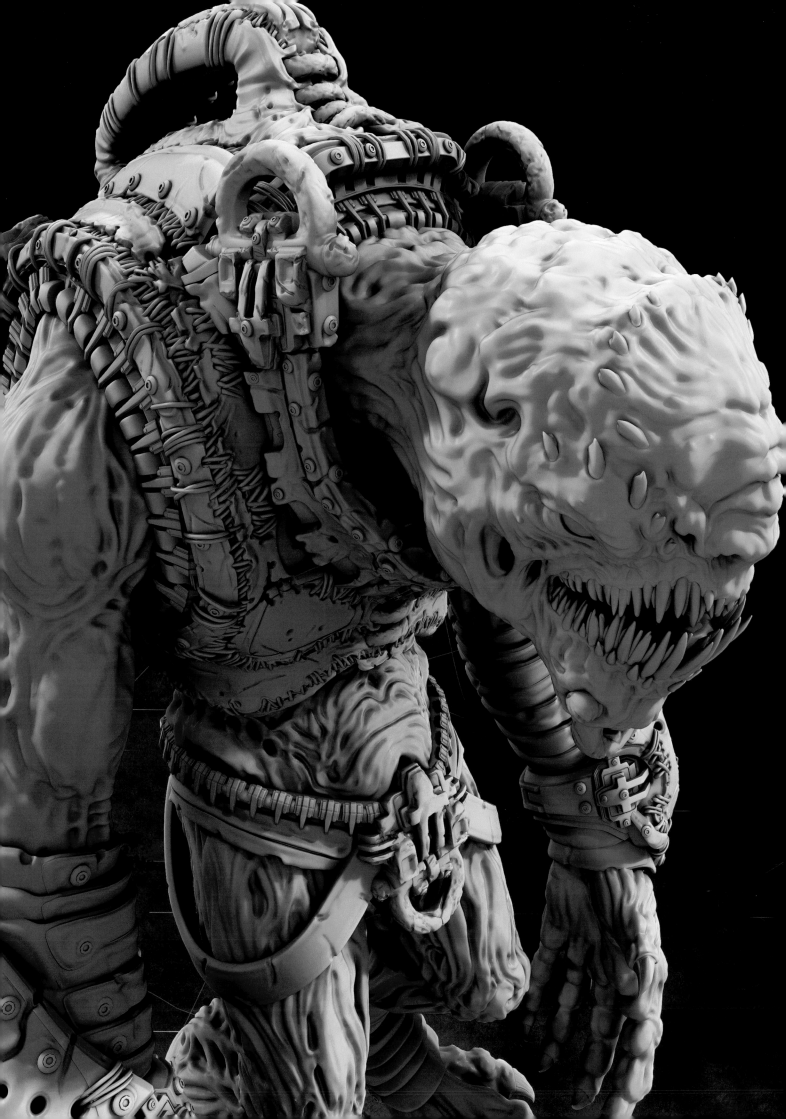

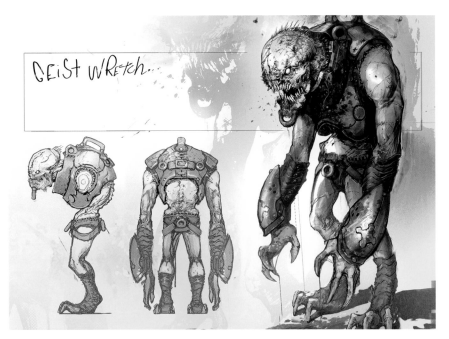

Idea to concept: The Wretch

As a starting point for this tutorial, I thought it would be a good idea to show off some of the concepts I receive from our Concept Artist (in this case James Hawkins). As a character modeler you become rather familiar with the style, quality, and direction of the concepts given to you. I have a huge amount appreciation for what goes into the concepting phase, and for the talent of the guys involved possess. The Locust Wretch is a great character to demonstrate the mixing of organic and hard surfaces. These creatures are little nasty scavengers with rotten flesh, razor sharp teeth, and old worn armor with a badass handle built into it.

Idea to concept: The Boomer

The Locust Boomer is another character I'll be covering (concept by James Hawkins). The Boomer was designed to utilize certain aspects of the original locust grunt to speed up the production of it. A good friend and co worker of mine Peter Hayes (Weapon/Vehicle Modeler) refers to this method of reusing assets as "kit bashing". The term has become rather popular within the studio. We'll cover more about kit bashing later on in the tutorial.

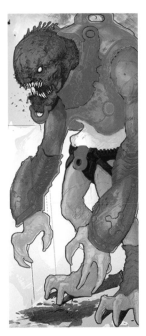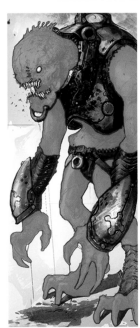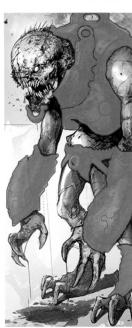

Concept analysis

When starting a new character, taking a couple seconds to breakdown the concept is always a good idea. Whether it's done mentally or visually is up to the artist. But it will help to simplify your character from one massive form into several smaller ones, in return making it a less daunting task to get the ball rolling. This breakdown will also help to determine what areas of the model will be organic, hard surface, as well as what can be "kit-bashed" from previous models.

Roughing in the form

I don't worry about details at this stage and instead begin the model by flushing out the major forms of the body. This initial mesh will be used as a base mesh which will then be taken into a program like Mudbox or ZBrush for further refinement and detail. This will also be used as a starting point for the low-poly mesh. Therefore it's always a good habit to save a copy of the pre-detailed meshes to pull from, whether it's for a low-poly mesh or a starting point for a new high-poly model.

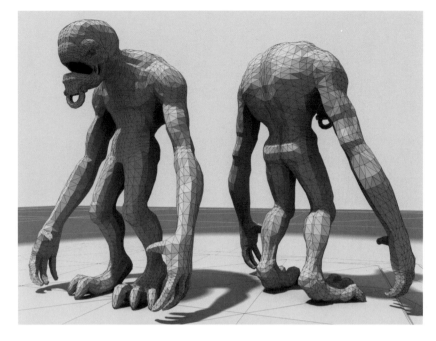

Adding armor

By modeling the character's armor over the body, it allows for more accurate decisions that will in return make a more believable looking wardrobe. This has also proven to be useful for creating a set of armor that won't be sacrificing your character's range of motion.

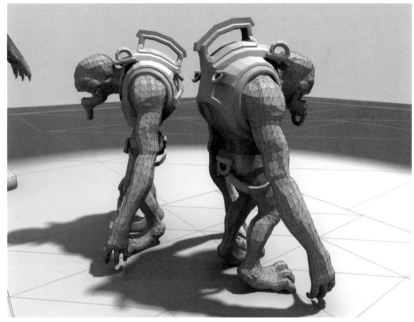

Keeping it simple

The simpler the base mesh, the better. The faster you can get a something into an application like Mudbox or ZBrush, the faster you will begin to see the results you want.

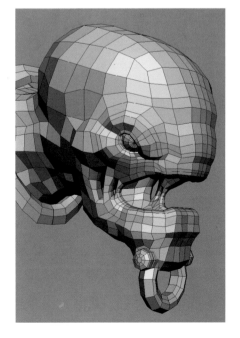
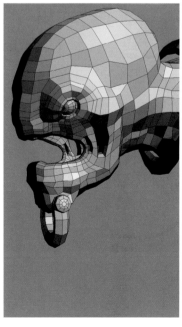

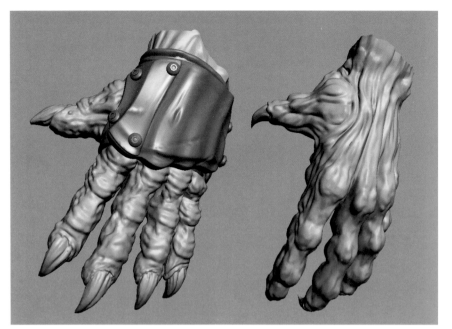

Kit-bashing

Kit-bashing refers to the method of reusing previously made assets to speed up production. Tweaking and modifying existing meshes is a huge timesaver when crunching for a tight deadline. Part of being an artist in this fast-paced industry is having the ability to utilize what you can to speed up production times without sacrificing quality. Keeping a digital library to pull meshes from is a great habit to have.

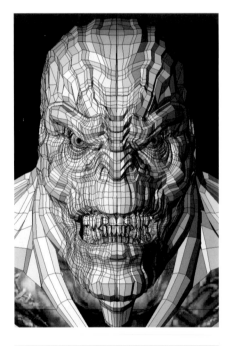
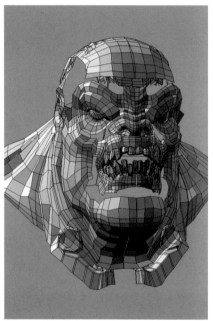

The art of dissecting

When beginning a new head such as the Locust Boomer, I'll start by dissecting an existing head model into several pieces for ease of reuse. By breaking the nose, eyes, mouth, and whatever other forms I'll be using into their own meshes, I can quickly begin forming the structure of the new head.

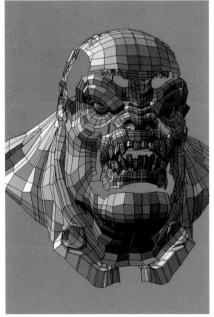
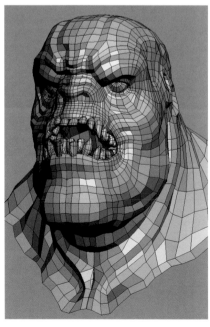

Stitching it all together

Once all of these meshes have been placed and refined to the proper proportions of the concept, I can begin stitching the meshes together. This mesh will then be used as a starting point to begin detailing and as a foundation for the creation of the low-poly mesh.

Building the body with spare parts

This same method of kit-bashing was used for creating the body of the Boomer. Taking existing assets and utilizing them when possible as a starting point.

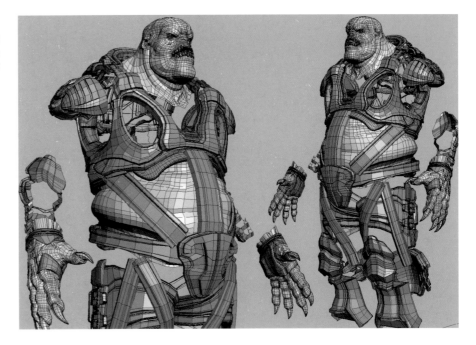

Body built

The model at this point has been kit-bashed together entirely of pre-existing models that have been tweaked and refined. From here, the pieces are then taken into an application such as Mudbox or ZBrush for a detail pass.

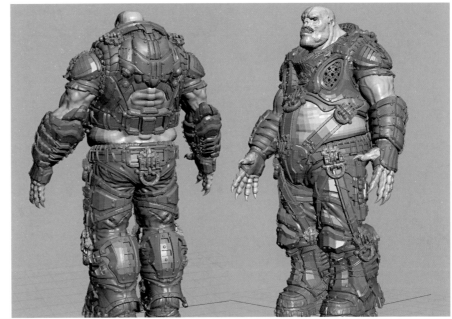

Detail pass (front views)

This is the Locust Boomer in its final high-poly stage from front views.

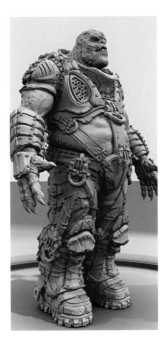
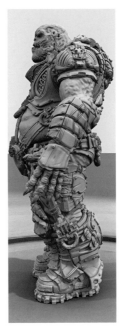
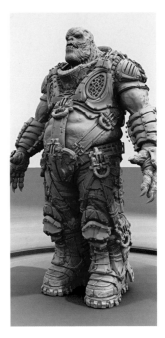

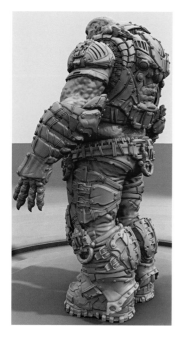 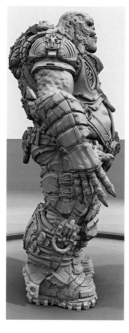 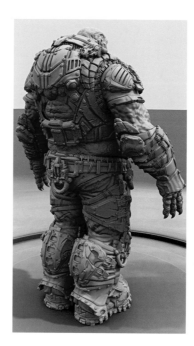

Detail pass (rear views)

Here is the Locust Boomer in its final high-poly stage from rear angles. The meshes have been detailed, and optimized down (this process is covered in more depth in the following steps).

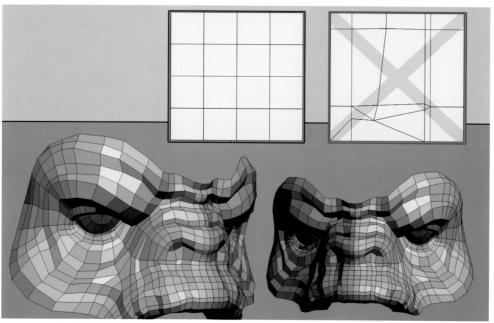

Even topology

Before exporting the meshes out of 3ds Max to be detailed, there is some preparation that needs to be done to achieve the best results in your detailing application. Make sure the polygons in the mesh are evenly distributed throughout the mesh; doing so will supply the resolution needed when dividing the mesh for sculpting. Avoiding triangles and five sides polys when possible will help prevent kinks in the mesh that will occur when sculpting.

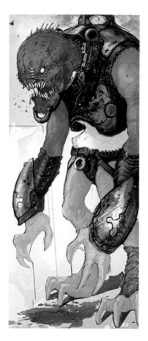 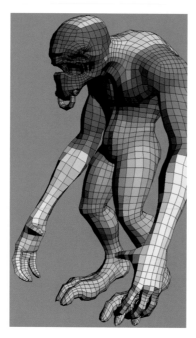 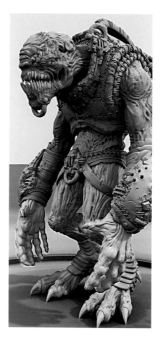

Natural seams

Taking advantage of the natural seams of a character's design is a great way to break up the character into manageable pieces. This is also ideal for creating UV sets that can be used as polygroups within ZBrush.

Adding a detail pass

Whatever sculpting application you prefer, they all have one thing in common. By sculpting on one level of division a time and gradually working up will always give the best results. Begin by working the existing base mesh focusing on the overall forms.

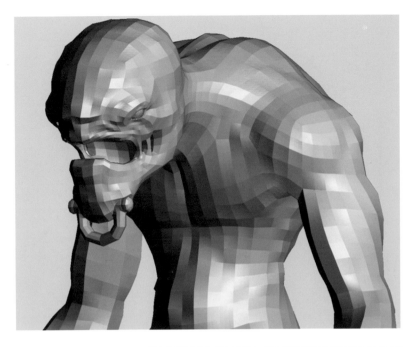

Adding a further detail pass

From there, subdivide and begin defining the smaller forms that create the larger forms of the character.

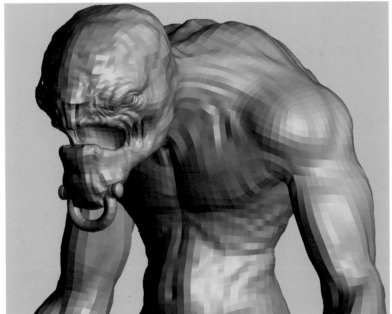

Adding another detail pass

Many artists starting out make the mistake dividing the mesh an insane amount of times and get caught up in the small surface details. The purpose your model is serving will define how much detail is needed and where it is needed. However, at this stage in the process continue to focus on form and shape verse minute details such as skin pores.

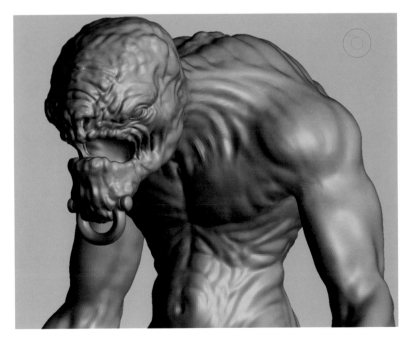

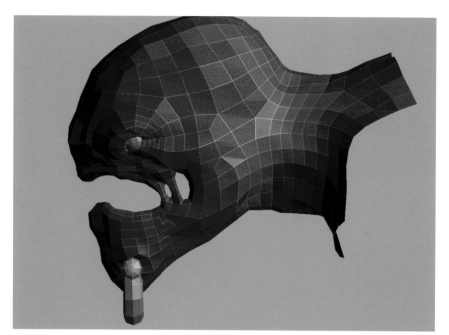

Breaking the file down

Depending on the capabilities of your machine, saving out sections of the character as a new file will allow for better work conditions. By doing so, it creates a more manageable scene allowing for focus on each individual section without limiting the subdivision of the mesh.

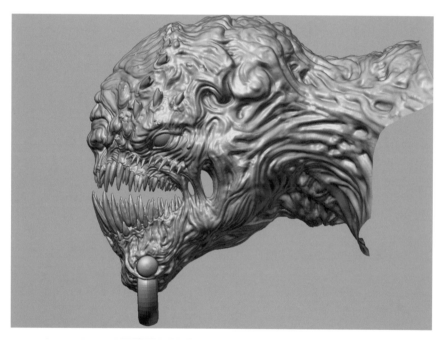

Final details

By separating the Wretch's head into its own file, I was able to gain enough resolution to finalize the detail pass while keeping a manageable file. This head of the Wretch came in at around two million polygons.

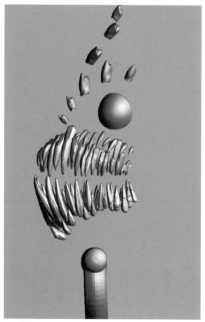

Exporting the mesh

The method I tend to use for getting the mesh back into 3ds Max isn't for everyone. For some, exporting out a displacement map will work best for their needs. However, I prefer to export out OBJs at the highest subdivision in chunks that can be optimized before bringing into 3ds Max.

Exporting the mesh in chunks

The mesh is exported out in chunks at around 500k polygons to avoid application crashes and hang times. This may seem like a rather destructive way to get the meshes back into 3ds Max, but since they're being used solely for normal map generation, it works rather nicely. Bringing this dense mesh back into 3ds Max also allows for the low-poly model to be built directly over this mesh. Therefore, having an accurate representation of the final product to use as a template is ideal.

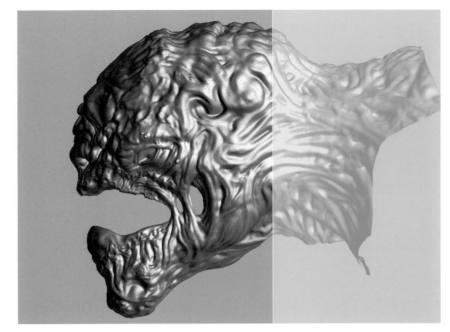

Mesh optimization step one

These chunks are then optimized using a plug-in called Polygon Cruncher. By optimizing the chunks, importing, working, processing, and render times are decreased in return increasing productivity. Polygon Cruncher allows for a mesh's polygon count to be optimized up to 75% while maintaining the meshes detail. Batch optimization is used to speed this process up. The first step is to simply point out the directory holding the OBJs to be optimized. Polygon Cruncher is available at www.mootools.com

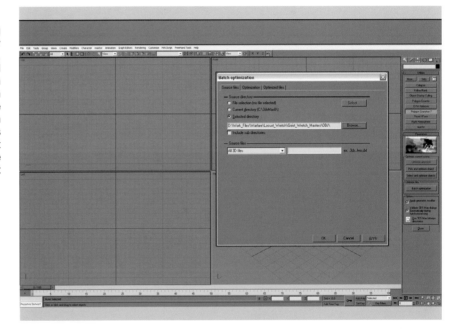

Mesh optimization step two

The second step is to determine the % amount to be optimized and enable 'Protect Borders'.

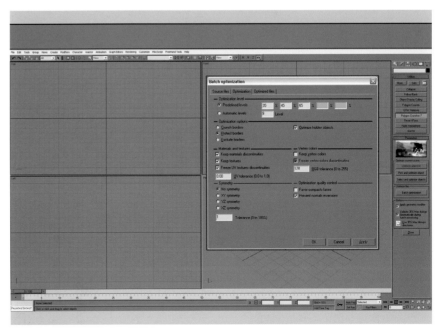

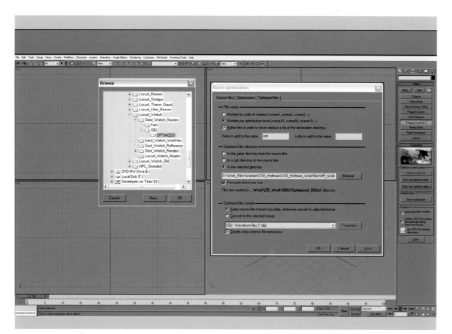

Mesh optimization step three

Simply create a new folder for the optimized OBJs to be saved in. Once doing so, Polygon Cruncher is ready to begin.

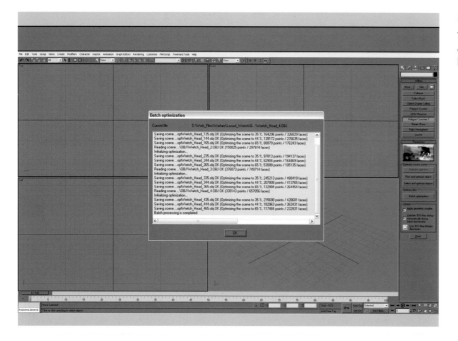

Mesh optimization step four

This process will take several minutes depending on the quantity of meshes you have and the capabilities of your machine.

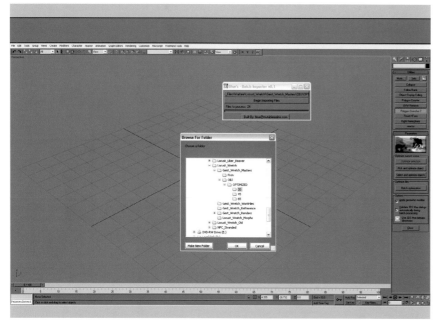

Importing meshes

With the new optimized OBJs created, they can easily be imported into 3ds Max. Blue's Batch Importer is a great script available at www.scriptspot.com. Simply point to the desired directory and begin importing.

Imported meshes

With the optimized OBJs now imported, it's easy to see that very little detail has been lost, and the meshes fit together seamlessly.

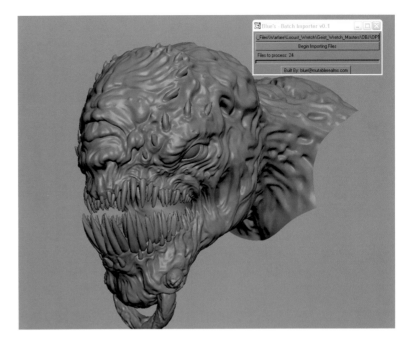

Further optimization

I tend to go in and optimize these meshes a bit more once imported in using Polygon Cruncher. Doing so will help to keep the file down to a decent size.

Final optimized mesh

By taking the time to optimize these meshes down, the initial two million polygon mesh is now sitting just over two hundred thousand faces without losing any highly noticeable detail.

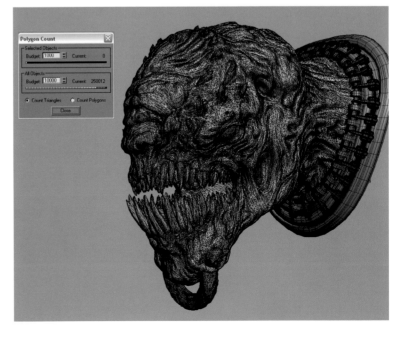

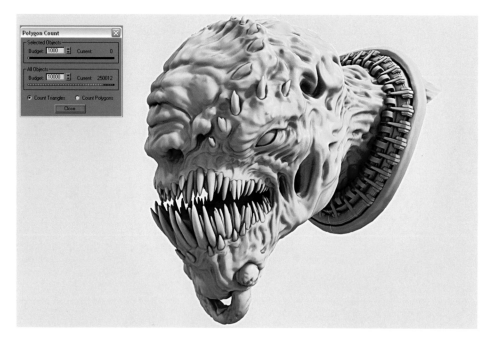

Render of optimized mesh

The amount of detail that has been retained can better be seen in this render of the optimized high-poly meshes. Any minor detail that has been lost, would only mud up the final normal map created from this.

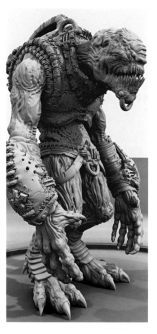
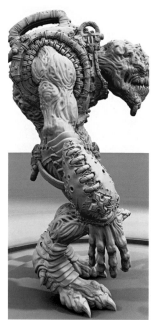
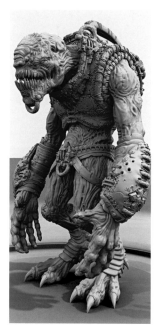

Final model (front views)

To finish out the model, this process of detailing and optimizing was applied throughout the majority of this character model. Doing so optimized the original twenty-four million poly model into a manageable six million poly model that is easily workable within 3ds Max.

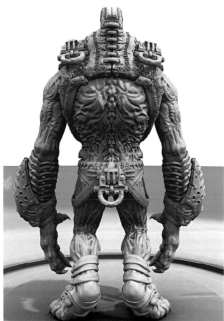
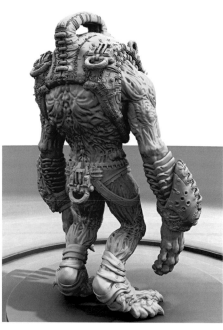

Final model (rear views)

The same method of kit-bashing assets used on the Boomer, can also be seen throughout portions of the Wretch model. By doing so, it creates a visual sense of identity between the Locust characters.

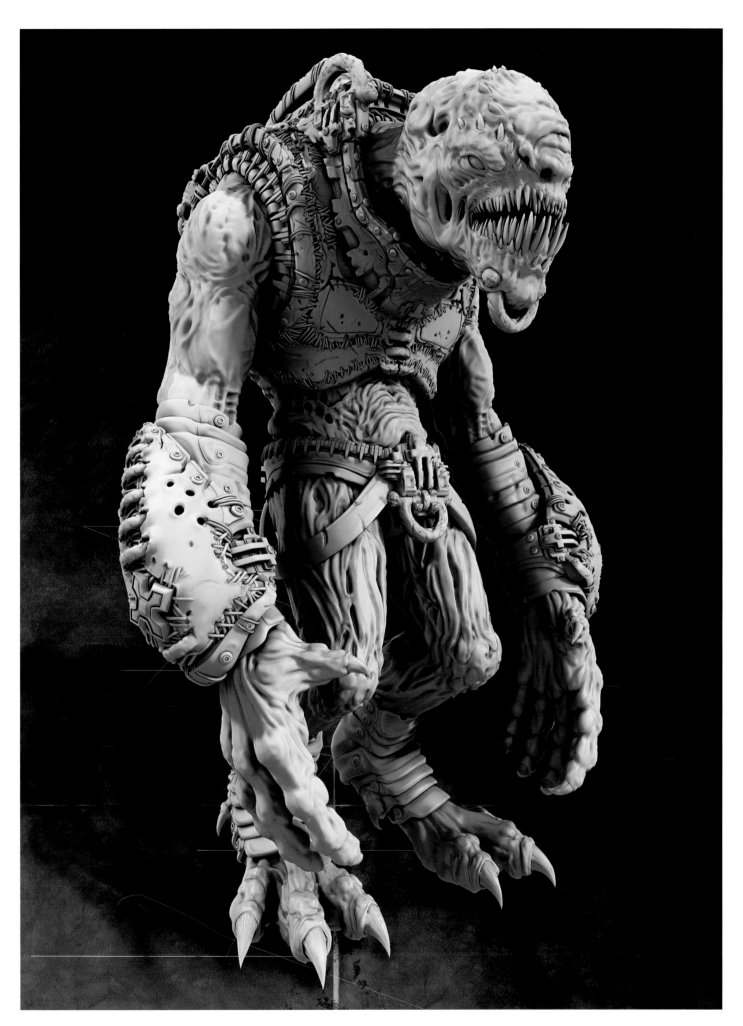

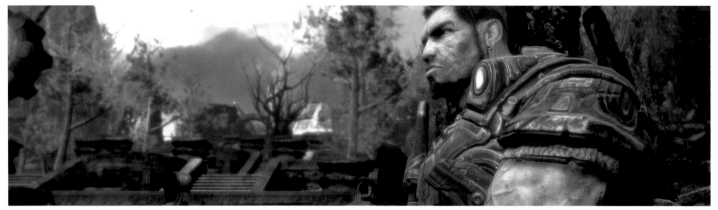

GEARS OF WAR: LOW-POLY WORKFLOW

Low-poly for modeling

With the high-poly model complete, it's time to create the low-poly model that will be used in game. Alongside the creation of this model are several key factors to keep in mind. All of the work and time put into creating the character from the initial concept all the way to the high-poly model will be displayed through this mesh. It will be handed off to Animators who will be spending weeks if not months of their time creating the rig and animations needed for the game. Therefore making sure that the low-poly model being handed off is created with the quality that will allow them to do their jobs without headaches is key.

Working with the animators

It's always good practice to work closely with whoever will be animating the character once you're finished on your end. I've been rather fortunate to work with some badass Animators who I've learned a ton from in regards to what I can do to help them out when creating a low-poly model. The amount of knowledge and skill that went into creating the animations for 'Gears of War' simply boggles my mind. Needless to say I have a huge amount of respect and admiration for every aspect of what these guys do. Putting in the effort to create a model that will deform properly and is clean for rigging is the least that I can do.

This section will cover the basic steps used in creating the low-poly models for the Boomer and Wretch, as well as a brief overview of the process used for creating hair for Dominic Santiago.

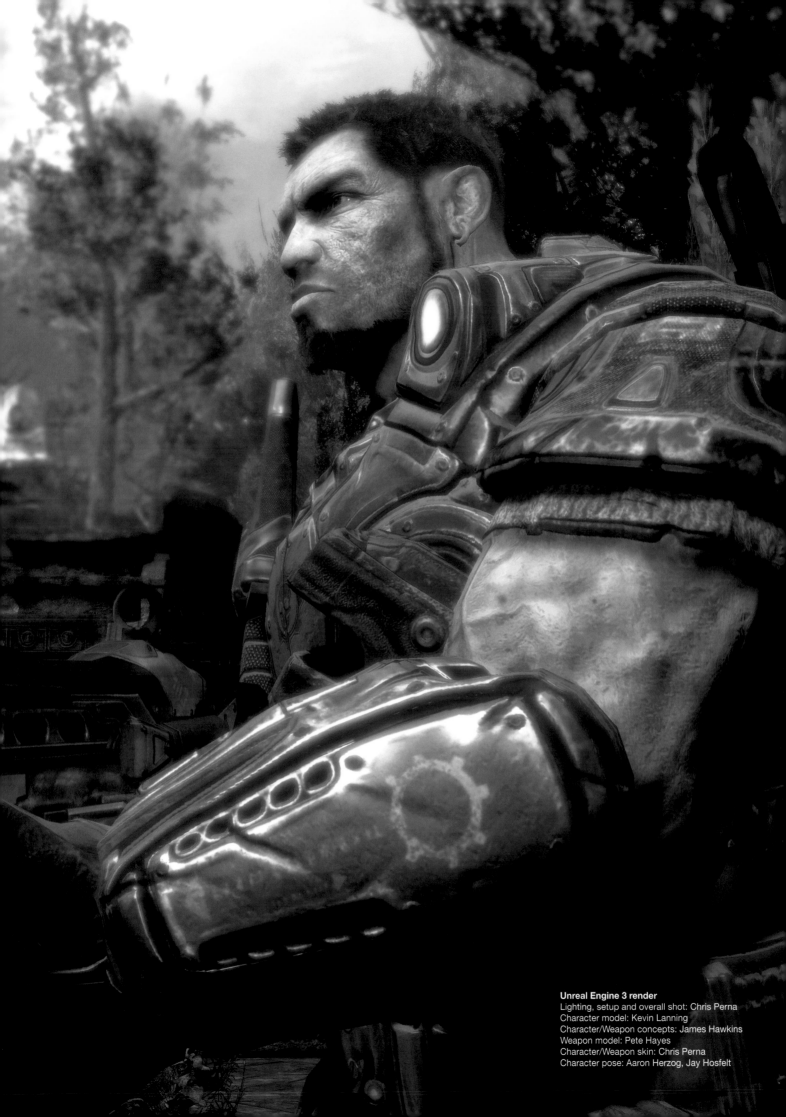

Unreal Engine 3 render
Lighting, setup and overall shot: Chris Perna
Character model: Kevin Lanning
Character/Weapon concepts: James Hawkins
Weapon model: Pete Hayes
Character/Weapon skin: Chris Perna
Character pose: Aaron Herzog, Jay Hosfelt

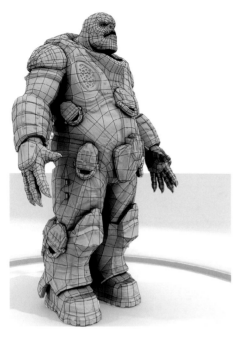
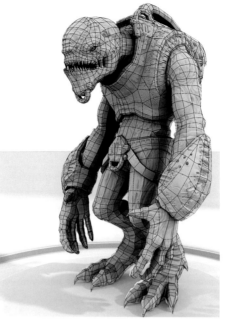

Starting point

With the high-poly model assembled within 3ds Max, we can now use it as a template for the low-poly model to ensure accurate normal map generation. Its important to keep in mind the relationship of the two models: the high-poly model represents the desired look we are trying to achieve by creating and applying a normal map to the low-poly model. With this in mind, overlooking the minor shapes and details of the high-poly will help when constructing the low-poly model. All of the minor details will shine through in the normal map as they should. By focusing on "blanketing" the low-poly model over the major shapes and forms of the high-poly model, you will achieve the best results.

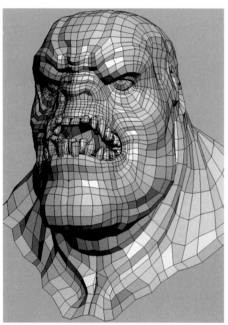
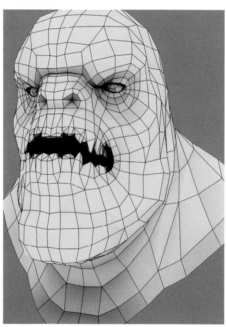

Utilizing the base mesh

Manually refining and optimizing the original high-poly base mesh is a great way to quickly generate a solid foundation of the low-poly model.

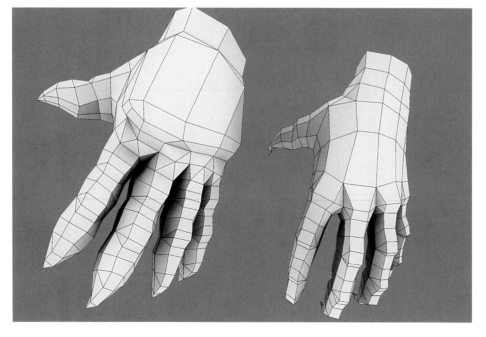

Kit-bash

By reusing existing ripped (unwrapped) low-poly models to generate your "lows", the time it takes to unwrap the UVs is quickly reduced. Keeping a digital library of every stage in the modeling process will speed up your workflow.

Edge loops

By keeping the placement of appropriate edge loops in mind while modeling, the mesh will deform properly once rigged. Since the animators will be working with this mesh, it's good practice to have them take a look at the mesh before signing off. This also allows for you to pick up some tips that will improve your modeling skills for the future.

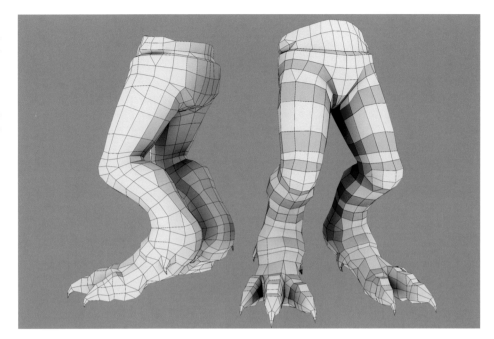

Silhouette

The use of proper edge loops for mesh deformation goes alongside creating a smooth silhouette. Both are key factors to keep in mind when trying to achieve the high-poly look for an in-game model. Nothing gives away that the model is low-poly more than having sharp polys protruding off the silhouette of an in game model. The goal with the use of normal maps is to achieve the visual impression that the in game model is much more than simply a low-poly mesh. By paying attention to these two things, this is achieved.

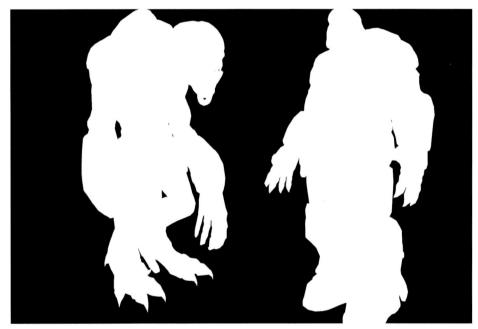

Low-poly breakdown

Segmenting the low-poly model into separate pieces will also help to convey the high-poly look we are after in today's games. By doing so, the animation department can also now go in and add some secondary motion to clamps, and pads to help sell this faked complexity of the model. This will also save on texture resolution if the mesh is unwrapped wisely by duplicating objects.

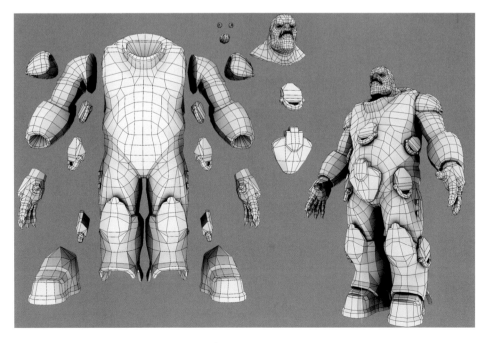

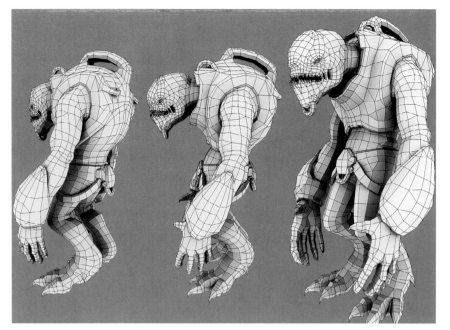

Final Wretch model

Here is the final Wretch in-game model. This low-poly character model came in at 10,292 faces. This is an ideal face count for a game like 'Gears of War' that is limited in the amount of characters being displayed on screen.

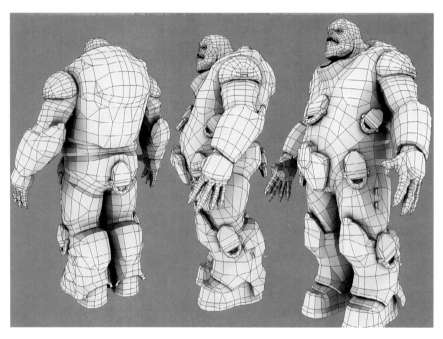

Final Boomer model

Here is the final Boomer in-game model. This low-poly character model came in at 10,952 faces. As with everything, the amount of faces used in creating the character, depends on the importance of the character. For example, Marcus Fenix the main character of 'Gears of War' was built with around 15,000 faces. LODs (levels of detail) are then made off this, for later use.

Creating hair

Our Technical Art Director at Epic, Shane Caudle was responsible for figuring out the best solution for creating hair for use in the Unreal Engine 3. This pipeline was then used in creating hair for the characters in 'Gears of War'. As a starting point, we rendered out hair strands from 3ds Max using a plug-in called Hair FX.

Assembling the texture

These images were then assembled into one texture that would be applied to several sheets for placement over the character's head. This texture is then used as the overall diffuse map for the hair.

Using the alpha

By using this process, we were able to save out the alpha channel along with the diffuse map. The alpha is then used as an opacity mask to achieve the sense of hair strands when applied to the sheets.

Applying the texture

This texture is then applied to several simple meshes that will be manually placed onto the character's head. It's a time-consuming process, but well worth it in results.

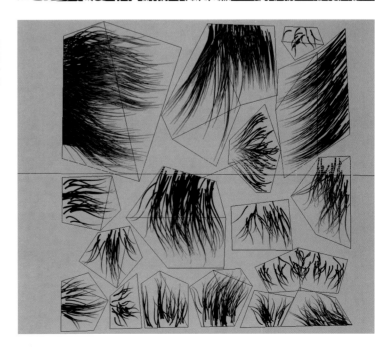

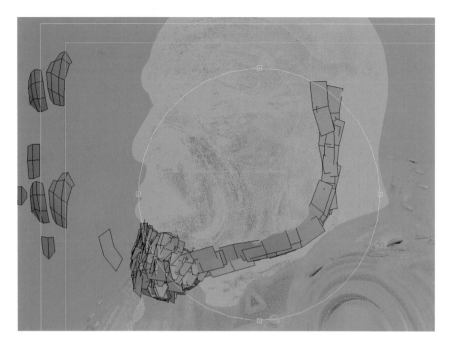

Placing sheets

A common mistake is to get caught up in the moment and start adding too many sheets as demonstrated here. By focusing on placing the large portions of hair first, this can be avoided.

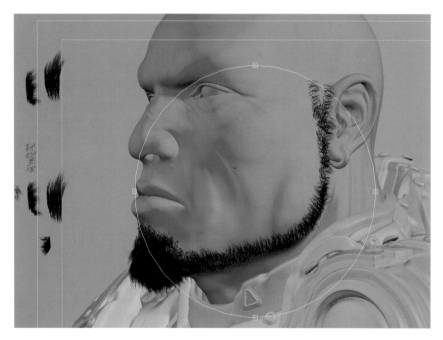

Checking the outcome

Constantly view the model at all angles when placing hair sheets. What looks good from one angle will more than likely not look so hot from another. Toggle the texture on and off to view how the sheets are looking in correlation with the head.

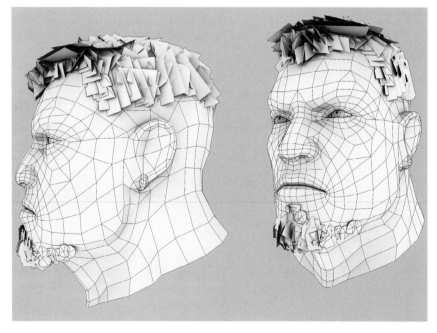

Final low-poly model

A better representation of the amount of sheets that should be placed to create the hair is displayed well in this wireframe shot. Although it doesn't look like much here, once the character is in game with the final textures applied, everything comes together nicely.

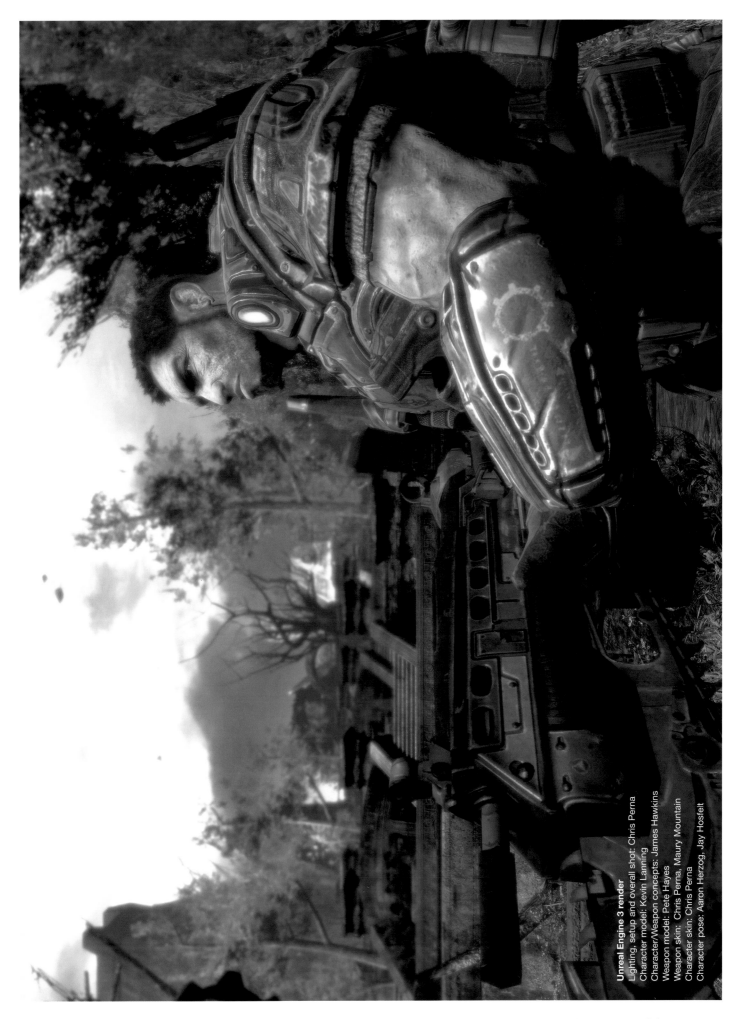

Unreal Engine 3 render
Lighting, setup and overall shot: Chris Perna
Character model: Kevin Lanning
Character/Weapon concepts: James Hawkins
Weapon model: Pete Hayes
Weapon skin: Chris Perna, Maury Mountain
Character skin: Chris Perna
Character pose: Aaron Herzog, Jay Hosfelt

GEARS OF WAR: RIP AND PROCESS WORKFLOW

UV unwrapping

For this third and final section of tutorials, we'll look at the process of breaking the low-poly model apart for ripping (UV unwrapping) and the generation of the textures. As with every stage in the pipeline thus far, this one is really important. Creating a clean rip that processes well is key in showing off the details put into the high-poly model. These textures created within 3ds Max are then applied to the in-game model and handed off for a Texture Artist to sink his teeth into.

Texturing

As with the Animators, the Texture Artist will also be spending a large amount of time creating and finalizing these texture maps. Making sure the textures being handed off are up to par is just as critical as the low-poly model. Chris Perna (Lead Artist) was responsible for creating nearly all of the character and creature textures in 'Gears of War'. His unique artistic style and vision has played a huge role in the final look of the characters as well as the overall game. I'm absolutely humbled by how far he pushes every character with his textures. This section will also cover the basic steps used in creating the UV rips for the Locust Boomer, normal map generation, and a brief overview of the process used for generating some base textures from the high-poly mesh.

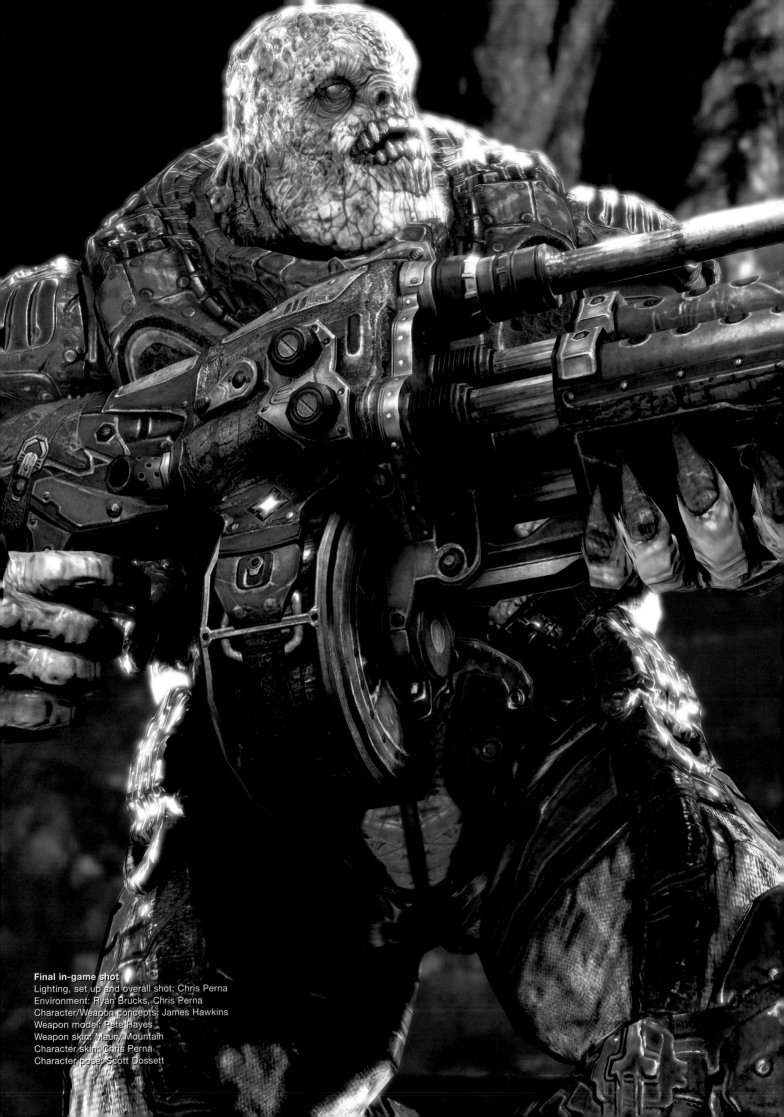

Final in-game shot
Lighting, set up and overall shot: Chris Perna
Environment: Ryan Brucks, Chris Perna
Character/Weapon concepts: James Hawkins
Weapon model: Pete Hayes
Weapon skin: Maury Mountain
Character skin: Chris Perna
Character pose: Scott Dossett

Starting point

Depending on the importance of the character, most UVs will be mirrored to provide as much resolution as possible. If there are multiple identical objects, they will often be duplicated off of one existing mesh that has been unwrapped to maximize the resolution of the textures. The clamps on the Boomer are a good example of this.

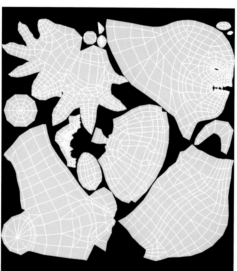

UV layout (pelt mapping)

Pelt mapping is a very fast method of laying out UV seams for quick unwrapping of the mesh. This is then taken into Deep UV for the final relaxing of the rip. A typical 'Gears of War' character will be ripped into two 2,048 x 2,048 textures, one for the head and arms, and another for the body and legs. These textures will then later be optimized down into one single texture for use of LODs (levels of detail).

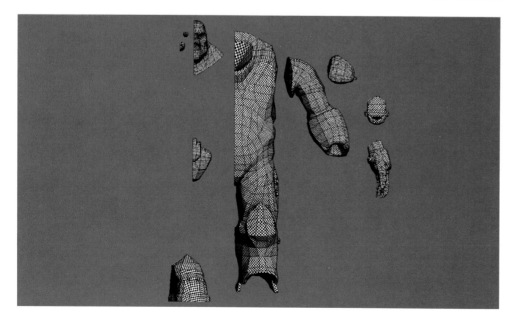

UV layout (unwrapped)

The sections of the Boomer mesh shown in this image represent the unwrapped portions of the model. As stated previously, the UVs are mirrored and duplicated when possible for maximum resolution of the textures.

Render to texture preparation

By placing these meshes far apart we can easily process the normal map without any tracing errors. If the meshes are processed too close to each other, there will be unwanted errors in the normal map from the arms tracing onto the torso for instance.

Adding color

By using 'Render to Texture' within 3ds Max, the ability to really jump start the texturing process is possible. Applying custom materials to the high-poly meshes will quickly generate a detailed diffuse map for the Texture Artist to start from. Assigning different colors to the metals, leathers, and skins of a character is ideal for this process. This can also be used to create selection masks for texturing within Photoshop.

Color applied to mesh

These images demonstrate this approach when applied to the high-poly mesh. I was amazed at how fast and efficient this technique was the first time Peter Hayes demonstrated it to me. It truly does speed things up.

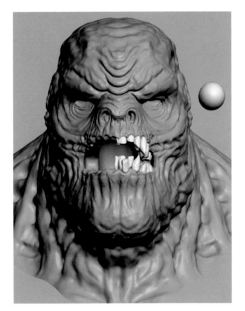
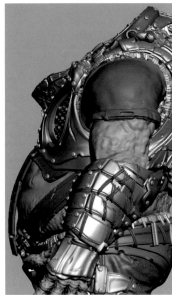

Projection modifier

The next couple of steps are rather straightforward. First, simply select the low-poly mesh and apply a projection modifier to the stack. With the modifier applied, select the high-poly meshes that will be used to create the textures.

Render to Texture dialog

Pull up the Render to Texture dialog, and clarify the size and type of the desired textures to be created. Enable projection mapping, adjust the padding, trace distance, and hit Render.

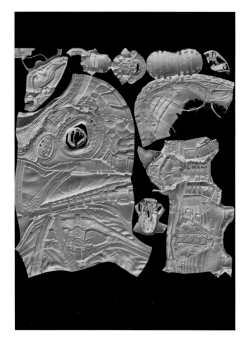
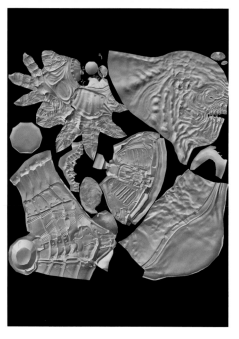

Generated normal map

With the rendering process complete, we can now take a look at the textures that have been created. The normal maps should be free of tracing artifacts and clearly represent the detail of the high-poly meshes.

Generated ambient occlusion map

Rendering out an ambient occlusion map is a great way to bake in some of the high-poly detail to the diffuse map. This map is often used as an overlay for the diffuse. It creates a nice 'dirty rays' type look. When used correctly, it can quickly add a sense of wear and tear to the character.

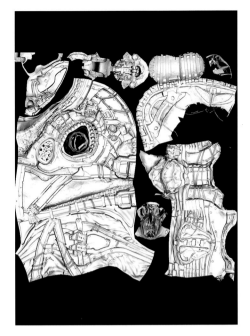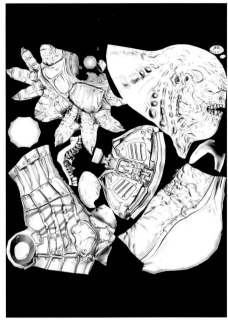

Generated diffuse map

This is the outcome of the diffuse map when materials are assigned to the high-poly mesh. As you can see, it serves as a huge timesaver by laying out a foundation of color specific materials.

Applying the textures

Here is a representation of the final low-poly mesh with these base textures applied. As you can see, this is a fairly decent starting point for the Texture Artist to begin on his end of the character work. This specific character was then handed off to Chris Perna to create the final textures. These images are the final textures created by Chris, along with a screenshot taken out of Unreal Engine 3 of the final character.

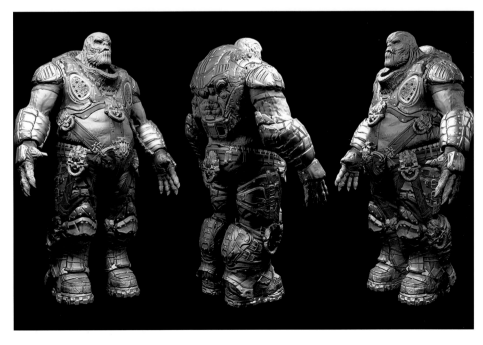

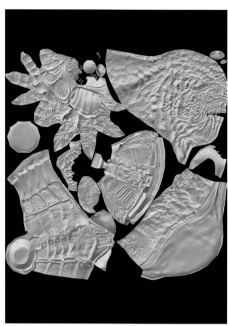

Final normal map (by Chris Perna)

A detail pass is applied to the normal map for the addition of minute details such as pores that were avoided in the modeling process. It's far more practical to achieve this in the texture versus the model when creating characters for games.

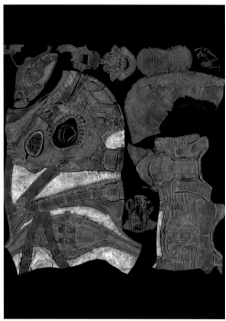

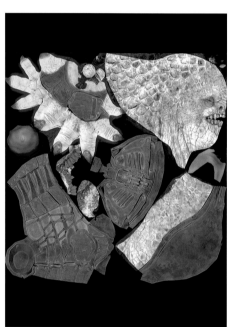

Final diffuse map (by Chris Perna)

The texture is a mix of photo-manipulation and some insane painting skills by Chris. A real sense of age and story is given by the amount of dirt and damage that has been put into this.

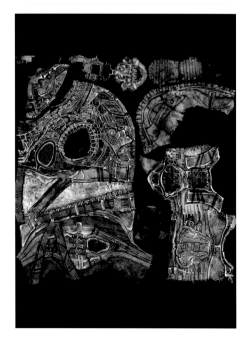

Final specularity map (by Chris Perna)

The specularity map can either make or break all of the work put in thus far. Too much and you get the feel of plastic. For that reason, it's important to spend the time needed on this texture. By throwing a hint of color into this, a sense of realism is achieved in the final product.

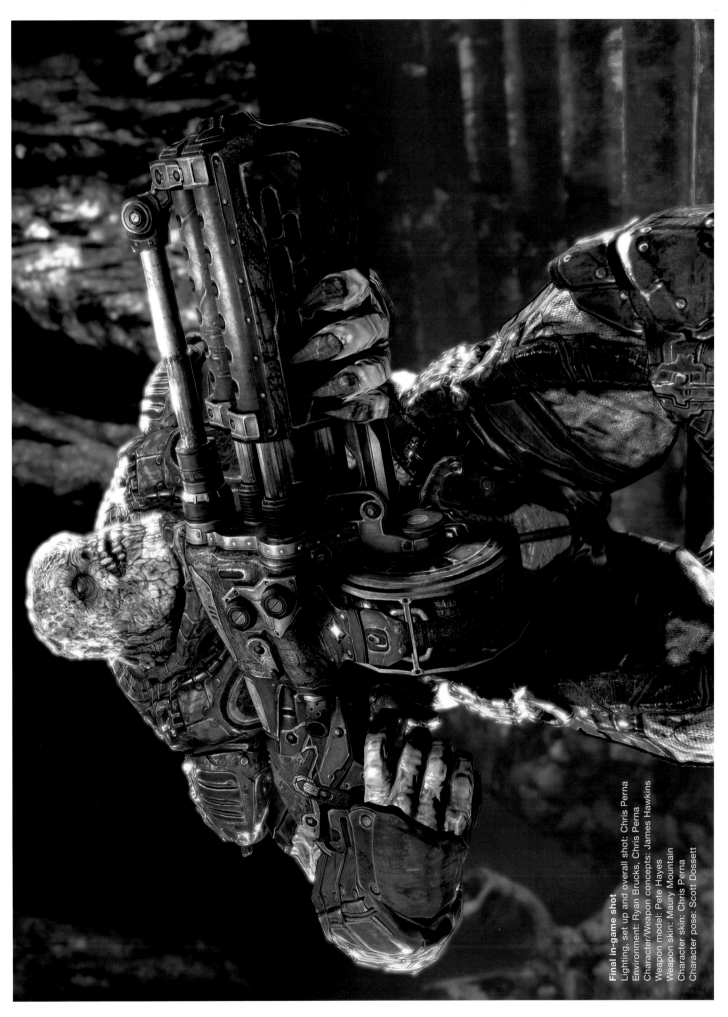

Final in-game shot
Lighting, set up and overall shot: Chris Perna
Environment: Ryan Brucks, Chris Perna
Character/Weapon concepts: James Hawkins
Weapon model: Pete Hayes
Weapon skin: Maury Mountain
Character skin: Chris Perna
Character pose: Scott Dossett

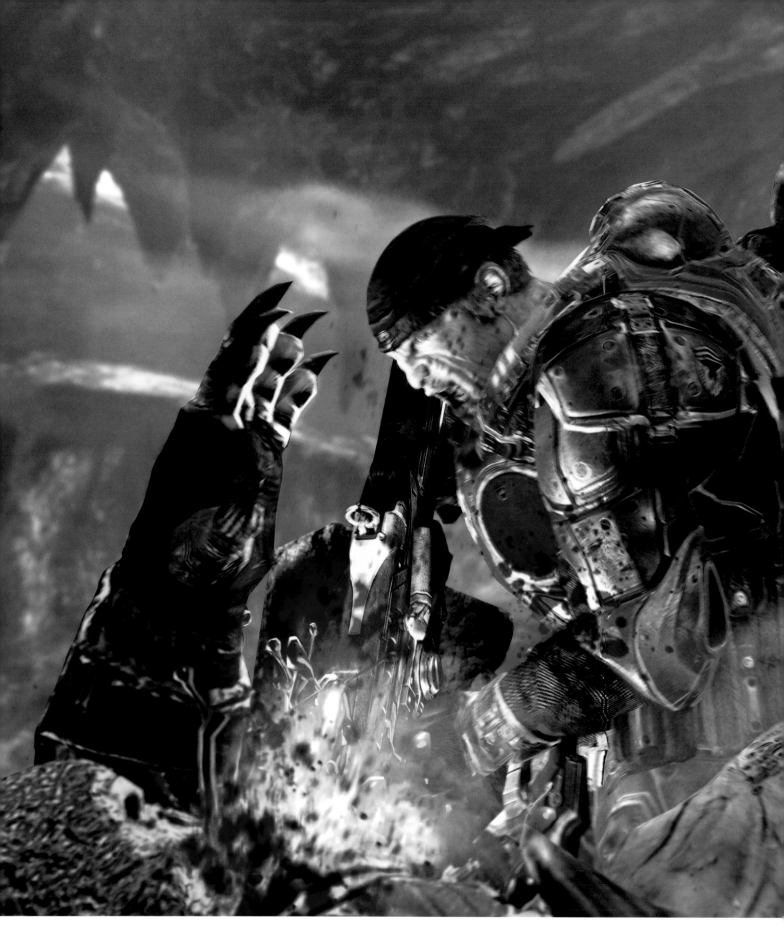

The Descent
3ds Max, Maya, ZBrush, Photoshop, Unreal Engine 3
Scene setup, lighting, shot and post/Character skins/Environment/Lancer AR
weapon: Chris Perna, Lancer AR Weapon Model: Pete Hayes, Character poses:
Jay Hosfelt, Scott Dossett, Aaron Herzog Character models: Kevin Lanning
Chris Perna, Epic Games, Inc., USA

Kevin Lanning
This is one of the coolest scenes I've seen Chris create. The amount of chaos
and destruction conveyed here is plain sick. Its shots like this taken out of Unreal
Engine 3 that truly amaze me.

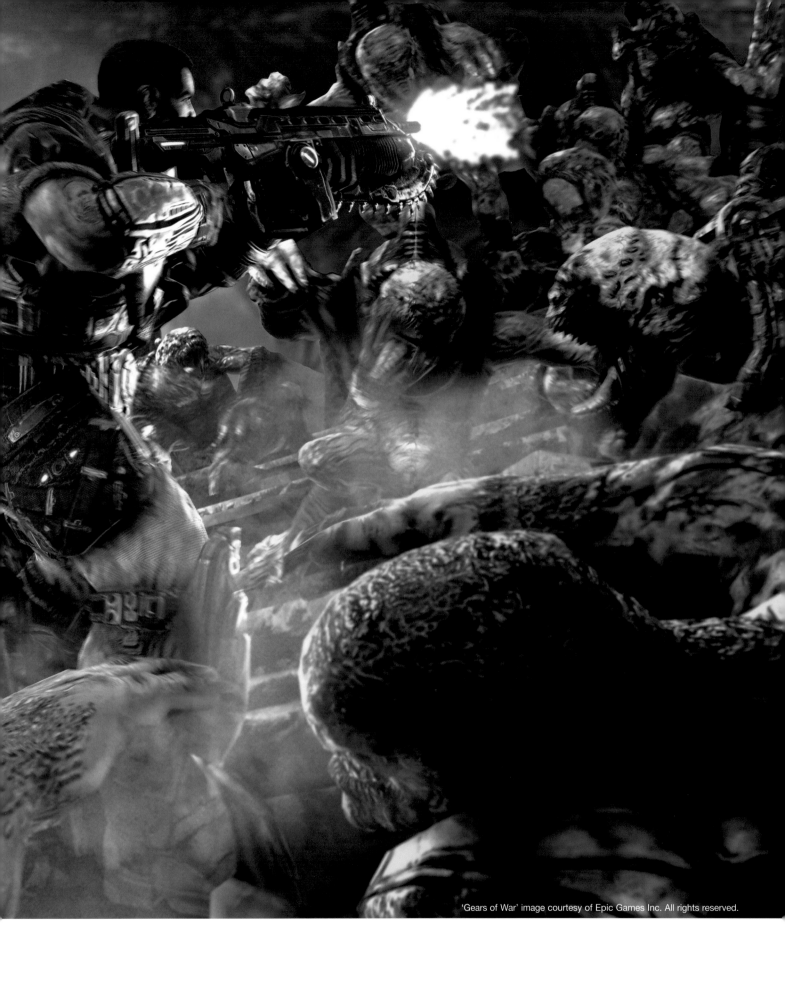

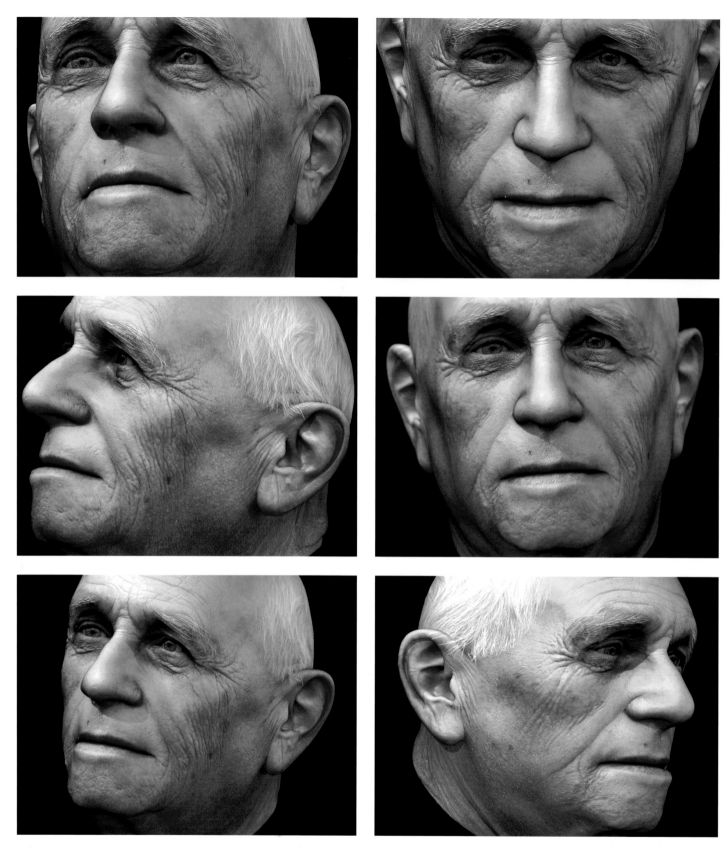

Old man
3ds Max, Photoshop, Unreal Engine 3
Shane Caudle, Epic Games, Inc., USA

Kevin Lanning
I'm constantly amazed how photo-realistic these set of images are. Shane holds a rare combination of an insane amount of technical knowledge and a pure artistic talent that is used in creating some of the most stunning pieces of art I've seen.

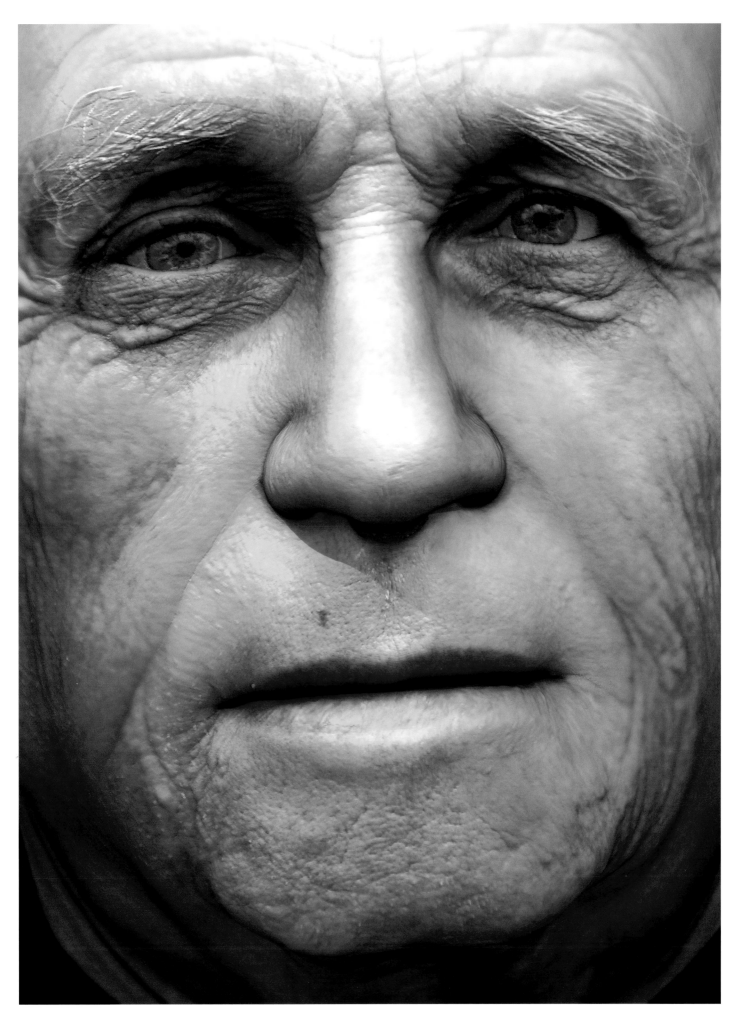

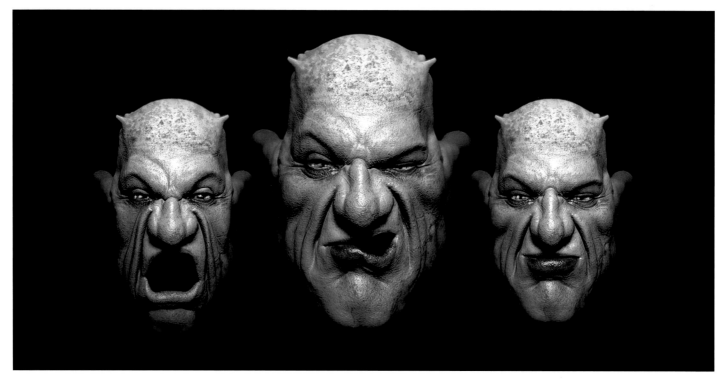

Goblin Mage
Mudbox, 3ds Max, Photoshop
Chris Perna, Epic Games, Inc., USA
[top left]

Kevin Lanning
There is certain rawness and rage in Chris' work that I have truly grown to love. The amount of skill and dedication that is put into his work creates some of the most inspirational images I have seen.

Lugon
SoftimageIXSI, Photoshop
Mario Ucci, GREAT BRITAIN
[above]

Kevin Lanning
There's quite a bit of character in this head. The expressions of the face work very well with the initial evil look of the model.

DemonMan
3ds Max, ZBrush, VRay, Photoshop
Alex Huguet, SPAIN
[top right]

Kevin Lanning
The use of proper anatomy mixed with the flare of creativity in this image really sells it to me. There is a very unique style here that twists realism with an almost fairytale type of atmosphere.

Yatoer, the bus stop boxer
Maya, mental ray, ZBrush, Photoshop
Loïc Zimmermann, FRANCE
[right]

Kevin Lanning
I've always been rather impressed with this artist's work. His ability to achieve the illustrative results shown in this image is very humbling.

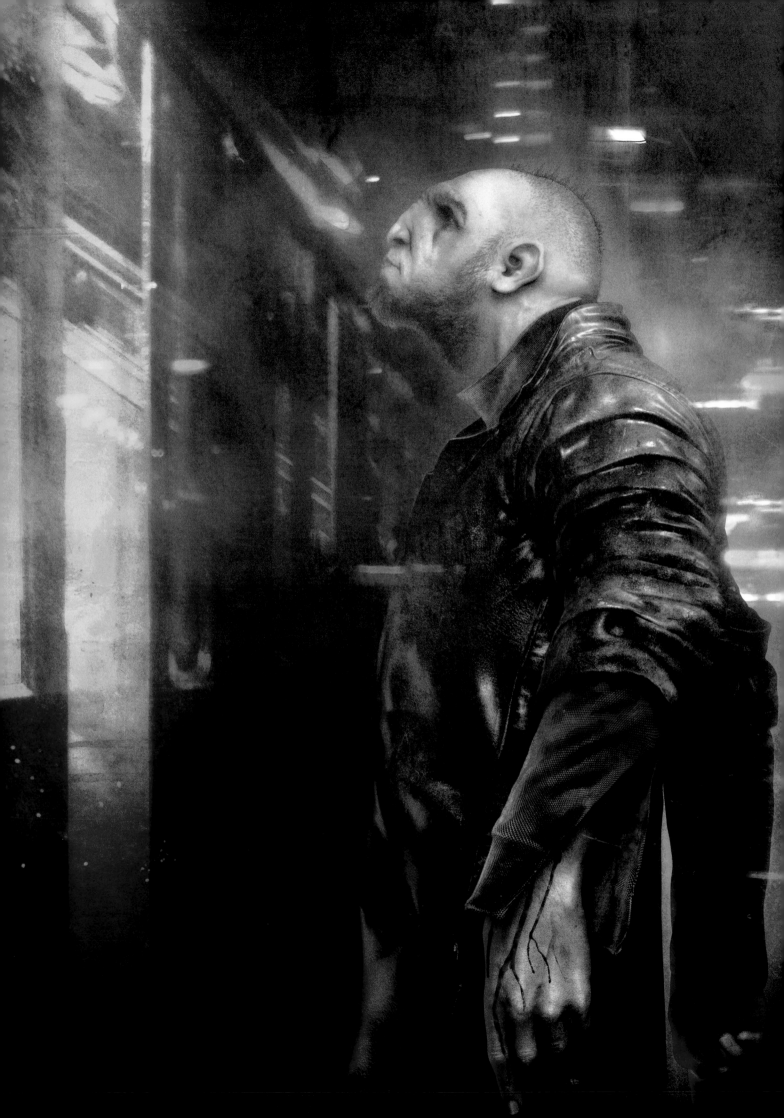

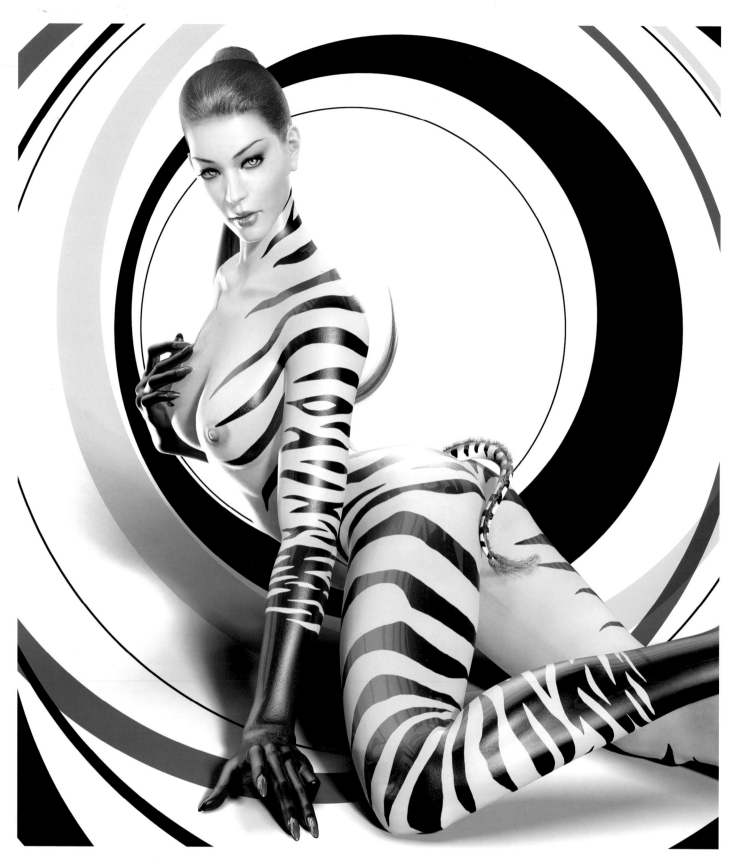

JW Studio: Body painting as zebra
Maya
Jung won Park, NCSOFT,
KOREA
[above]

Kevin Lanning
The use of blacks and whites between the model and background create a real sense of modeling that I think the artist successfully conveyed. The exotic pose of the character only adds to this photo shoot feel.

The Faint Aroma
Maya, Mudbox, mental ray, Photoshop
Yang Zhang, CHINA
[right]

Kevin Lanning
This piece of work can simply be described as beautiful. The use of purple accents this remarkable piece nicely. I'm also extremely impressed with the artist's ability create such a realistic head of hair. Awesome work indeed.

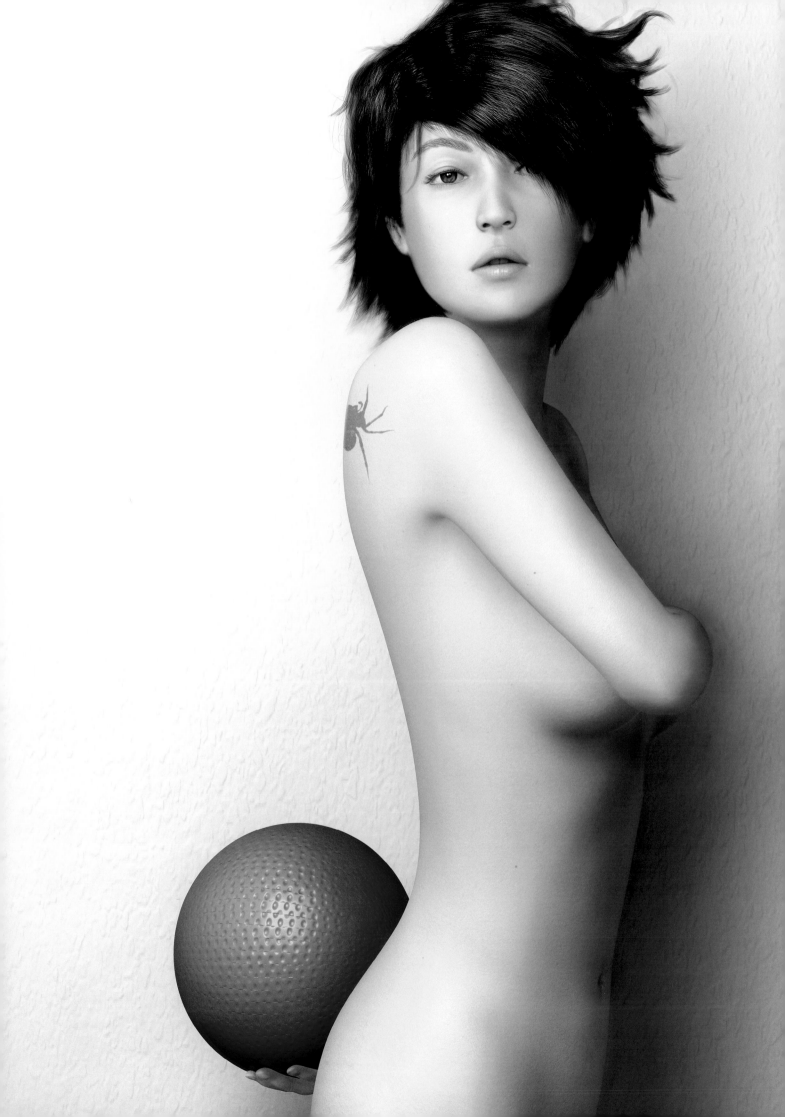

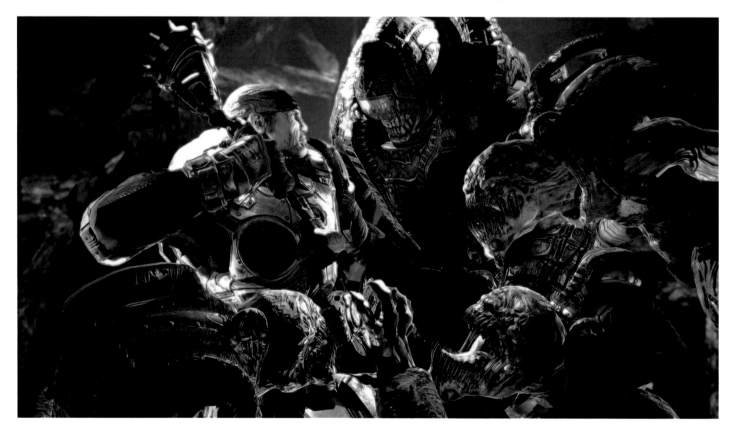

Grizzled warrior
3ds Max, Maya, ZBrush, Photoshop, Unreal Engine 3
Scene setup, lighting, shot/Character skins/Environment: Chris Perna, Character poses: Jay Hosfelt, Scott Dossett, and Aaron Herzog, Character models: Kevin Lanning, Character weapon model: Pete Hayes, Character weapon skin: Maury Mountain
Chris Perna, Epic Games, Inc., USA [top]

Kevin Lanning
This is a great piece to show off all of the texture work Perna did for Marcus' face. The amount of detail he was able to cram into the texture really holds up in this close-up in game shot.

Last stand
3ds Max, Maya, ZBrush, Photoshop, Unreal Engine 3
Scene setup, lighting, shot/Character skins/Environment: Chris Perna, Character poses: Jay Hosfelt, Scott Dossett, and Aaron Herzog, Character models: Kevin Lanning, Character weapon model: Pete Hayes, Character weapon skin: Maury Mountain
Chris Perna, Epic Games, Inc., USA [above]

Kevin Lanning
One of the things I admire most about these pieces is Chris' ability to quickly take in-game assets and create these insane looking sets. By utilizing Unreal Engine 3 he places the characters in a level and applies an appropriate animation to them to aid in telling a story with his shots.

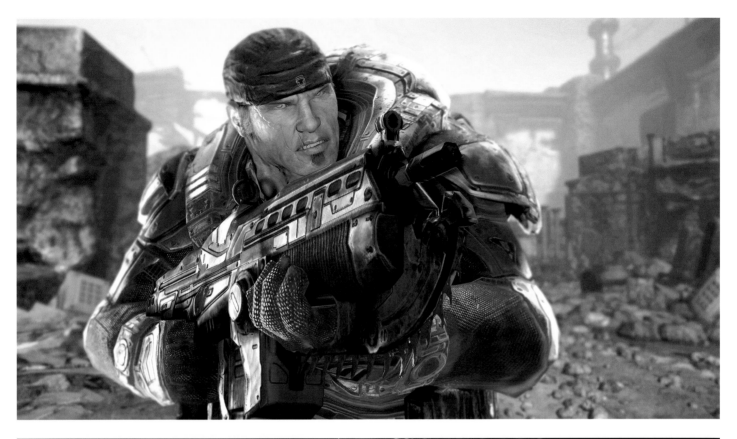

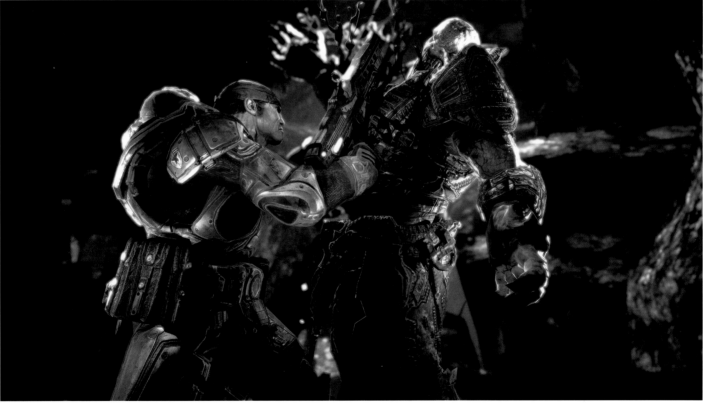

Chainsaw ballet
3ds Max, Maya, ZBrush, Photoshop, Unreal Engine 3
Scene setup, lighting, shot/Character skins/Environment/Lancer AR weapon: Chris Perna, Lancer AR weapon model: Pete Hayes, Character poses: Jay Hosfelt, Scott Dossett, and Aaron Herzog, Blood effect: Matt Hancy, Character models: Kevin Lanning
Chris Perna, Epic Games, Inc., USA [above]

Kevin Lanning
This is a nice representation of some standard chainsaw action in Gears. For some reason that never gets old.

Battle-weary Marcus
3ds Max, Maya, ZBrush, Photoshop, Unreal Engine 3
Scene setup, lighting, shot/Character and weapon skins/Environment: Chris Perna, Character poses: Jay Hosfelt and Aaron Herzog, Character models: Kevin Lanning, Character weapon model: Pete Hayes
Chris Perna, Epic Games, Inc., USA [top]

Kevin Lanning
In this second shot of Marcus, you really get a sense of the constant danger he's in. I always enjoy seeing a good close-up of the work Pete, Maury, and Chris put into the Assault Rifle.

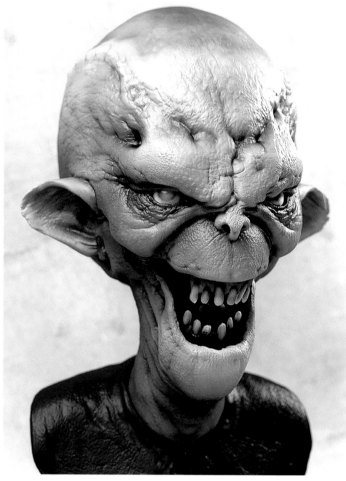

It's an orc!!!
3ds Max, ZBrush, VRay
Damien Canderle, FRANCE
[above left]

Kevin Lanning
There is a nice feline touch integrated into this design that really complements the orc features. The subtle cracks and folds of the skin around the mouth create a nice sense of depth and darkness to this character.

Made In Saturno
ZBrush, 3ds Max, Photoshop
David Munoz Velazquez, SPAIN
[left]

Kevin Lanning
There is an interesting design built into the armor of this character that really appeals to me. I love how the armor is being inset into the flesh of the character's forehead.

Smiling Gobelin
ZBrush, modo, Mudbox, VRay
Damien Canderle, FRANCE
[above]

Kevin Lanning
This is another cool character; it has a sense of evilness to it while also having a bit of comical style incorporated into it. The surface detail of the brow flowing into the forehead is a nice transition.

Fate
3ds Max, Photoshop
Zubuyer Kaolin, BANGLADESH
[right]

Kevin Lanning
This piece really stood out to me when viewing all of these images. There is a sense of righteousness in this piece that is very unique. I really dig emotion displayed though the poses of the characters interacting with each other.

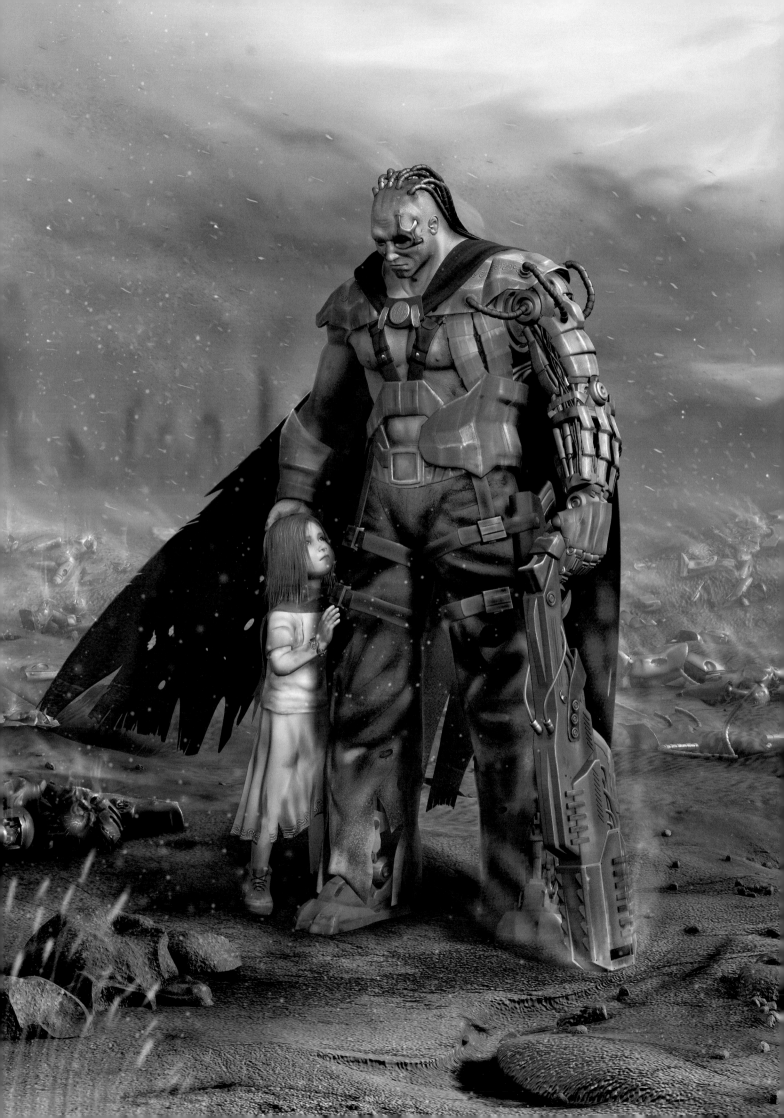

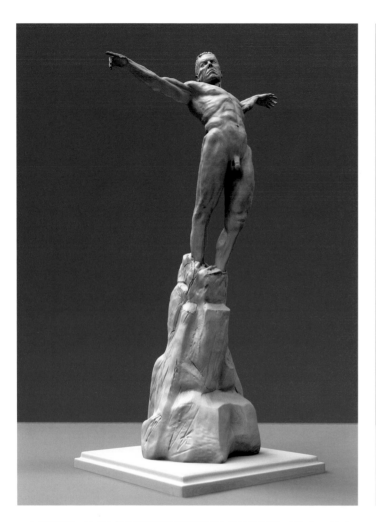

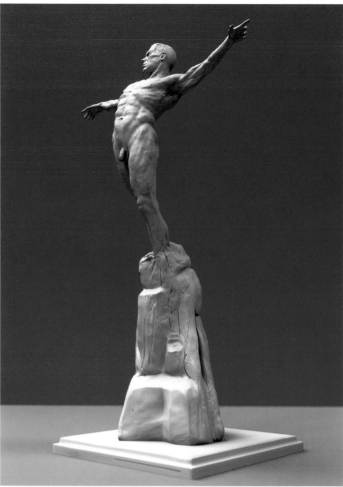

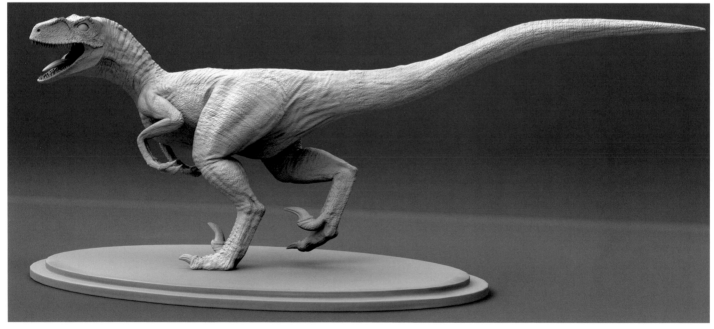

Soar
Maya, Mudbox, mental ray
Peter Zoppi,
USA
[top series]

Deinonychus
Maya, Mudbox
Peter Zoppi,
USA
[above]

Nicko
3ds Max, Photoshop
Chris Wells, Epic Games,
USA
[right]

Kevin Lanning
What I like most about this piece is
the form in which it is presented in.
This reminds me a lot of a traditional
figure sculpture, which is rare to see in
this medium.

Kevin Lanning
This has to be one of my favorite
dinosaur models. The level of detail
modeled in creates a very realistic
looking skin.

Kevin Lanning
This is another one of my favorites. The models,
textures, pose, and overall composition of this image
all come together to create an outstanding piece.
The ability Chris has to bring this amount of life and
character into his work is just plain awesome.

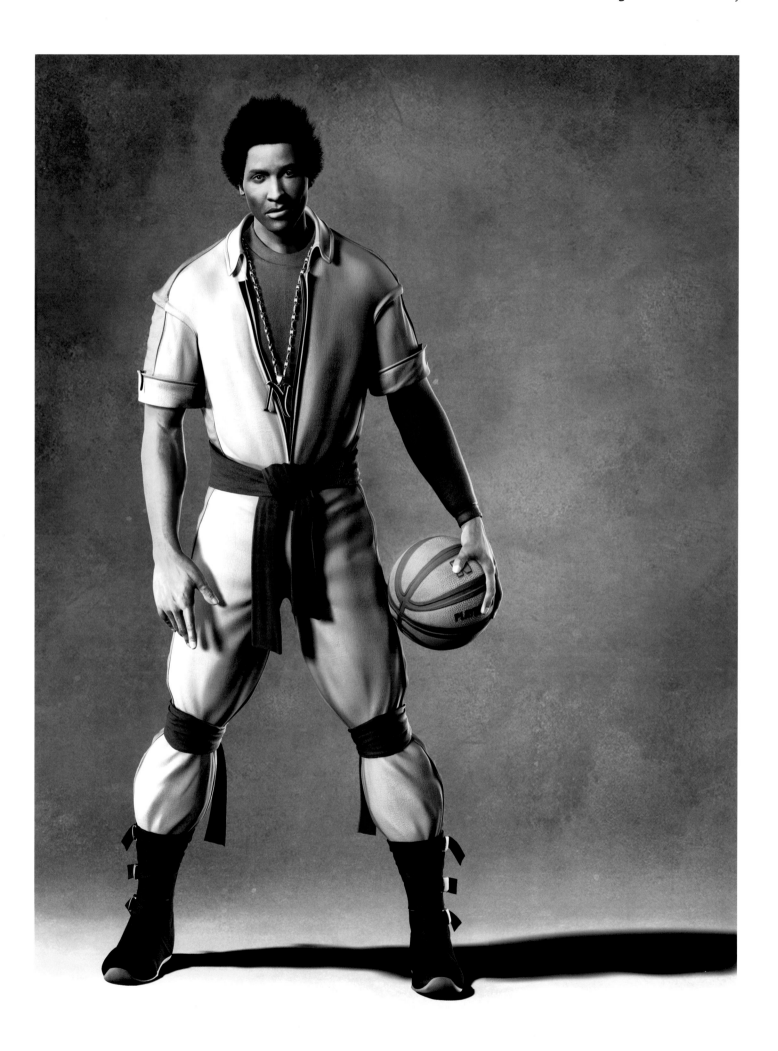

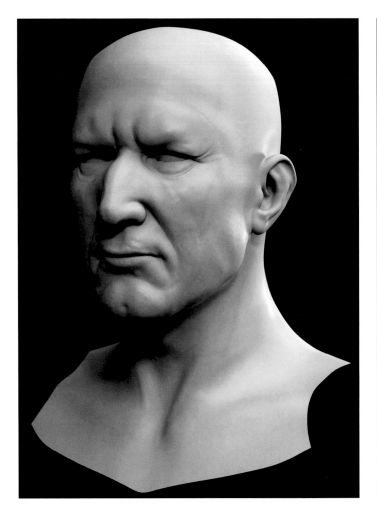

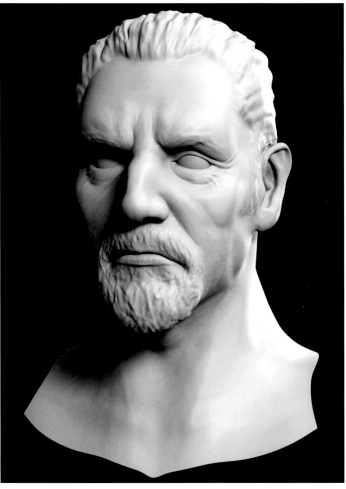

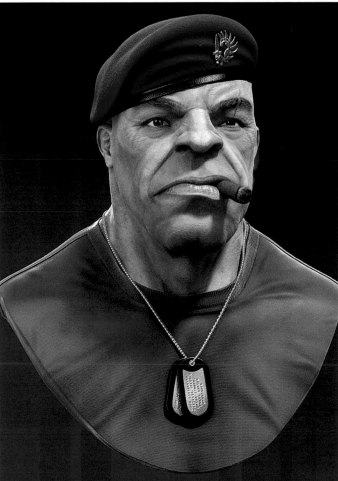

Head Study 1
Maya, Mudbox
Peter Zoppi, USA
[above left]

Kevin Lanning
Creating head studies is a great practice every artist should do from time to time. With each piece, you gain knowledge that will improve and speed up your modeling.

My Sweet Little Bird
3ds Max, ZBrush, VRay, Photoshop
Cyril Verrier, FRANCE
[left]

Kevin Lanning
Square-jawed, cigar-chewing soldiers are just cool. The variations and quality of materials used on this character are really impressive.

Head Study 2
Maya, Mudbox
Peter Zoppi, USA
[above]

Kevin Lanning
There's a looseness to this piece that again reminds me of a traditional sculpt. The sense of skin drooping down and over the underlying structure of the cheek bones is quite nice.

Old man's portrait
Maya, ZBrush, Photoshop, mental ray
Peter Zoppi, USA
[right]

Kevin Lanning
The quality of texture work involved in creating this character stands out the most to me with this image. The artist's attention to detail of what areas of the face produce more of a spec from oils than others makes for a nice sense of realism.

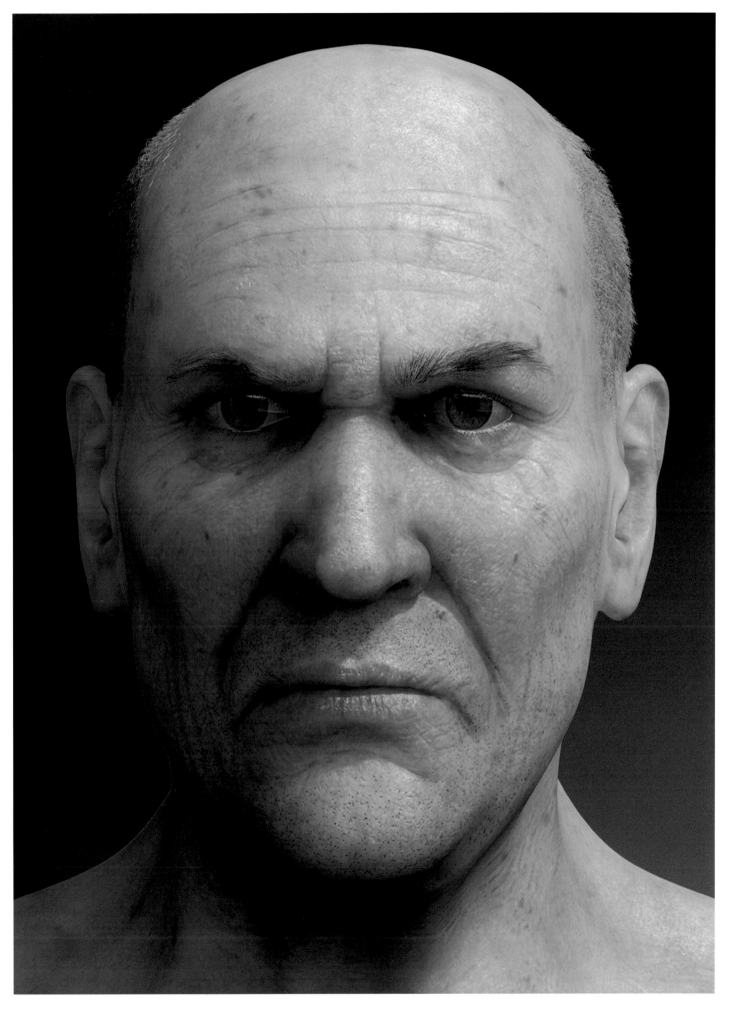

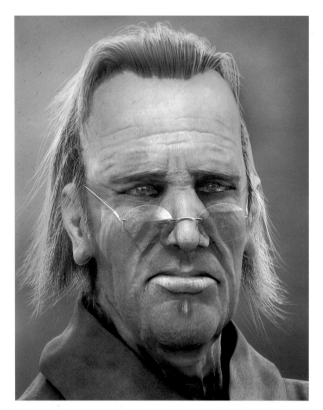

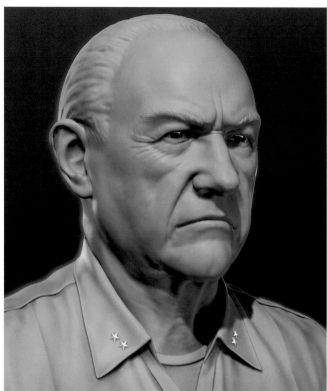

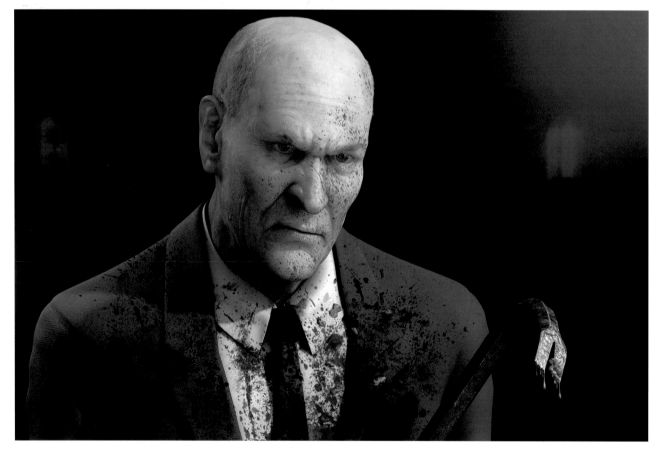

Portrait of an old man
3ds Max, ZBrush, Photoshop
Sergio Santos, SPAIN
[top left]

Kevin Lanning
I thought the artist of this image did a rather good job in conveying the age and expression he was going after. Just by looking at the eyes of this character you get a sense of tiredness.

Portrait of a killer
Maya, Photoshop, ZBrush, mental ray
Peter Zoppi, USA
[above]

Kevin Lanning
This image does an extremely nice job of representing its given title. Adding the little chunks of flesh and dripping blood from the crow bar is a really nice touch.

Mr G
Maya
Jinwoo Lee, USA
[top right]

Kevin Lanning
I remember seeing this image online a while back and saying to myself "wow—nice job". The model clearly represents the actor the artist was going for.

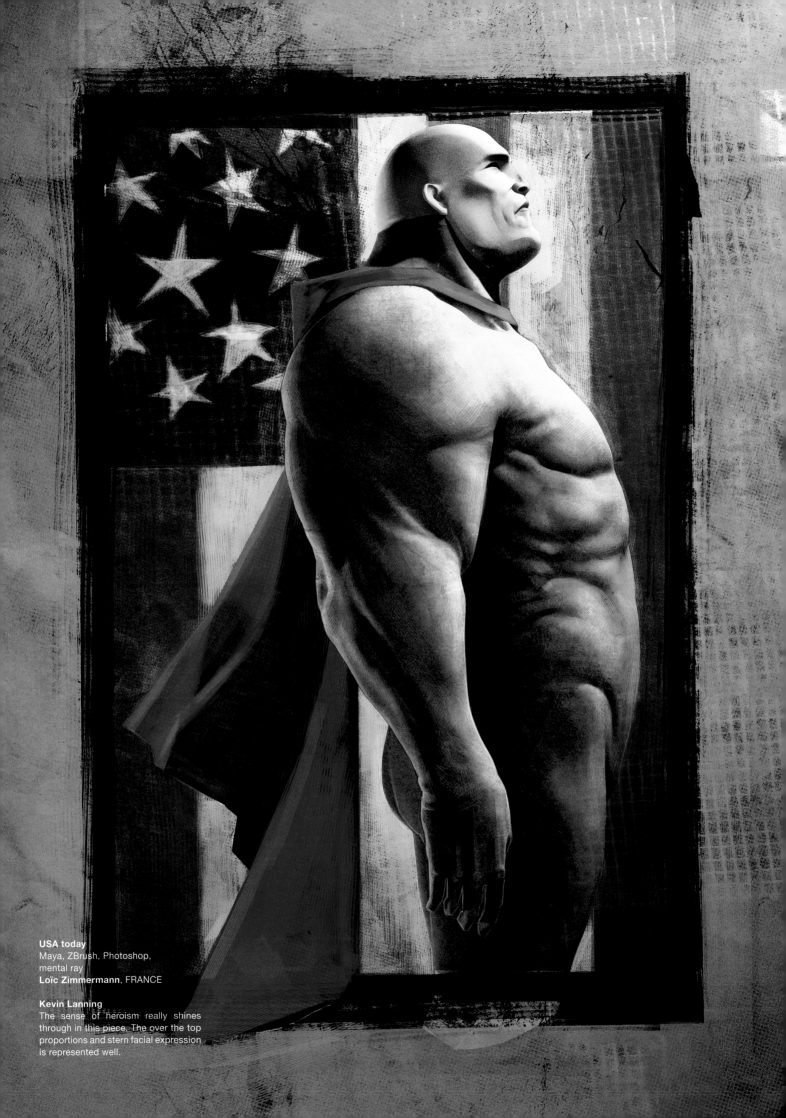

USA today
Maya, ZBrush, Photoshop,
mental ray
Loïc Zimmermann, FRANCE

Kevin Lanning
The sense of heroism really shines
through in this piece. The over the top
proportions and stern facial expression
is represented well.

Frankenstein
3ds Max, ZBrush, VRay
Inspired by Miles Teves
Cyril Verrier, FRANCE
[above left]

Kevin Lanning
This is truly an inspirational piece of work. The overall polish of the image is very satisfying. I love the stylized design of the character. The amount of subtle details incorporated into the model and textures complements this piece even more.

Stranger
3ds Max, Photoshop, ZBrush
Murat Afsar, TURKEY
[left]

Kevin Lanning
What captivated me most about this piece was the sense of realism in the character's eyes. The amount of depth and reflection put into them creates a very realistic look.

Petite Soeur
ZBrush
Sebastien Sonet,
FRANCE
[above]

Kevin Lanning
This is another model I really enjoyed seeing come to be on the ZBrush forums. I found the design choices in this image to be rather interesting, from the stitching together of the bear to the construction of the head.

My Little Arsonist
Poser, Photoshop
Charli Siebert, USA
[right]

Kevin Lanning
This is another one of my absolute favorite pieces. Charli has a real gift in his ability to illustrate emotion. The cool blue colors and uniquely stylized character design work hand in hand to create a truly beautiful piece of art.

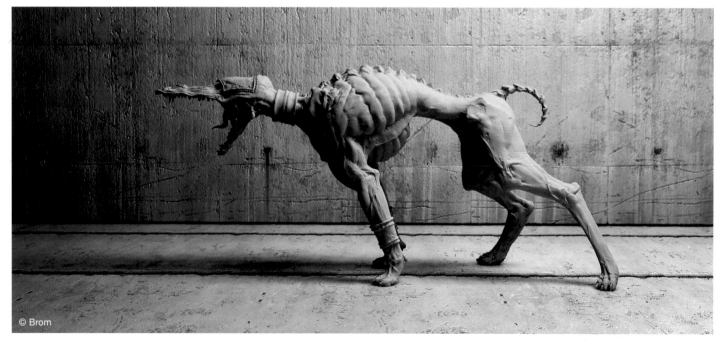

© Brom

Tusked
Photoshop, Painter, Maya
Steve Argyle,
USA
[top left]

Kevin Lanning
The amount of detail used in creating the face and hair of this character is very nicely done. I really dig the tension in the face muscles being used to create the snarl.

Brom Dog
3ds Max, ZBrush, VRay, Photoshop
Client: Inspired by Brom
Abner Marín, SPAIN
[above]

Kevin Lanning
Recreating the work of Brom in 3D is not an easy thing to do, but I feel the artist nailed it. I love the sense of darkness. The tension of the muscles flexing in relationship to dog's pose is done well.

Swamp thing
ZBrush, LightWave 3D, Photoshop
Jason Gary,
USA
[top right]

Kevin Lanning
There is a stunning amount of detail used in this piece. The use of color choices also really complement this character's "swamp thing" feel.

The CARNIVORbot
CINEMA 4D
Peter Hofmann,
GERMANY
[right]

Kevin Lanning
This is a very unique piece of character work. The complexity of the design works very well and is quite impressive.

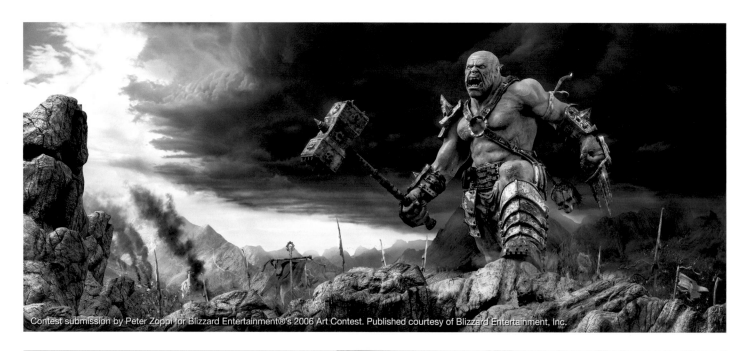

Contest submission by Peter Zoppi for Blizzard Entertainment®'s 2006 Art Contest. Published courtesy of Blizzard Entertainment, Inc.

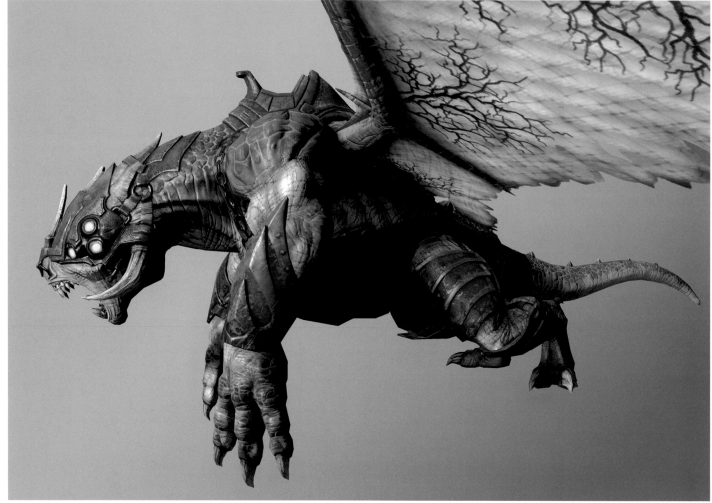

Leading the Horde
Maya, mental ray, Body Paint 3D, Photoshop
Peter Zoppi, USA
[top]

Kevin Lanning
The sense of an upcoming war and destruction is displayed very well throughout this image. I can't help but be reminded of 'Lord of the Rings', which brings a smile to my face. The darkening of the clouds moving forward are a very nice touch to this piece.

Ingame
3ds Max, Photoshop, Unreal Engine 3
Shane Caudle, Epic Games, Inc., USA
[above]

Kevin Lanning
Now this brings back some memories. The mere fact that this was completely modeled in 3ds Max before applications like Mudbox and ZBrush came out is amazing.

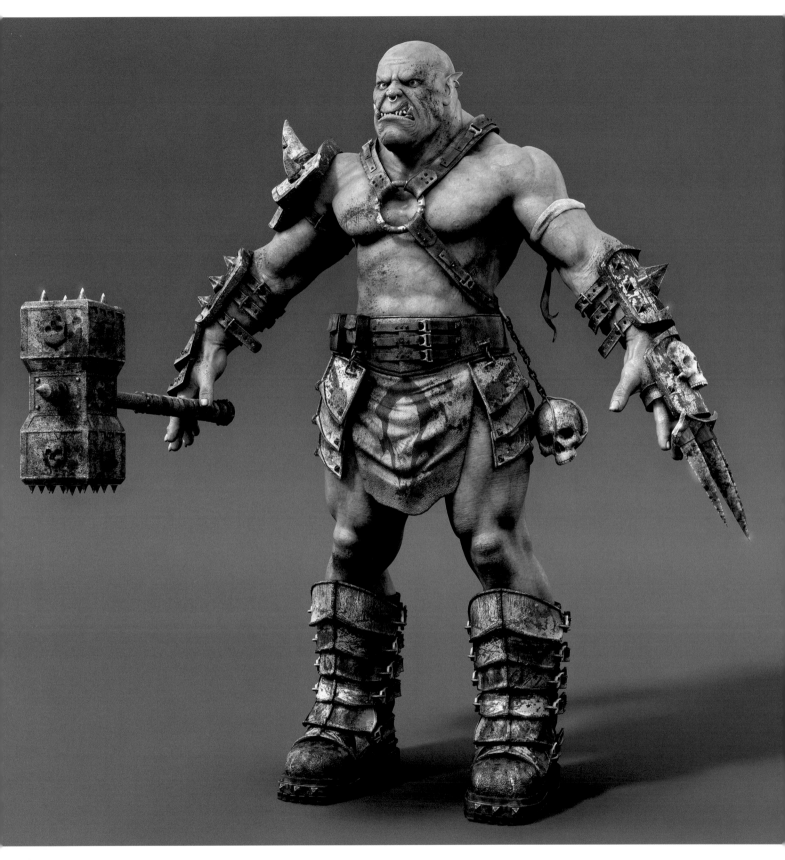

The Orc
Maya, Mudbox, mental ray, Photoshop
Peter Zoppi, USA

Kevin Lanning
I had a blast watching the progress of this character on the Mudbox forums. The artist was able to convey a real sense of story behind this character. By adding the wear and tear of the armor to the blood splatters across the weathered flesh, this character looks as if he belongs in the battle.

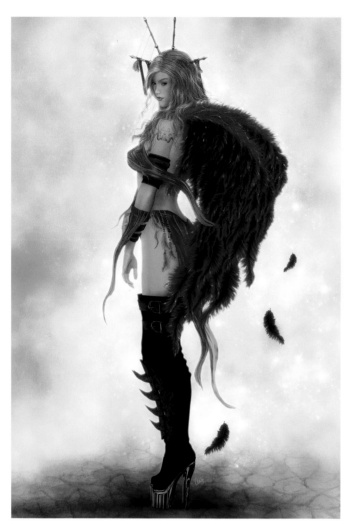

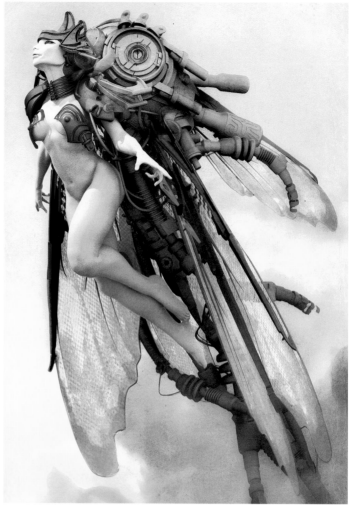

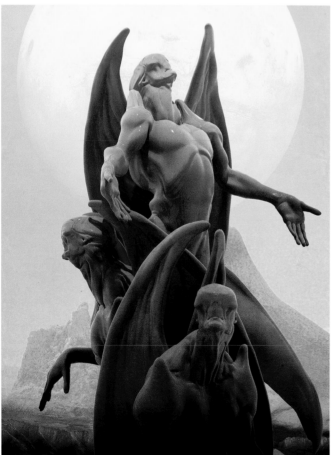

Anendien
Photoshop, Poser
Antje Darling,
USA
[above left]

Kevin Lanning
I think what really pulled me into this image the most was the unique set of wings given to the character that seem to tell a story of sorrow. The feathers falling off the wings along with the saddened expression of the face work very well.

Gamma 10
3ds Max, ZBrush, VRay, Photoshop
Pascal Blanché, UBISOFT,
CANADA
[left]

Kevin Lanning
Being a huge fan of all of Pascal's work, I simply love this piece. The composition of his images continues to inspire me.

Queen bee
3ds Max, ZBrush, VRay, Photoshop
Pascal Blanché, UBISOFT,
CANADA
[above]

Kevin Lanning
The set of soft pastel color tones chosen fits this character quite nicely. There's a real sense of emotional escape that is conveyed when looking at this piece. The mix of flesh and mechanical parts that are incorporated into the work, along with the unique color choices are a great signature to Pascal's art.

Princess Predator
3ds Max, Photoshop
Inspired by Boris Valejo
Denisa Mrackova, CZECH REPUBLIC
[right]

Kevin Lanning
Being a huge fan of the Predator myself, this image really pulled me in. I love the hint of brutality layered in with the beauty of the female. This is certainly one of my favorites.

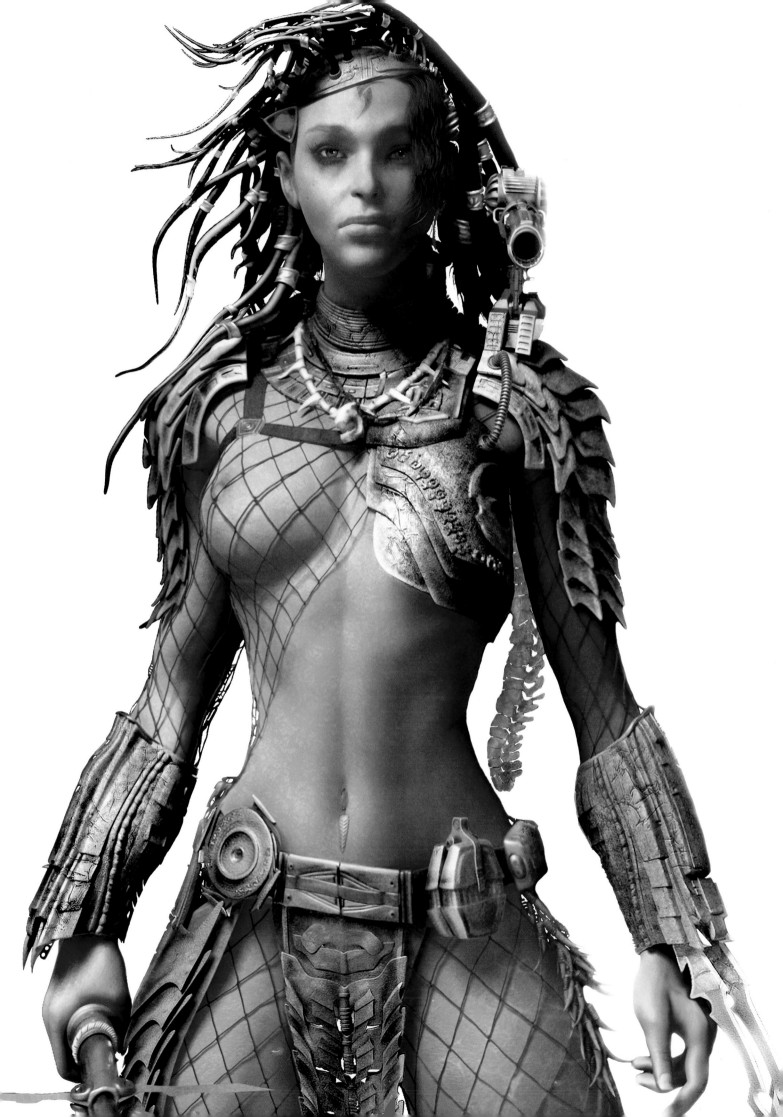

TIMUR BAYSAL

Timur started to work with computers at age 14 and taught himself modeling and rendering. He started his VFX career in the U.S. with Station X Studios in 1998. He then worked in several visual effects houses in the roles of animation director, head of R&D, lead animator, 3D animator and character animator among others. His feature film credits include: 'Syriana', 'Reeker', 'The Dust Factory', 'Gothika', 'Spy Kids 2: Island of Lost Dreams', 'Impostor', 'Megiddo: The Omega Code 2', 'Dracula 2000', 'Battlefield Earth' and 'Dogma'. Looking for a change, Timur moved to the realm of developing 3D tools with pmG, creators of the rendering and animation environment messiah:Studio.

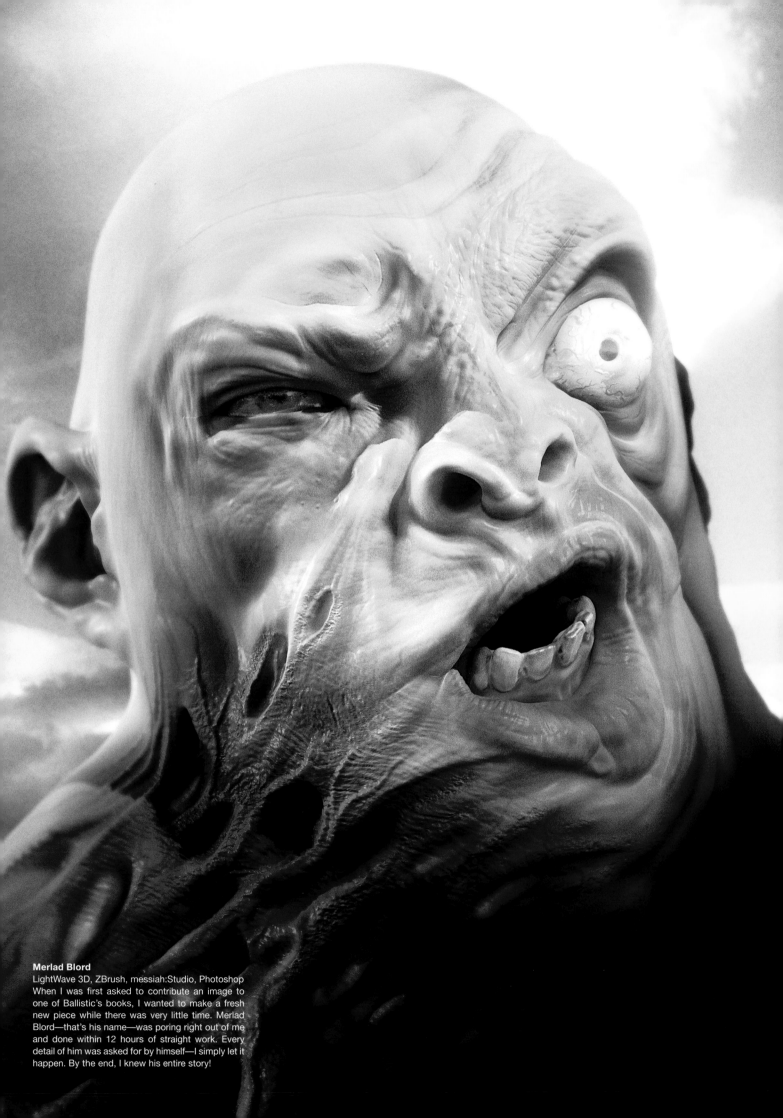

Merlad Blord
LightWave 3D, ZBrush, messiah:Studio, Photoshop
When I was first asked to contribute an image to one of Ballistic's books, I wanted to make a fresh new piece while there was very little time. Merlad Blord—that's his name—was poring right out of me and done within 12 hours of straight work. Every detail of him was asked for by himself—I simply let it happen. By the end, I knew his entire story!

CONTENTS

Timur Baysal
Gallery

82

Timur Baysal
Tutorials

90

Timur Baysal
Invited Artist Gallery

108

Background

In the mid-1980s living in Germany, I was experimenting with 2D pixel graphics. When I started taking jobs in computer graphics, there really weren't too many software packages in existence, and those that were around required a fair bit of programming to allow the images to generate; so that's what I learned.

First job

The multimedia industry was gaining steam in the early 1990s in Germany, and I found myself right in the middle of it. It was the perfect time to learn about the translation of visual ideas and impulses into computer graphics. I nurtured a great understanding for pixels and how to make the best of them. My first film job came right when I began to develop my character modeling and animation methods. I created a ghost figure that interacted with a live-action actress. Although the film itself was never finished, it was an amazing experience. It did actually prove that we could make cinema-quality character VFX in a smaller studio. Even though Real3D was the first 3D software I had used for a job, during that production I switched across to LightWave and it was a great success. It opened up a new world back then. I even came up with a whole bunch of hybrid methods combining 3D with 'traditional' pixel graphics!

Hollywood!

My work was having some amazing exposure on the web in the mid-1990s, and soon I received that magical phone call out of Hollywood from Jeff Barnes asking me across to work with them at StationXstudios. After the initial leaping euphoria, I flew to the States to find myself in a laid-back world surrounded by artists, who were as least as crazy as I was. Project:Messiah was pretty much the most beautiful thing that came out of this bunch at StationXstudios, not forgetting some of the most important friendships I have made in the US. Jeff Barnes' company, staff, and surroundings were very impressive, and I had a very hard time not to go with them right away. Although he expressly told me that I shouldn't feel obligated to StationXstudios, just because they flew me to the States, I very much felt that way. I couldn't have led my wife (girlfriend back then) halfway around the planet to stick her straight into California's Outback in Santa Maria. Anyway, when StationXstudios closed, it was a perfect opportunity for me to finally join Jeff and the crew. Even better was the fact that they had just opened a Santa Monica office. It was a super-small place with four people in it, including myself. I had never felt more at home than back then. In my heart, I know that I would have stayed there forever. We really had everything. Direct client contact, even creative freedom here and there and we grew to be nothing short of a family. John Travolta even came by, some of the big supervisors and some even bigger directors. We had a blast.

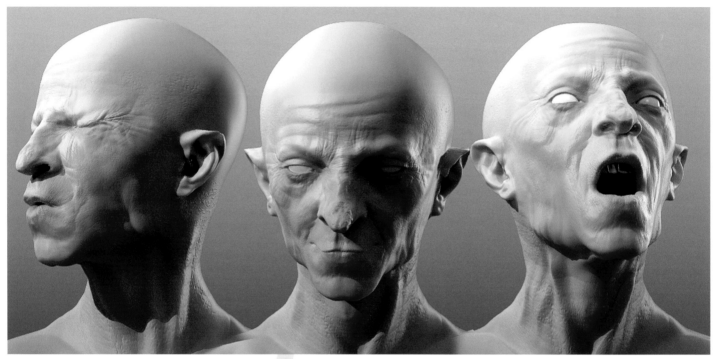

Neckling trio

The next step

But, as I always say, everything good comes to an end and if you don't follow destiny, fate kicks you in the butt to get you on your way again. Therefore, 2000 was the first year of having encountered both freedom and reality. A new country, new culture, and a different way of living made me very vulnerable to the power of examples. But all of that was about to change for the better. I finally did get to work on a lot of movies, commercials, and music videos. I found myself with a group of like-minded, humble and passionate peers, and my wife and I finally got married after having lived together for ten years. In 2001, I got back into programming and began experimenting with new ways to animate. This ultimately led to a new kind of success for my work, which had pretty much started the wave I'm still riding on.

"Volumetric Translucency" was born, and I wrote my first shader to deliver proof to myself that I wasn't completely insane. In the past, I always had ideas and never managed to explain them sufficiently to any programmer around me. Now, finally I could just write the shaders myself and they worked perfectly. Programming was about to become a constant part of my work. I felt like nothing was impossible anymore. For a lot of my animation work, I used project:Messiah, which allowed me to tie rendering parameters to animation, through expressions. That meant yet another degree of freedom. I was still humbled by the privilege I had to be around great people and having had such great opportunities to create.

ZBrush

ZBrush is the biggest innovation the 3D industry has seen since Fori Owurowa's MetaNurbs.

MetaNurbs translated the smooth subdivision process into real-time so it could be used for modeling as well as animation. In the early years, I'd heard of displacement, but when I started working with it, I was so unspeakably happy. Not only was anything possible, I could create something on the screen to prove it. When I sit down to model I prefer not to elaborate for too long before I hurl myself into the process. I used to love finding solutions within existing tools but, now I'm so incredibly aware of what's possible with the set up that I have I'm mostly drawn to solutions that don't exist yet. Not to burden myself, but to push possibilities that further evolve the whole way of creating digitally.

Workflow

When I have a creative urge, I digest for about 25 seconds the general idea of what I want, then

I go into LightWave 3D's modeler and make the base geometry of it—generally for no longer than an hour—then it goes into ZBrush. Exporting a new low-res geometry and displacement maps out of ZBrush I go into messiah:Studio. I do some quick lighting and rendering tests and start hooking in bones. Then I may do adjustments to geometry or displacement, go back into Messiah to have fun doing animation controlled displacement and/or texture changes. I may figure out a new shading tool to do something unusual or simply cool. When I'm making an animation, sometimes I add dynamics, or I get so inspired that I add a background to it. That goes through the same initial stages and gets everything except bones. After this, I'm staring at the rendering times and wondering if there's a faster way of rendering that directly in compositing.

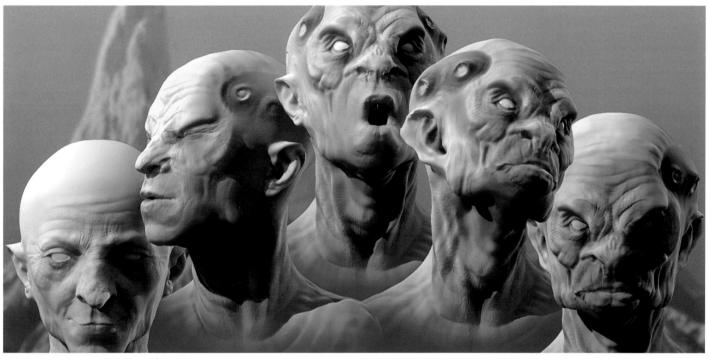

Neckling changing

Once it's all done I take it into After Effects and give it some final touches.

Colors

A Japanese artist I know called Minory made a beautiful short movie and showed me some of his storyboards. I was amazed by his choice of colors. Action and Anger is red, Calm is blue, Night is blue, Day is yellow. I thought this clarity was really impressive. I honestly didn't think it was possible to expose people to such simple choices anymore, but it did inspire me a lot. Then there are all the standards of course. I would almost feel funny mentioning them again, but such things as coldness for distance and warmth for closer elements and various ways of breaking these rules for specific effects. I love using simple things such as complimentary colors to raise contrasts and guarantee harmony.

Lights

Images aren't just made of color. They are also made of light and shadow, just like everything we see everyday. Placing a light becomes a modeling tool, because this is how you show the beauty of your model. You may have prepared the greatest model ever, but if you don't expose the best of your model in the clearest way to make sure it can be seen and enjoyed, you just wasted a lot of love on a hidden treasure. Then there's the story telling aspect. Light is not only a modeling tool but also an actor. I have my own way of lighting my models, because I love to expose their strengths and give them the world that surrounds them to make them more understandable to the audience. I absolutely love minimal lighting. If I want the outside, I want ONE sun and the environment should do all of the rest.

Zborn Toy

Ever since I wrote the Zborn Toy with Philipp Spoeth, I've been augmenting my workflow by running depth renders (Alpha Grabs) of my ZBrush models and 3D animations. Zborn Toy is an effects and surfaces plug-in designed to be used in conjunction with ZBrush, Fusion, After Effects or Combustion to generate 'after effects'. The goal was to create a plug-in that would work with the same depth and performance as a full-scale render engine. The lighting engine is the most impressive, with a variety of shadows, direct and point light, and environmental illumination, which can be based on either panoramic or spherical maps. Initially, this was an experiment, but it only took a day before I started making serious renders and full images with it. The ability to adjust images in real-time, creating the shading, texturing and lighting on the run, really does wonders for your workflow

and 3D rendering. It's still a young technology, but I'm not used to waiting for a render anymore. I've revisited more traditional art, which seems like a paradox of sorts. It brings back the fascination of visual content for the eyes and the mind by exploring new forms. With Zborn Toy, I simply lay down some colors and forms in Photoshop and expose aspects of them that I had never seen before. It has already influenced my workflow and style in a permanent way. The most beautiful thing about the Zborn Toy is the extra time it gives me to explore, instead of waiting for renders. I'm currently in the second half of my 20th year of creating professional digital art. I've always believed in the purpose of making and sharing experience, while the sharing became a lot stronger aspect to me in recent years. But, I never would have expected it to be so incredibly tough.

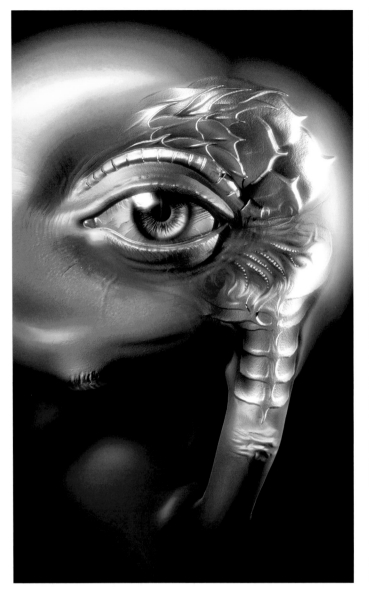

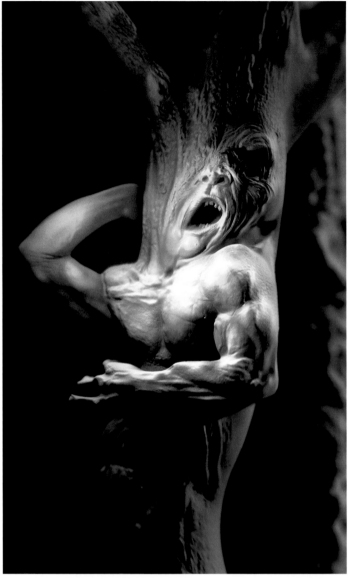

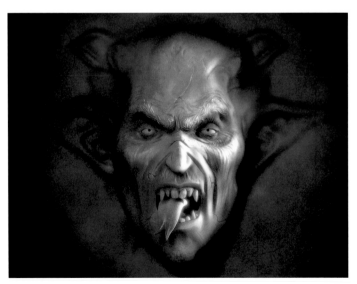

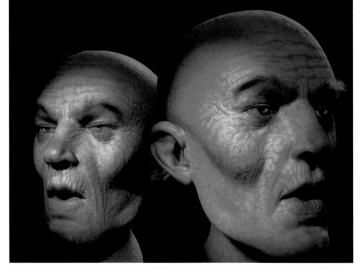

i-no
LightWave 3D, Photoshop
My first magazine cover shortly after arriving in the US for NewTekniques. At the time people seemed to like my eye creations a little too much, so I thought I'd put an end to this by making the most eye-focused image I could think of.
[top]

Endless Why
LightWave 3D, Photoshop
Initially, this had been a quick organic modeling sketch. It took only a few hours, became the most copied image I've made, and brought me more money than any other experiment. It also graces the entire back of a tattoo artist called Fred!
[above]

Treemare
LightWave 3D, ZBrush, Photoshop, messiah:Studio, After Effects, Zborn Toy
Treemare represents the opposite of my reality. An entity trapped in a form that could outlast time itself, with the same desire to be free, but 'near' immortality as its enemy.
[top]

Funny
LightWave 3D, Photoshop
My own shader creation called volumetric translucency—nobody was talking about SSS at the time. This was an experiment to see how it worked with finely detailed skin structures. I liked his attitude—observing his own strange looks.
[above]

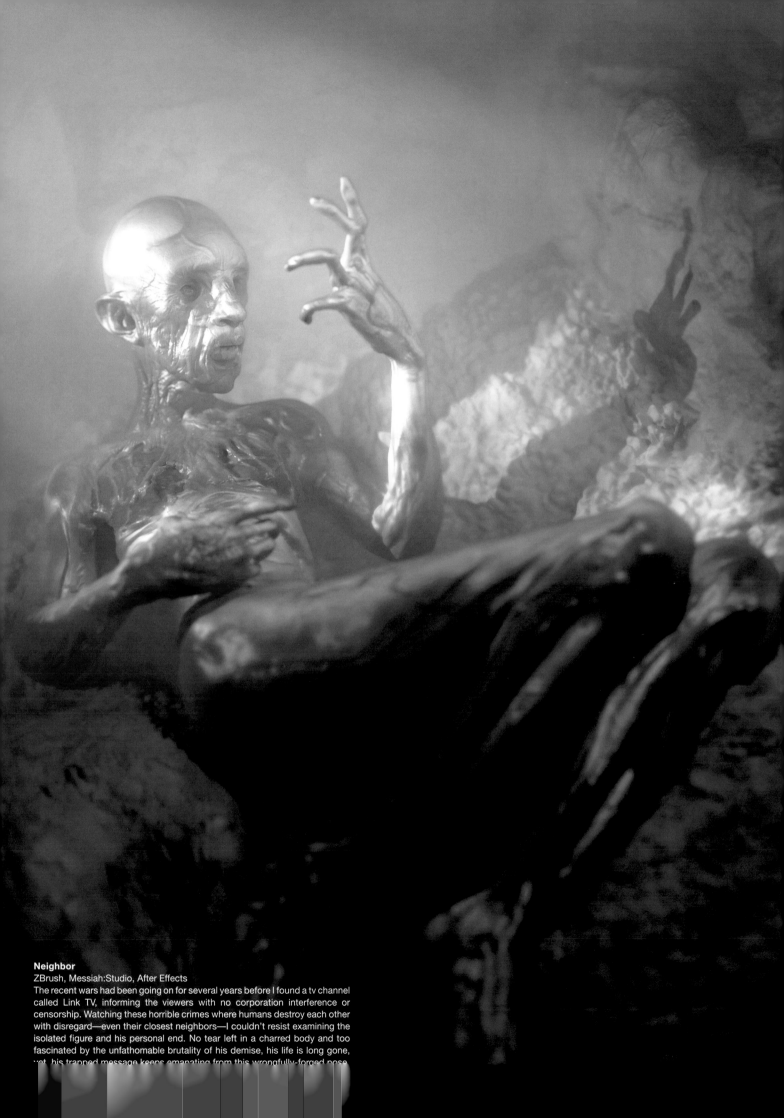

Neighbor
ZBrush, Messiah:Studio, After Effects
The recent wars had been going on for several years before I found a tv channel called Link TV, informing the viewers with no corporation interference or censorship. Watching these horrible crimes where humans destroy each other with disregard—even their closest neighbors—I couldn't resist examining the isolated figure and his personal end. No tear left in a charred body and too fascinated by the unfathomable brutality of his demise, his life is long gone, yet his trapped message keeps emanating from this wrongfully-forged pose.

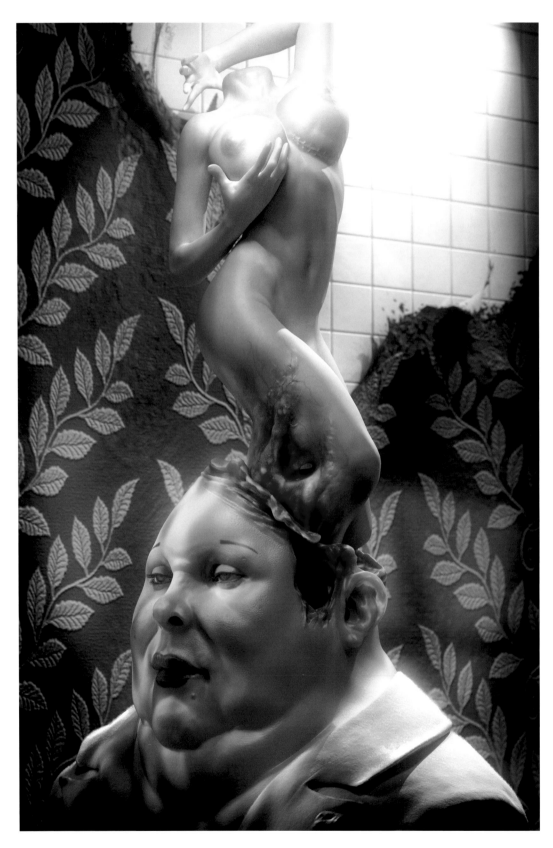

La augmental
LightWave 3D, ZBrush, Photoshop, messiah:Studio, After Effects
An image can be more than just some nice thing to look at, and the expression it contains should at least sometimes transcend the means of self-exposure. This is one of those images that came to mind after a freeform session of creating the "old" lady's head. Creating the augmented body rising from her was also a great exercise of working without direct reference to see how far my imagination could take it. As for the name, although I don't like to explain the little word games, I so love to use "la". It doesn't represent an article, but is more of a locational hint.

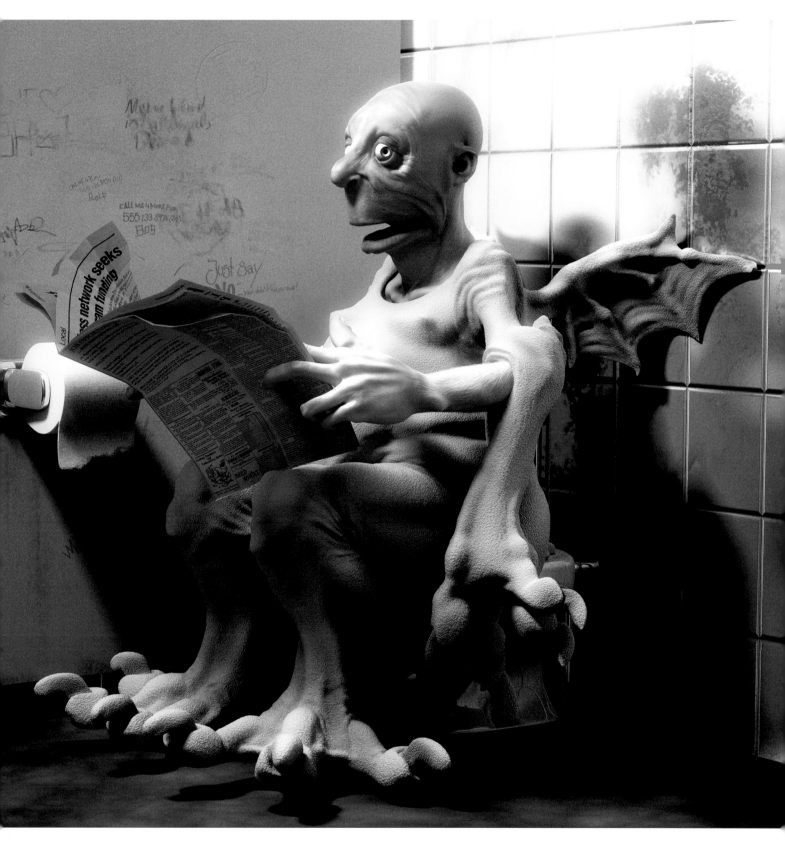

Job hunter

LightWave 3D, ZBrush, Photoshop, messiah:Studio
Quickly conceived, this image is very high up in my personal favorites, because it is truly a sketch in response to the face, which I had started with. I just saw where he was at and what he was doing and wrapped it around him without any hesitation. Rendered in messiah:Studio it went straight into Photoshop, where I've done the more unusual task of writing the nonsense to the walls.

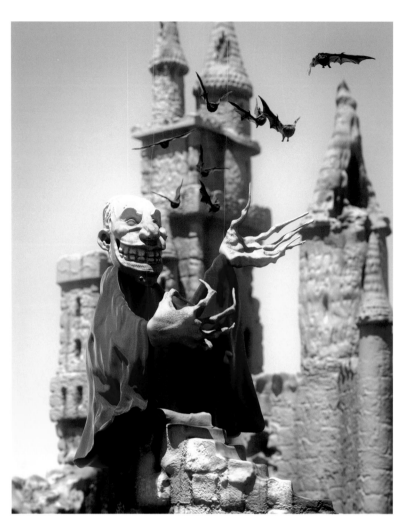

Vladimir Logheadovic

LightWave 3D, ZBrush, Photoshop, messiah:Studio, After Effects

This picture is very close to my heart; looking at it somehow has a liberating effect on me. Someone mentioned that it reminds him of the old lenticular postcards, which might have been exactly what made me feel so comfortable with it. I chose to make the marionettes, because they not only matched the scale of the background set (created almost entirely within Zbrush), but because it was such a direct process creating them. I rendered the scene in messiah:Studio and took it into After Effects to use Frischluft's beautiful Lenscare plug-in for the depth-of-field solution.

[left]

Lil' Devil

LightWave 3D, ZBrush, Photoshop, messiah:Studio

When I created this character, ZBrush had just become the tool of choice for me. Inspired by the possibility to add tremendous amounts of fine details to a surface with very little effort, I just wanted to play around a little bit and out came the lil' devil! The eyes, as many of them before then, were created using my DollEyes shader which I wrote for messiah:Studio. They gave him another edge to arrive at his curious attitude. It means a lot to me, when a character makes me smile from somewhere deep within. He certainly knows something!

[right]

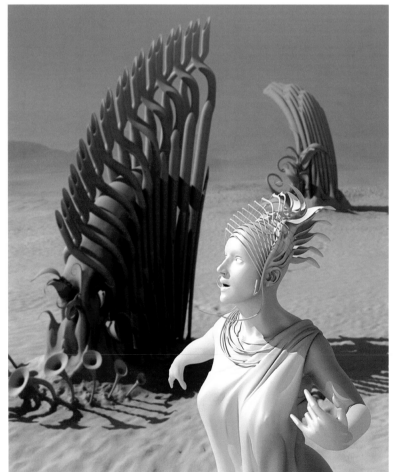

Sand harps

LightWave 3D, Photoshop, project:messiah

This was the second magazine cover I was asked to create—without any specific requests; just the way I like it! I wanted to let this become a short animation, showing a dancer frozen in a desert full of sculpted instruments. As wind suddenly builds up and blows through them, they reasonate and create a massively strong and beautiful sound. The vibrations break free the woman, who then starts to dance to the emerging music of those sculptures only to eventually evaporate into a mild sandstorm. Again, it showcased my volumetric translucency in LightWave 3D. However, I used the messiah plug-in to bring the character into pose. Initially, she was naked which led to a beautiful side story. The magazine showed her nude, but U.S. teachers complained. So I gave her a dress, which got published as a cut-out in a following issue of the magazine (NewTekPro).

[left]

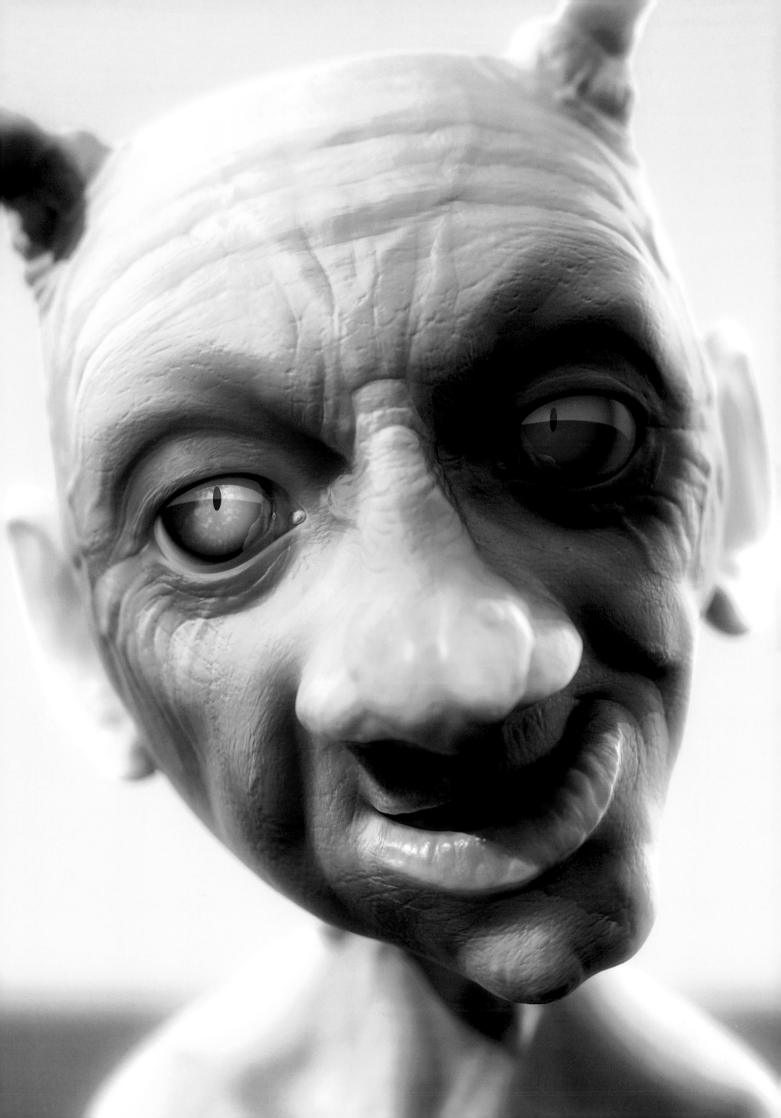

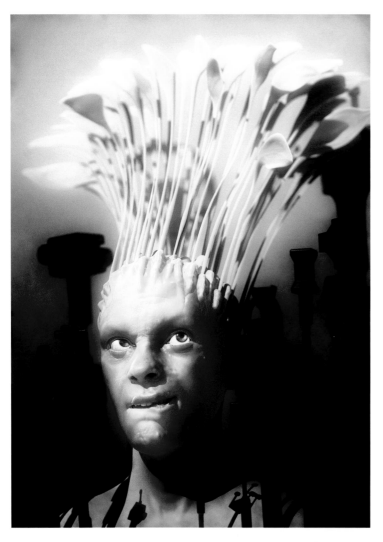

Sprouting big ideas
LightWave 3D, ZBrush, Photoshop, messiah:Studio
This was the first creation for this gallery and exhibits my thought process more than anything else. In a world full of mechanical art where much of that art is derivative this guy just happens to think of something different. Ironically, it ends up being the same thing, except it's grown and not manufactured—it's flexible as opposed to rigid. So the leap is really not that far.
[above left]

Eye alone
LightWave 3D, ZBrush, Photoshop, messiah:Studio
This piece is a homage to one of my own older images—I was interested in a comparison to my former self. I used LightWave 3D for modeling, ZBrush for displacement maps, messiah:Studio for rendering and Photoshop for slight color treatments.
[above]

Vio
LightWave 3D, Photoshop, messiah:Studio
This was the first messiah:Studio full-page advertisement I did back in the day. I wanted to show all of the things that made the software special back then. Character animation, soft-body dynamics, and an expression implementation, all of which was so easy to use. I did not focus on the rendering and shading, but wanted to really bring across the symbolism, speaking without words. Curiously, the legs actually work (at least the left side), where wires and complex gear systems automatically respond correctly to the motion of the leg.
[left]

People: a daydream
LightWave 3D, ZBrush, Photoshop, messiah:Studio
An excerpt from my 'People' animation. It was designed to demonstrate the use of displacement for animation.
[right]

CHARACTER MODELING: BOX MODELING

The beauty/efficiency of box-modeling

When I first tried modeling a head I sought out tutorials—they suggested the use of spline patches, sending me on a wild three-day odyssey that ended with a small section of a face that looked like nothing I'd meant. But, when I ran into a small tutorial that used what was called "Metaform"—starting your model with a box—I immediately saw the power of the smooth subdivision method. A few years after that "Metanurbs" were introduced, featuring a real-time display of the smooth subdivision geometry while you could work on the low-res cage of it. I was more than thrilled, and my modeling method quickly found the major refinements that are still the foundation of how I work today.

Technique

My 3D tool of choice is LightWave 3D. Starting with the box-modeling approach, I add details by extruding selected polygons using LightWave's Extender Plus tool (I also have symmetry turned on). I don't use Extender Plus to its full capacity. Instead, I only use it to create new geometry at a specific location and manipulate its shape manually afterwards. This leads to the use of very few tools during the entire modeling process. The list of tools I use is therefore very short and reads as follows: box; symmetry mode on; Extender Plus; Stretch; Rotate; drag points, SpinQuads; collapse polygons; merge polygons; and occasionally broader

deformers like Magnet, Pole, and Vortex. In the clean-up parts of the process, I use the statistics for points to find, select, and delete remaining unconnected points which happen due to my constant optimizations during the modeling session. This is not some kind of compulsive behavior, but actually part of the design process. This modeling session took less than an hour, despite the fact that I've taken snapshots for every major step and actually only used undo for recording purposes.

A beginning

In these beginning moments of the modeling process it is all about simply creating geometry. Ideally, we grow our mesh at the right places for the general idea behind the design. This example shows the process of modeling a head—we are all familiar with what a head is roughly supposed to look like. It all starts with rather broad design choices before molding on the pieces that best describe the silhouette—the kind of shape you'd see if you squinted your eyes. Working this way leads to a strong result and also motivates and inspires as you can watch the model develop. It helps to submerge yourself into the subject you are creating. Remember though that your model can change dramatically during the course of its construction, but every stage should give you some form of gratification. It should be fun!

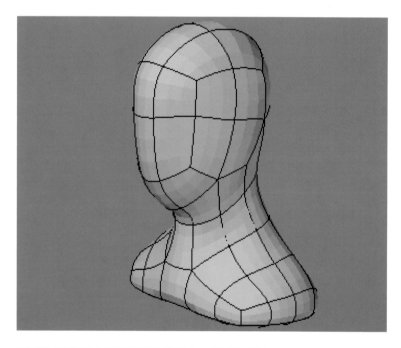

A full shape

Another big advantage of this kind of modeling is the fact that you are always dealing with a complete object—a full shape. You can always get feedback for the overall look of it, and you even can experience a type of communication with the geometry where the model suggests and inspires you toward a certain path. You can always supervise proportions and style and go right to the perfect place without having to waste energy on imagining what the details around it might look like. It may sound trivial, but it really has a major impact on the modeling process. Together with the symmetry mode, you have very little to worry about but to create exactly what it is that you want to take care of. Focus and submergence are the most vital traits you should use while modeling. This is yet another reason why I love this method so much. The whole nature of this modeling style is expansion and there's nothing that prohibits reduction—in fact, this is part of the process, too!

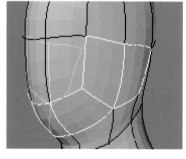
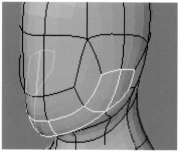
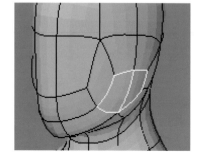
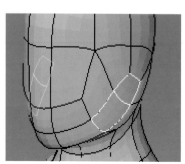

SpinQuad

Here, you can see the accentuation of a jawline using LightWave 3D 9's Extender Plus (formerly known as Supershift or Smoothshift in earlier versions) which is essentially an extruding tool. It also exhibits the use of the SpinQuad tool which is used to alter polygon topography, yielding a better edge-flow along the surface of the geometry. In a nutshell, SpinQuad rotates a selection of two adjacent Quads about each other. This serves two main purposes and one rather minor technicality. It serves the design process, because it refines areas into more precise sections while the mesh is still very coarse! It also helps the deformation of the mesh during animation or posing. The minor technicality refers to rendering issues with subdivision geometry which are affected by certain edge conditions when too many edges lead to one point.

Extruding with Extender Plus

Here, I extrude selected polygons using Extender Plus again to prepare the creation of the nose. You can see that I simply picked polygons at approximately where the nose should be. Let me use this chance to describe another part of my standard procedure—the stretching after the extrusion. Extruder Plus doesn't move the points of the extended geometry, which is exactly what we want it to do. Instead, we simply use the kind of deformer we need to bring the new polygons into exactly the position we want. Usually, I first stretch them smaller so it's easy to see where they are and how they are connecting to the surrounding geometry.

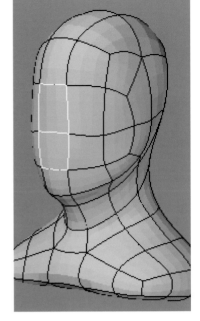
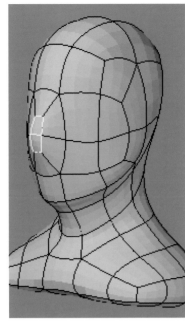

Fix it when you can

You can see the process of collapsing and merging of polygons here. It is quite stunning how quickly a geometry evolves using this method. During the modeling process I frequently jump in to do some broader adjustments to the proportions by grabbing larger areas like the entire head to deform it to my liking. I find it very important to always stay in control of the mesh. If you spot a bad area—particularly when you're not planning to add anything specific to it at this moment—you should fix it or make it look nicer.

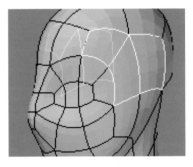
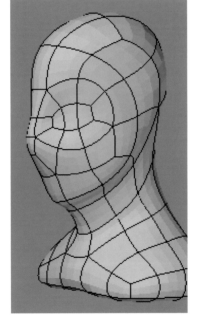
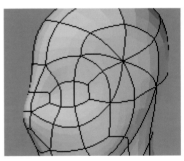

Model intuitively

Here's my process of selecting an area for adding more detail. It also shows that experience leads to the right decisions far more than rules can explain. This experience comes from wild experimentation. It is very important to stay loose and not to tense up with worries that things could go wrong. In fact, during the making of this tutorial I didn't make any funky little mistakes by extruding an area which I later wouldn't want anymore. I usually do that quite a bit, just because I don't want to waste thought power on preconceiving the perfect mesh structure. I want to model intuitively!

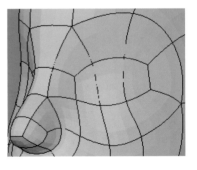
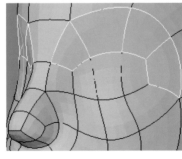

Be brave

If I see an opportunity to try something different, I just go ahead and try it. Not only could I simply undo the process if it was just horrible, but I could also repair it again based on my standard maneuvers. This can lead to a much more interesting flow and lead to other positive developments of the model. Essentially, you shouldn't have one worry in the world while you're modeling away, except that you do what you want to do!

Simplifying the topography

I've broken down the individual steps to show the process of reducing the number of facing polygons. If you look at these steps you'll notice that I've extruded one polygon on the upper cheek, which I then melted more into the edge-flow only to eventually, nearly make it disappear altogether.

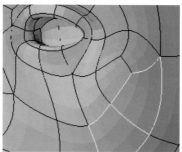
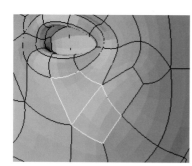

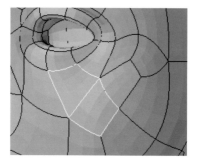
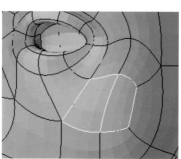

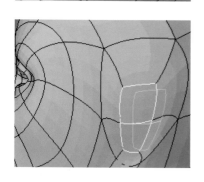

Edge-flow

Every now and then this is the kind of thing I do to add only minor amounts of geometry or even just change the edge-flow to support specific design ideas. Some people use a deceiving term they call "edgeloop" for this process, which I find misleading. The edge-flow as I like to call it describes really both the design of your geometry as well as the way it wants to deform. Those edges really don't have to loop—you really don't want to look for where and when they might loop. It's most important to observe if they describe the proper form. I often end up with something that might be called an "edgespiral"—the techno-art-geek within me finds this really entertaining.

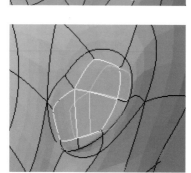
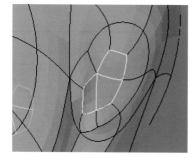

The ears

Here, I am looking at a possible position for the ears to emerge. I'm looking for both their rough placement as well as for the geometry around them. For details like the ears, I don't just jump straight in. I examine and modify the foundation around them to make it a smoother process for the progression! In this case, I've found two nice polygons that may just do the trick. This is where I think about displacement maps. The ear is usually a body part with the highest polygon density, because of the intricate interweaving of shapes in its basic form.

Low-poly start

Since the introduction of Pixologic's ZBrush and messiah: Studio's flawless integration of displacement maps, I have stopped squeezing too much detail into the animated geometry and instead leave that challenge to the displacement maps. It's now sufficient to begin ears with only two or three polygons. As a rule, I no longer work as much definition into low-res ears, but for this example I went right up to the point where it was both nice for the model itself and for the latter displacement map creation.

Mesh control freak

After the ear is done I optimize how it is integrated into the surrounding area one last time and look at the overall mesh again. I do this quite a bit because it always reveals shortcomings or other little problem areas which can be addressed right away. These fixes help to stay on top of your topography. I am truly a control freak when it comes to that, because I really want to know at all times what is happening with my mesh overall.

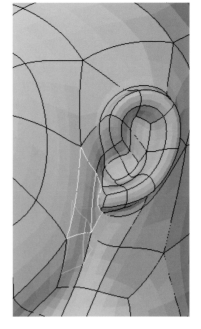 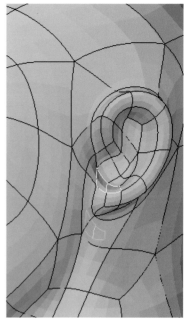

Artist first

One of the reasons that I'm a mesh control freak is that I don't want to go from detail to detail only to find out that I have some ugly areas in between. Checking the mesh gives me the opportunity to try different approaches to the details. The alternative is that down the line "ugly" fixes will be required or I could miss a flaw that only becomes apparent at the animation and displacement stage. Worse still, I could compromise my artistic vision by getting caught up with the technical fixes. As far as I'm concerned, you should be an artist first—no matter how technical it might get. There'll be plenty of time for being an engineer later in the game.

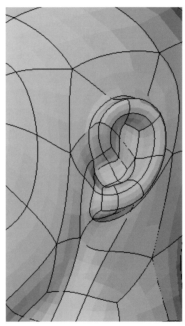 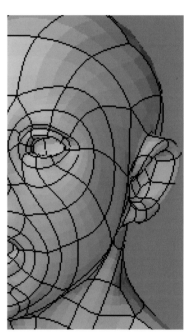

Tut Mesh Amon

After the principle geometry is done, I start playing around with it a little more just see what other fun things could be done to it. My next step will be to go into the ZBrush grinder for the real details. Why not go a little nuts? For this example I simply worked the existing character into a more aggressively shaped form, taking it from a dull boy (all work and no play) into what I like to call 'Tut Mesh Amon'.

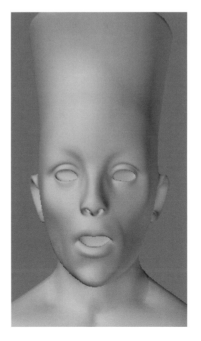 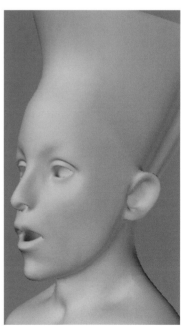

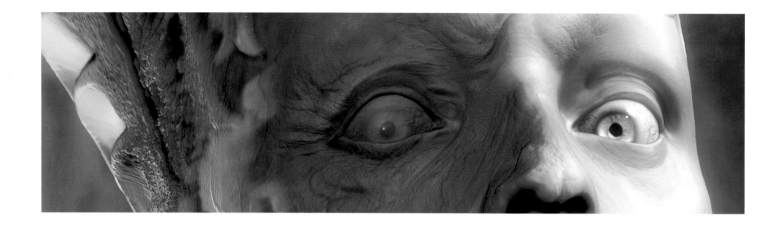

CHARACTER MODELING: ZBRUSHING & TEXTURING

Kid in a candy shop

ZBrush is truly the first highlight in my pipeline since it allows me to go beyond all previous restrictions in terms of forming exactly the kind of shapes I want. It never ceases to make me feel like a kid in a candy shop. I do practically everything regarding the model's exterior within ZBrush including all layers of textures like color, glossiness, translucency, and of course displacement. It's really challenging to describe the procedure of sculpting in ZBrush. Not unlike my low-res geometry modeling needs, I use very few features in ZBrush as they are more than sufficient for what I need. One of the key advantages of ZBrush 2.5 is its speed and the ability to handle millions of polygons. It does this so easily that you can use any brush on it with patterns (alphas) to apply structure during the modeling process. Formerly, it was necessary to use either stencils or go into ZBrush's ProjectionMaster. Without needing to do that, the amount of fancy features needed shrinks again. So here we are, reading about me using a set of brushes and alphas to do practically all of the ZBrush modeling and painting.

New materials

Worthy of mentioning in advance is also the set of new materials that are now part of the package. Wax and skin-like translucent materials help to get a very good feel of the model while you're working on it. However, by default they all are saturated in a way that doesn't help the painting process. You can easily change that and still take full advantage of the great real-time shading of them. More on that later, when we arrive at the color texture painting section.

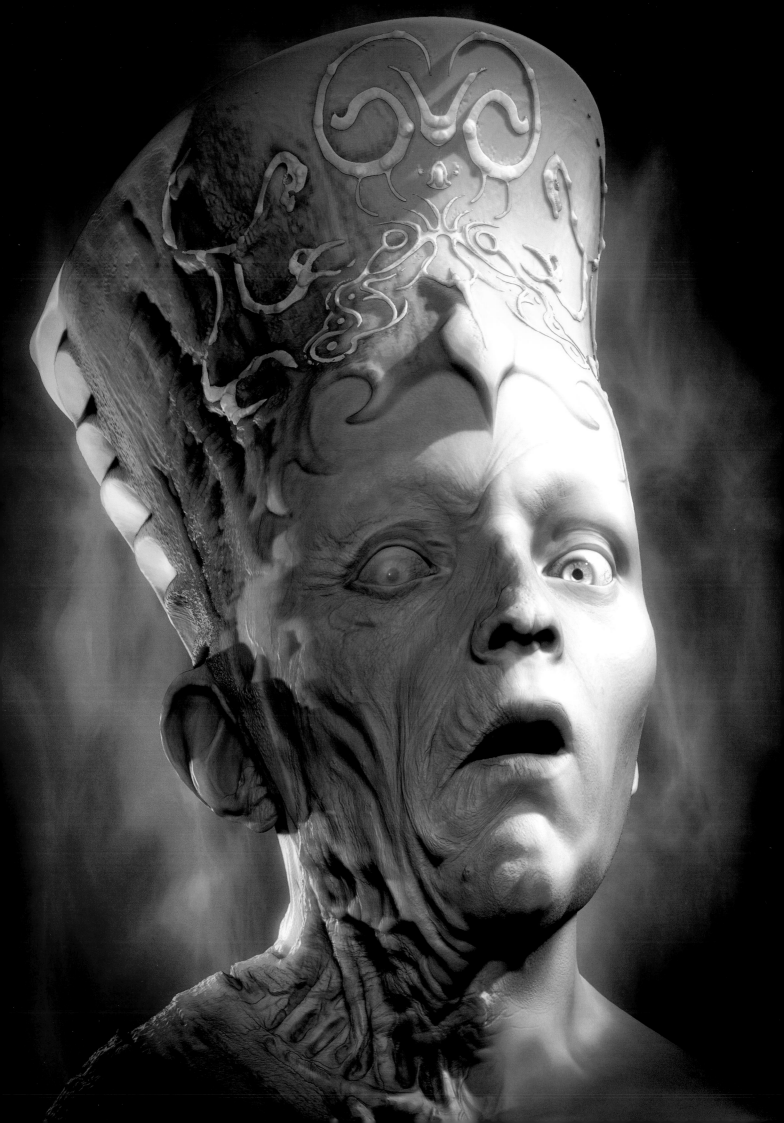

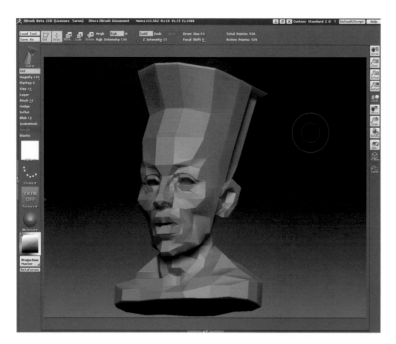

Sparking passion

After importing the geometry into the tool, I'm first excited to just do some almost generic modeling to the head. Even seeing it in facets gets me excited knowing that I will divide the geometry in a second and get to really make it pretty. This excitement may sound shallow, but it's an important part of the process. You might want to call it "passion"—and you'd be absolutely right in doing so! For an artist, it should be of greatest gratification to have such powerful access to refine their creation. So let's prepare to have some fun!

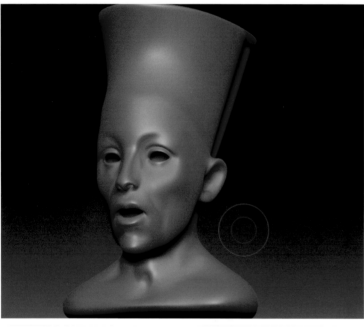

First touch

Dividing the head brings out the instant beauty of one of ZBrush's new materials, "Red Wax" which is a default in the version. At this point I don't even examine the model too much, because I have already homed in on the first thing I want to do. In Tut Mesh Amon's case it's the cheekbones and the eyebrow area. I fill in more defined bone structure first, which I only suggested in the low-res geometry. Thanks to the mirroring function, I don't have to worry about anything but what I'm working on.

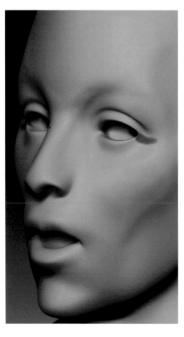 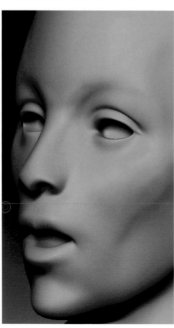

A sense of reality

I move onto the eyelids, using my first masking stroke to make a defined overlap of the upper eyelid. This helps to get a more skin-like or fleshy feel to it. I often start with particular, yet broad details that enhance the sensation of working on a "real" head. They are like incentives to proceed with care and to stay in the proper mental mode.

Who is this?

The order of areas that are getting addressed may be very similar to the system in which we recognize faces. After the eyes, I swing by the nose, and down to the lips and chin area. With those pieces refined, it's a lot easier to begin recognizing the person we're working on, no matter how fictitious he or she might be. Having done that, a glance over the entire face triggers some minor tweaks and strokes, just to pronounce the overall features of the character a little more. It's almost like a detective process; is this really who I think it is?

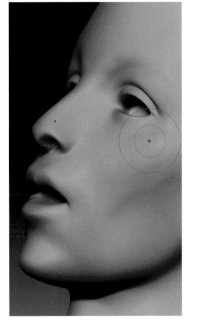 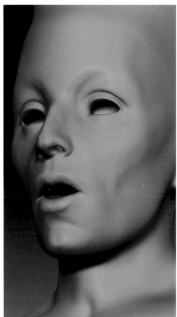

Ears

Now for another fun part—the ears! Yes, the ears are really fun, mostly because of the former pains it took to get well-defined ears which do not look too sterile or lifeless. Now we can freely model them to our heart's content and I celebrate that every time. I always take the time to try discovering new specific subforms in the shapes of an ear. I've studied them quite a bit over the many years, yet, I still find new associations to individual sections of them and how they connect or interact.

Stroking masks

The very first brush strokes are rather generic, however, this time around I even use an alpha stroke to mask out the major fold on the inside of the ear for a speedy bulging of it. All of what I've been doing so far has been with the standard brush and no specific alpha for the brush itself. Even the continuing detailing of the ear won't require the use of anything else.

Not just facades

It's vital to look at the model from several angles every now and then. Different angles reveal weaknesses or missing parts and forms. An ear is a prime example of that, because of its many internal windings and skin flaps. After having dealt mostly with the parts of an ear we see most of the time, I look at the back of it to model those usually hidden places a bit more neatly. This is important for several reasons. Not only could your character have an accident at the local hairdresser and baldly reveal the back of his ear, but these ears often reveal the quality of your sub-surface scattering renders, with light that illuminates them from behind. If the backside of the ear is not properly modeled, it won't have a chance of looking right.

Character traits

Now that the major facial elements are prepared, it's time to have a look at it all again. What do I want to address next? In the beginning, a lot of the modeling really has been nearly completely generic. I have prepared myself to see if the character is thin or not so thin, potentially sensitive or not so sensitive, male or female—all of this by means of proportions mostly. Now I begin more directly to examine and produce his life and history. I add a bit more definition into his eyebrow and forehead area. I give him the first trace of a character trait. The folds between his eyebrows above the nose are very much referenced by my own, which is something we all do subconsciously. In my case it's a borderline laziness issue, but I dare to assume that it's human enough to be plausible.

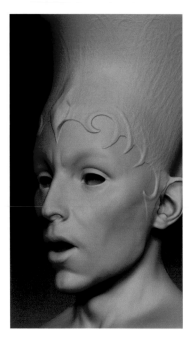
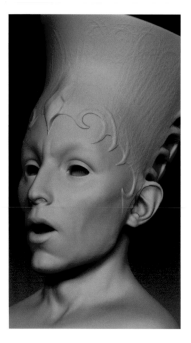

Splitting the hat from the head

After having reviewed the model again from several angles I decide to add some embellishments to the hat. The separation now becomes more clear, and it provides him with more definition. Who is he now? Where does he come from? Who am I to him? I let the character again speak to me from all angles—the hat is no longer a tumor growing from his temples.

Age besides beauty

Of course, the name "Tut Mesh Amon" as well as the overall shape are testimony to a pre-conceived idea, yet, it had been nothing but a hunch before now. Right now, I can make new associations, among which is the idea of age and the desire of immortality that is found in those ancient cultures. What if this one character would show his entire existence including his undoing? Playfully, I begin to add wrinkles to one side, switching off the mirror feature.

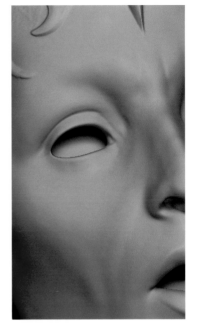 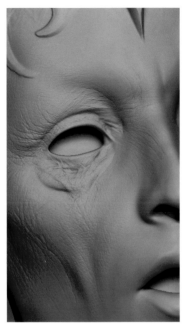

Wrinkles and folds

ZBrush comes with a set of very powerful alphas for the brushes. Some of them are clearly for wrinkles and cell structures, and they work just beautifully. Using only these I can quickly sketch in the age with even fine wrinkles and foldings. I'm using a streaked alpha—inverted to indent wrinkles, as well as outwards for fine folds. Those fine folds suggest very thin skin and really help to establish a substance. Drawing from very obvious observations I'm adding a bulging sack underneath the eye.

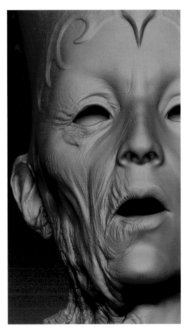 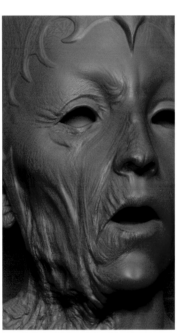

Making history

My chief motive now is to make that skin old and sagging, practically hanging from muscles and bones. All of this is pure fantasy. I'm thinking as hard as I can about what might happen to this skin. I'm also drawing conclusions based on all the faces I have seen in the past. How long has the skin been hanging there? What has he done with his face the most during his life? What else might have happened to him? Which side does he sleep on most? To be honest, I didn't think too deeply—I was more excited by the idea of getting a nice hanging feel to loose skin! The feel of super-soft, thin leather should come across—just moist enough to still be alive.

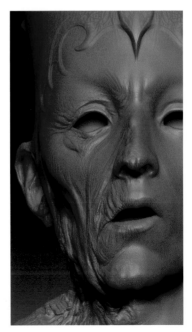 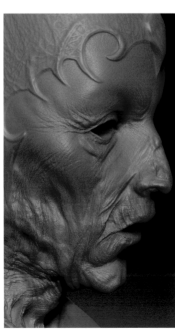

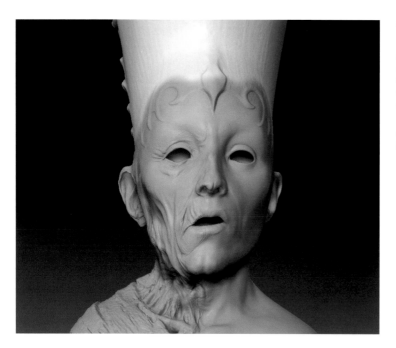

Color coating

In phase two of the process, it's all about giving color to the character. This procedure also invites a whole lot of tweaking of the geometry itself. Details become more prominent and the constant reviewing between each step makes it hard to ignore flaws here and there. That doesn't even account for the inspirational aspect, like adding veins and other fine irregularities on the skin of the face. I start by giving a type of base coating to the face with a few mild color variations to sketch out zones.

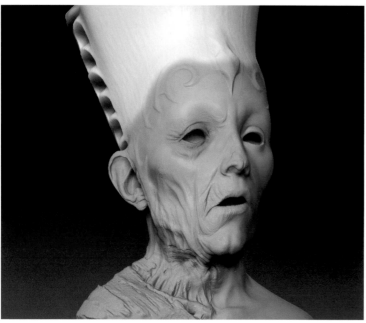

Discovering relativity

Experimentation in a loose manner is key to a relaxed start. I lay down some colors that are far from perfect, but which reveal the relative nature of hue changes as well as brightness changes. It's a tricky thing to deal with these variations for the duration of the color map painting.

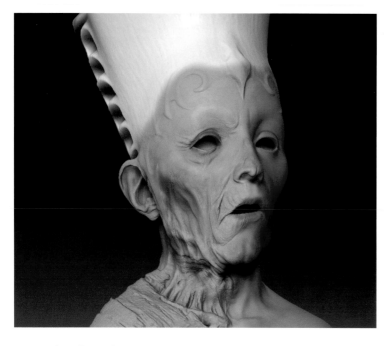

Vessels and pigments

Using some of the alphas I had already used for the displacement detailing, I lay in larger zones of discoloration with only mild pressure. It's a bit like molding the color without too much fuss. There are typical color areas on a face, like red cheeks and chin as well as blueish shades around and under the eyes. Those indicate the dominance certain blood vessels have on different parts of a face. Usually there's also the variation in pigmentation and the influence that exposure to sun would have had. In Tut Mesh Amon's case, I have assumed less exposure to sun, due to his aristocratic nature. At this point, it's not really about his history—it's about getting some color on him to enable a better judgement.

Pure color

Along the way I also change materials and render modes, like flat rendering, which only exposes the unshaded colors. That way I can see how colors react under different circumstances. However, for the painting itself it's best to use the most generic material possible, which does not tint the color too much. It still needs to show the geometry well enough so that we can see where we're painting.

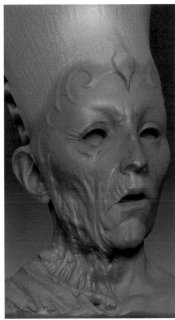

Revealing highlights

Some painting tasks require a focus on different kinds of surface traits. For example, some details can't be properly judged with too much specularity interfering with the visual feedback while you're coloring them. Other areas need those highlights to let us understand their forms better. When I was putting in those veins on the neck, I didn't want to commit to specific colors yet. I first made the displacement strokes for them and applied color afterwards.

Isolation

Some careful alpha painting isolates the hat from the face so that I can finally color that part and look at the whole model. While I was at it, I also added some minor embellishments and gave them some painted highlighting and mild aging. Now I can have a look at the whole thing.

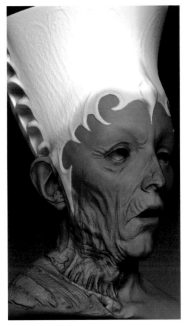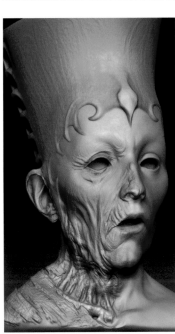

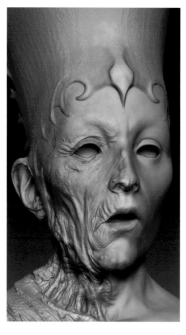
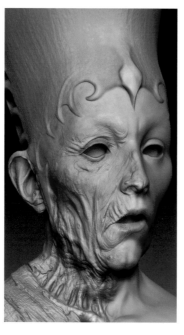

Imperfections

I decide to add tiny veins and blemishes over the face now by both painting color and displacements at the same time. The time has come to get into the tweaking frenzy, which means countless tiny strokes and adjustments in order to make him more complete and somewhat more natural. This also means nudging back some of the strokes and correcting little mistakes here and there. I often do an "extreme" addition first and then blend it back in more carefully. If you are too hesitant, you tend to miss possibilities and stiffen up too much. Dramatically speaking, being scared to create keeps you from creating. It's as simple as that. But, the more details you add, the scarier it gets—that's for sure!

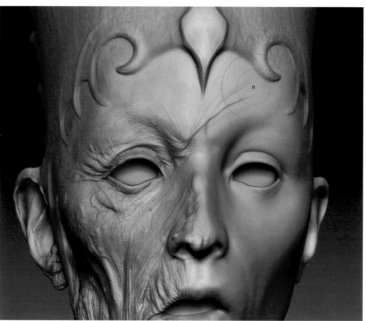

Stroke of genius

After having looked at the model from several angles and with different materials again, I've decided it needed something bolder. Although in this case, the idea for the change came before that boldness revelation. I saw that a large pulling fold over the forehead would melt the two sides together more powerfully and expressively. It's very much like a scar, which adds a somewhat dramatic tone to it. It also makes the transition from young to old far more dynamic; almost as if it was in progress.

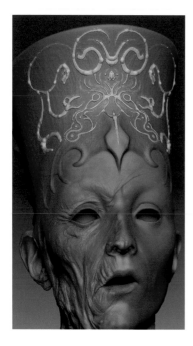

Mesh Extract

The hat now deserves some more attention. I wanted to add more embellishments, but this time I've decided to use one of the new features in ZBrush called "Mesh Extract". A very quick alpha mask of the ornaments allows us to hide the rest of the mesh to activate and use the Mesh Extract function. After determining a small thickness for it, it spits it out as a new subtool, which is another new feature. This allows you to have subtools, which are part of your tool very much like layers in Photoshop, but in form of geometry and without blending modes.

Recycle bin

Sometimes certain details have the side-effect of revealing a 3D nature too much and I like to keep those as minimal as possible. When some transitions seem a bit more crummy, dirty, or imprecise, like from the face to the hat, it also gives it an eery feel—oddly enough this helps to add visual appeal. It all depends on the kind of image you want to arrive at. I've already made up my mind to let it become rather painterly.

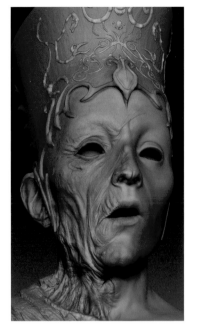 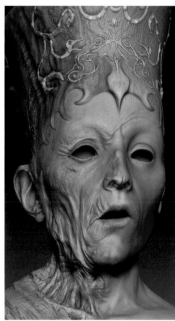

Coherence

Now it is time to look at the young side a bit more closely. So far it has been utterly neglected. A very quick session of adding fine cell structures just wasn't enough. The color variations had also been a bit too much on the conservative side. As I'm adding more geometry structure to it, I also use color on my brush to tie more displacements to discolorations. This always has a more coherent impact visually. It's somehow satisfying to see a bump or a dent with a specific color and gives it a sense of actual complexity.

Challenging relativity

Another review of the whole model reveals a potential problem with the relative hues. It's hard to judge if something is too red, or too dark. Misjudging the influence of an active material can also lead to some less desirable changes. It happened to me in this case—I fell for the skin material, which gives everything a red undertone. It prompted me to adjust it with broad brush strokes of a more yellowish, almost green color.

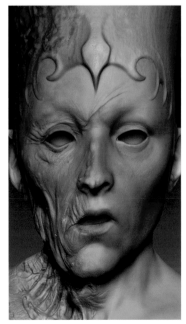 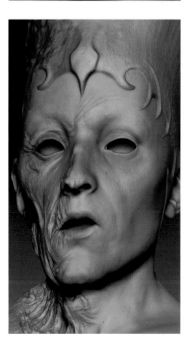

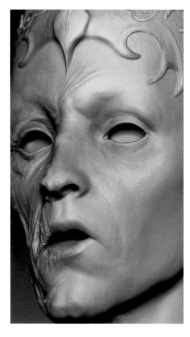
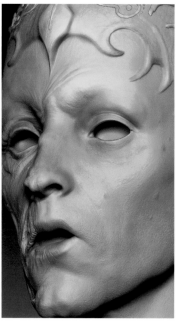

Reviving details

This unfortunately killed some color details that were tied to displacements. Nothing that can't be fixed or turned into a new virtue. I've decided to add even more beauty spots, reintroducing details that are bumped and colored at the same time.

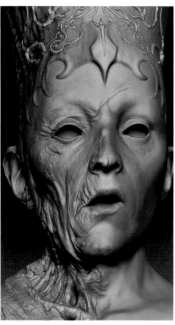
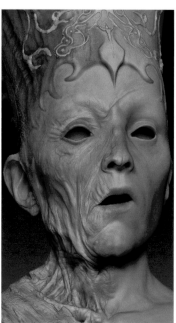

Rebuilding muscles

Finally, it was time to review it all again by using different materials. I noticed some areas on the neck appeared almost wrong and added some more believable muscles and tendons. I love to study the result of imagination and recollection simply to review my own understanding. But, the subject matter itself is outside the realm of reality, which makes such a decision all the easier.

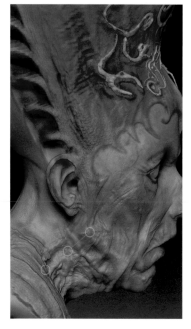

Posing

Since most of the geometry now made me somewhat happy, I took a leap into the last stage—posing and rendering the character! I had no intention of animating him, so all I wanted to get from ZBrush was a decent pose and a basic set of layers. I would take these into After Effects to create the final result. For the posing, I used the new transform tools of ZBbrush which allow very simple masking and deforming with move, scale, and rotate. In this case, I only needed rotate. Instead of rotating the head, I rotated the shoulders, which was much easier and faster.

To see or not to see

Something has been missing: eyes! I first turned the internal primitive of a sphere into a PolyMesh and then dropped it into the head by appending it as a subtool. Moved into position I've extracted it without any thickness to create a copy of it at the right size and place so that I only had to move it over to the other side. A very brief texture session for the veins turned them into all I needed.

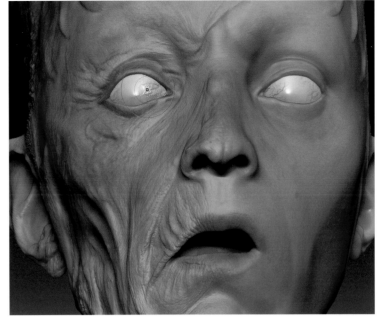

Three's company

I changed the image format to 1,500 x 2,000 pixels and brought him into position. I then used "alpha grab" to get the depth image of the document and exported it with the proper alpha depth factor in the file name—a useful thing to do! I then turned the render mode to "flat" so that I'd get only the surface colors without any shading. At this point I had an ingenius idea. I really love the feel that comes through with ZBrush's new materials. I realized that I could use them as a kind of fill light and then simply add lights to it in After Effects using the ZbornToy. I exported a preview render out of ZBrush as a document. This left me with three layers: depth; flat color; and preview shaded render.

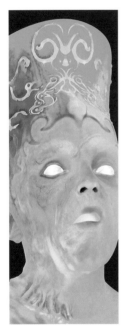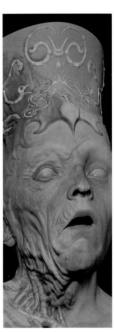

The Zborn ending

Finally, it's playtime in After Effects. All that needed to be done now was to load in our three layers and switch the After Effects project to 16 Bits per channel. A new comp provided the ZBrush render. On top of it went the depth layer with the ZbornToy. I placed a point light behind his right shoulder and a direct light from the upper left to illuminate his young half. I wanted to keep the wrinkles as smoothly lit as it came from ZBrush with all the intricate details. The Zborn Layer's transfer mode was on screen to just add those two lights on top of the ZBrush render. I used the Zborn once again as an adjustment layer on top of everything to age it all a bit with a desaturation and tinting in overlay mode. Some pupils and vectorpaint highlights for the eyes, a little glow and voila, it was done.

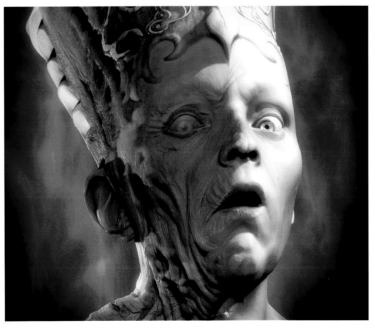

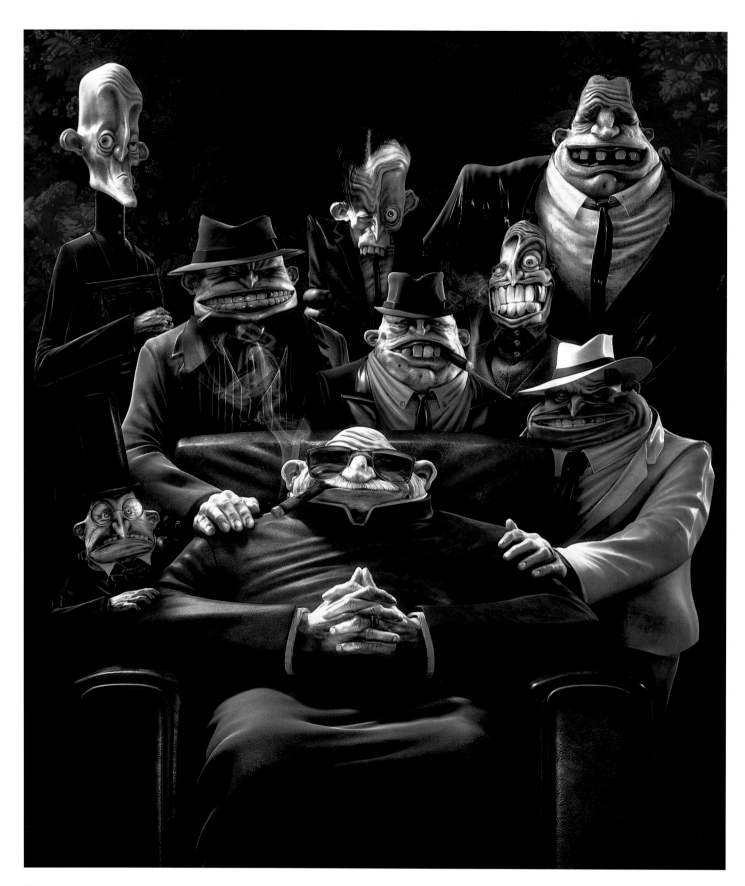

Giuseppe
3ds Max, Body Paint 3D, mental ray, Photoshop
Laurent Pierlot, Blur Studio Inc., USA
[above]

Timur Baysal

It's just a feast for the eye. So much to explore at such fitting quality. I really enjoy Laurent's sense of substance and texture as well as the tremendous style. One could only dream of a whole show with these characters.

Barfly
3ds Max, ZBrush, mental ray
Sebastien Sonet, FRANCE
[right]

Timur Baysal

Sebastien manages to deliver a clear motive that's easy to look at, yet full of carefully crafted details. I wished for the eyes to be a little less stylized, but altogether it's an amazing demonstration of skill and sensibility!

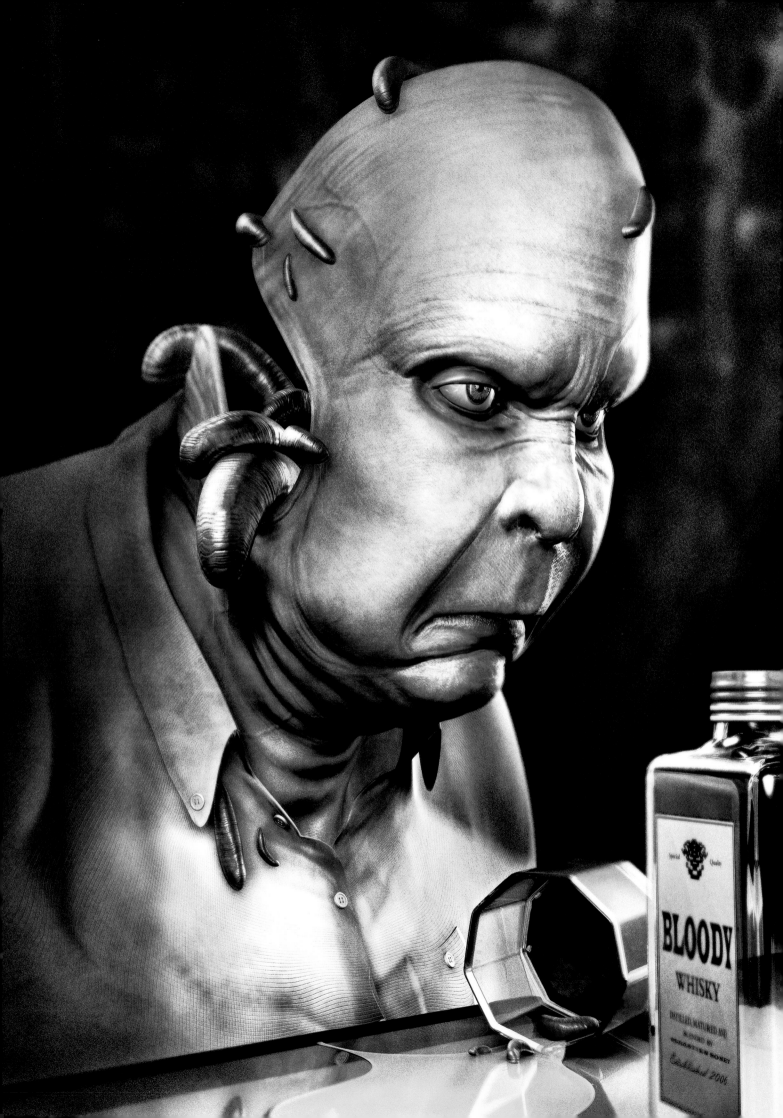

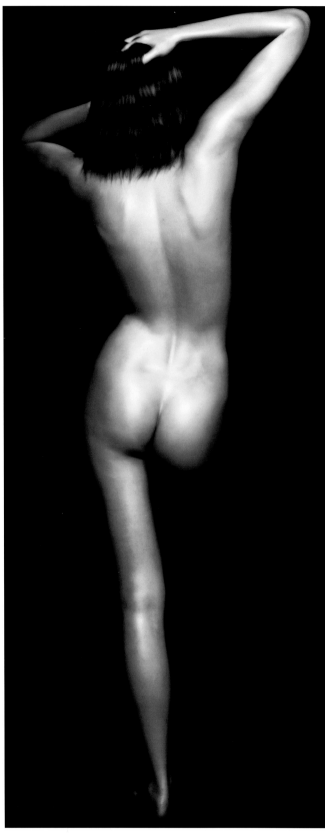

Nude
LightWave 3D, Photoshop
Gros Olivier, FRANCE
[above]

Timur Baysal
Gros observes very carefully judging by the fantastic variations of skin tones. They suggest a situation right before the snapshot which we shouldn't discuss here. I salute this work of fine art. However, the hair could use some work.

David
LightWave 3D
Rod Seffen, NORTHERN IRELAND
[above]

Timur Baysal
I'm not sure what he's made of here. It's well made, and I actually have a rather big souvenir version of David right next to my monitor. It makes me feel right at home! I like the hair best in this case.

Pallantides conan
3ds Max, ZBrush, VRay, Maya
Sunghun 'Ryan' Lim,
CANADA [right]

Timur Baysal
Manga goes Roman! The beauty of embellishments that sometimes end up on female characters finally make it onto a warrior giving him real grandeur. It's all about the armor and the overall feel that comes from the pose.

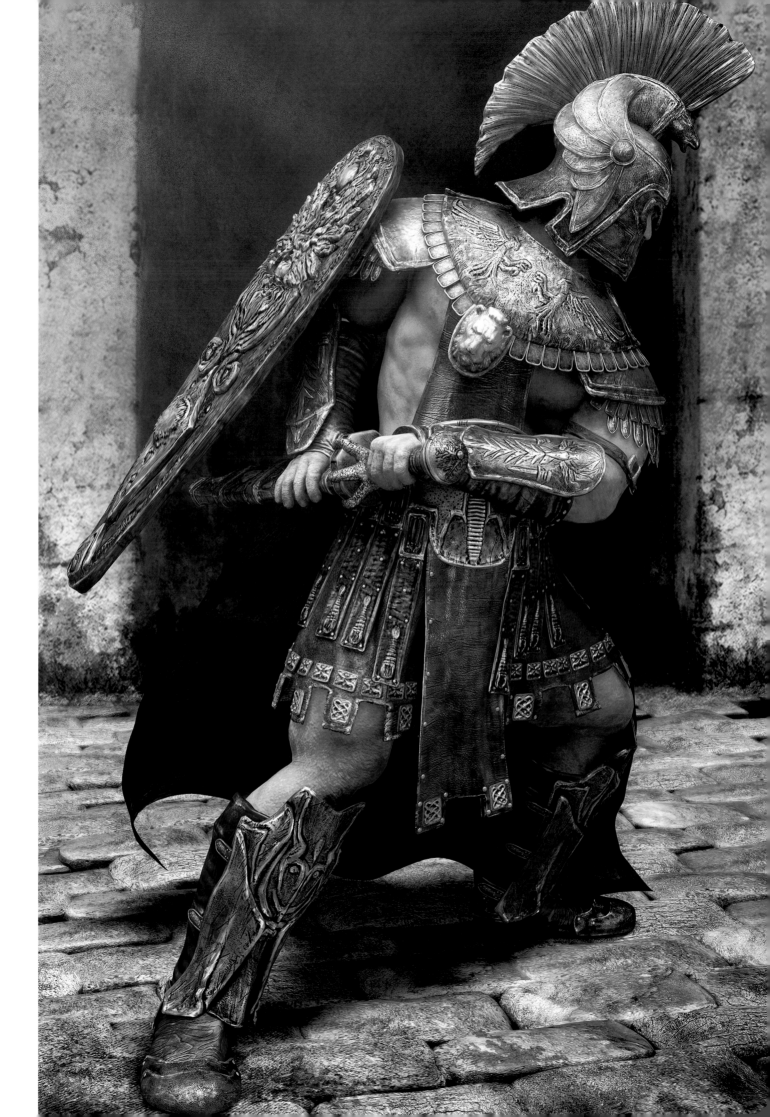

Monstreusien: Cold Meat
3ds Max, ZBrush, Photoshop, mental ray
Fred Bastide, SWITZERLAND
[top]

Timur Baysal
It's somehow perfect—the most wicked style with total clarity. Meat, meat, meat. My cholesterol level rises just looking at it! Great skill and great style by not showing off shaders and using radiosity in a purposeful way!

Self-caricature
CINEMA 4D
Jacob Saariaho, USA
[above]

Timur Baysal
I believe it is accurate. I don't know Jacob, but somehow I feel if I looked at it long enough, we'd know each other! Great work, great simplifications and good sense of form. Reminds me of 80s airbrush posters in a funny way.

Tiny Robot
Maya, mental ray, Photoshop
Eugene Beskhodarny, RUSSIA
[right]

Timur Baysal
If No.5 from 'Short Circuit' had children over several generations, I could see evolution bringing forth this little fellow. Great attitude and beautiful curiosity. The pose is very sensitively composed. Good use of depth-of-field!

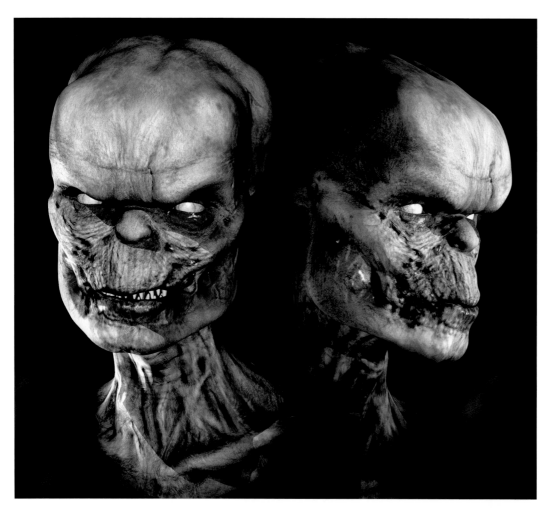

Demon Zombie
LightWave 3D, ZBrush, Photoshop
Ken Brilliant, USA
[left]

Timur Baysal
Ken always puts a smile on my face. There's something inherently funny about his style, which combines both awe and comedy with a strong control over complex structural geometry like tendons, muscles, and decaying skin. He's got a unique style.

Greed of the King
LightWave 3D, Photoshop
Corrado Vanelli, ITALY
[right]

Timur Baysal
Corrado juxtaposes horror and surrealism in a current style, but he makes it feel original to me. I would love an entire collection of his stuff, despite the disturbing nature of it. Look at those eyes—shape, placement, and shading. More soul in this amorphous blob than in 90% of all 3D creations! Corrado has a fan new fan!

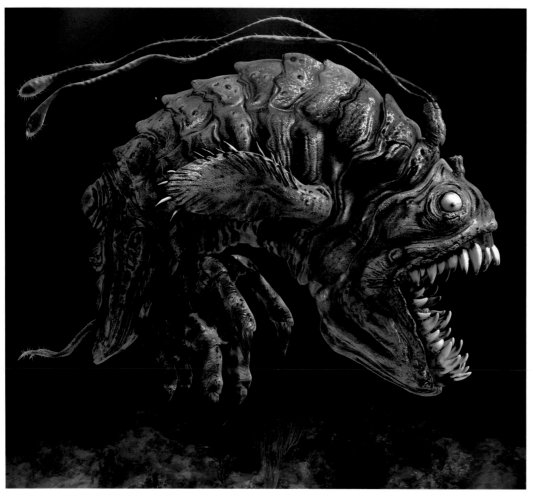

Deep sea creature
3ds Max, Mudbox, Photoshop, Brazil r/s
Avinash Hegde, INDIA
[left]

Timur Baysal
What a delightful little monster fish. This chimera of the seas has the qualities of religious symbols, or icons. Again, a great clarity and distinction between shapes and therefore very pleasant to look at. I think it's inarguably demonstrating a special style.

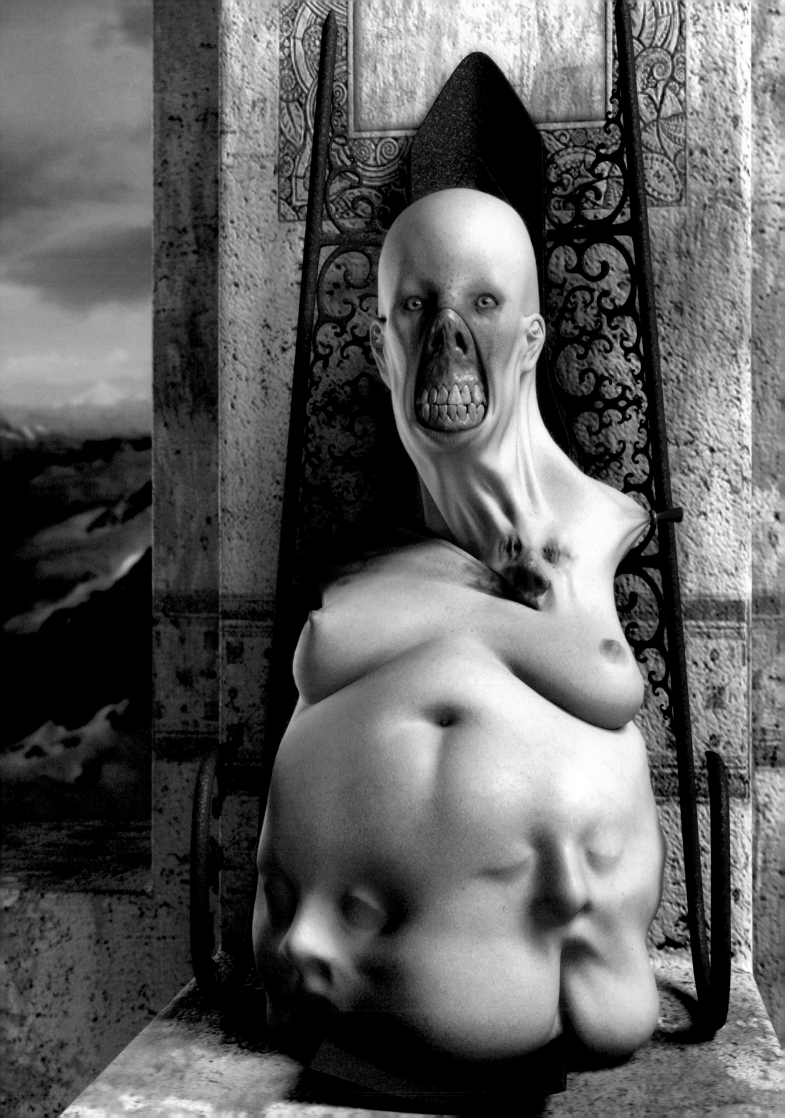

Carrier crew
ZBrush, Maya, Photoshop
Sebastien Legrain, CANADA
[left]

Timur Baysal
Fantastic realism with the perfect attitude and a fantastic choice of a moment. It looks like he just checked the flight plan and can't find the approaching airplane to be listed on such an ordinary day—a subtle sense of confusion. I love this one! Beautiful irregularities in the form as well.

Buzz
3ds Max, Combustion, Photoshop
Andrea Bertaccini, Tredistudio, ITALY
[right]

Timur Baysal
How easy Andrea makes it appear to fake a new moon landing. Classic motive with perfect new execution. I'm not sure about the supersaturated valves on the body, but it's such great clarity again. Well done!

Not Always Proud
Softimage|XSI, ZBrush, mental ray, Photoshop
Inspired by Francois Truffaut
Marco Menco,
ITALY
[left]

Timur Baysal
Marco managed to perfectly foreshadow Pan's Labyrinth, I think. This character, although a little crudely executed, displays both childlike traces and dishonoring actions still written all over him. It feels like a 3D painting somehow and promises the rise of a great talent!

Espadachin
3ds Max, ZBrush, Deep Paint, Photoshop
Abner Marín, SPAIN
[top]

Timur Baysal
I really enjoy the bold outlines of this highly-stylized Romanesque prince. Nice anatomical details provide a very enjoyable contrast to the costume design. The sword seems a little forced into pose and doesn't quite reflect the graceful elegance of the rest.

Low Poly Arkeon Sanath (Confrontation)
3ds Max, Brazil r/s
Dani Garcia, CATALONIA
[above]

Timur Baysal
Frazetta leaps into my mind, looking at this very solid fantasy knight in not too shiny armor. I think it's an outstanding low-poly character that's well worth being shown as an example for carefully distributed details and well-weighted shapes.

No, I'm not Pinocchio's sister!
3ds Max, Photoshop, VRay
Zoltán Pogonyi, HUNGARY
[top]

Timur Baysal
If the title of this piece was "therapy" or something more ambiguous, it would have reflected more of the great sensitivity displayed here. The lighting is clear and narrative, which really makes it very easy to read the sculpture as well as the situation.

Constructor 'on robot
Maya
Michael Sormann, AUSTRIA
[above]

Timur Baysal
This is the kind of comic style I would love to see in a movie; full of character and complexity. I love practically everything about it. A fantastic sense of translating texture and substance into an illustrative world.

Digital John: The everlasting anger
SoftimageIXSI, ZBrush, After Effects, Photoshop
Fabrizio Bortolussi, ITALY
[left]

Timur Baysal
This "thing" works best, when it fills the screen, because there's a whole lot of power in this character. I love the gemstone feel to the whole thing, and it's very decorative. Fabrizio is clearly a gifted artist!

Mechanic Wounds
3ds Max, mental ray, Photoshop
Luiz Fernando Rohenkohl, BRAZIL
[right]

Timur Baysal
I would've called it Machomechanico because it shows the spirit of a pool-side macho with the truly bizarre and well-deconstructed mechanics. In a crowded category, this is a unique piece!

Birdhouse
ZBrush, 3ds Max, mental ray
Sebastien Sonet, FRANCE
[left]

Timur Baysal
I really dig the clarity of his motive and the mixture of simplicity and very detailed but subtle structures. Instant absurdity. Easy to look at.

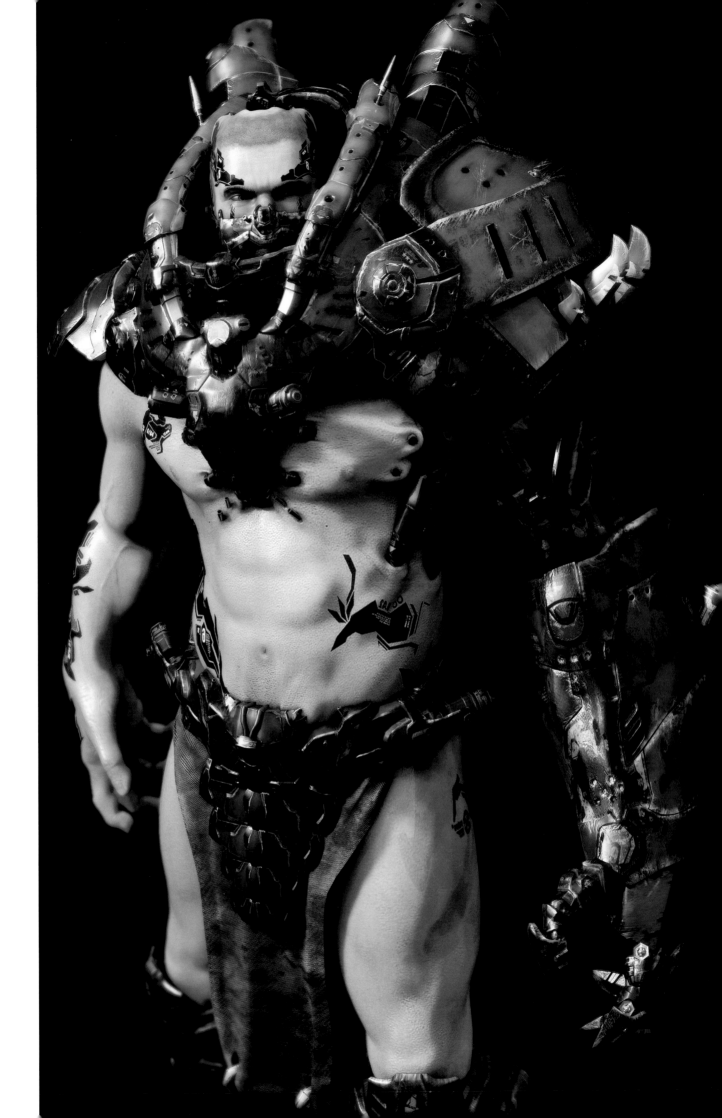

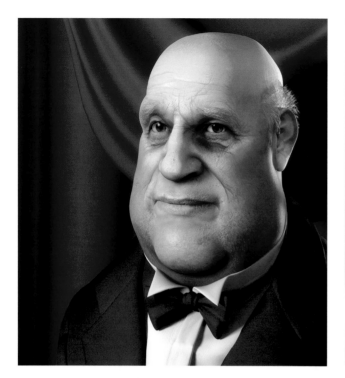

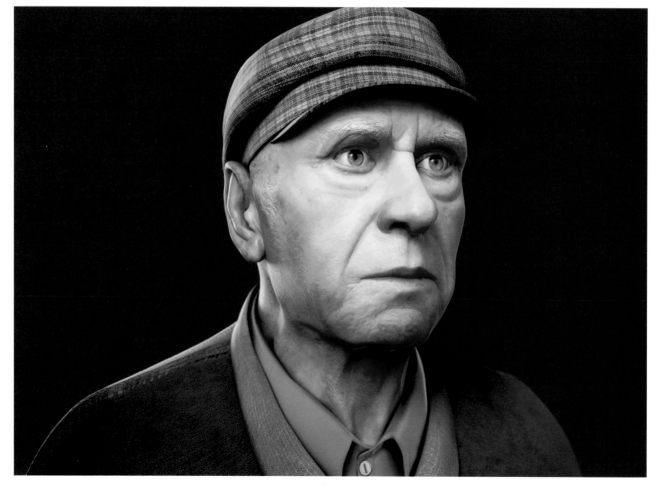

Jeeves the Butler
3ds Max, Photoshop
Maurizio Memoli, ITALY
[top left]

Timur Baysal
Maurizio discovered a sense of reality in this one, which makes this caricature transcend through the genres. Not that this wouldn't happen a lot, but I do like his sense of realism within a clear stylization.

Mr. Coutinho
3ds Max, ZBrush, mental ray, Photoshop
Wesclei Barbosa, BRAZIL
[above]

Timur Baysal
Although the eyes show a distinct sensation, they are the weakest point of this otherwise stunning model and render. SSS shading has become the standard, but in this character it comes through beautifully fleshy.

The Aviator
SoftimageIXSI, ZBrush, Photoshop
Concept: Ben Henry
Brent Wong, USA *[top right]*

Timur Baysal
Top notch skin stylization and a fantastic stereotypical depiction of an old warrior of the skies. Pain and only traces of pride are left in this character with history.

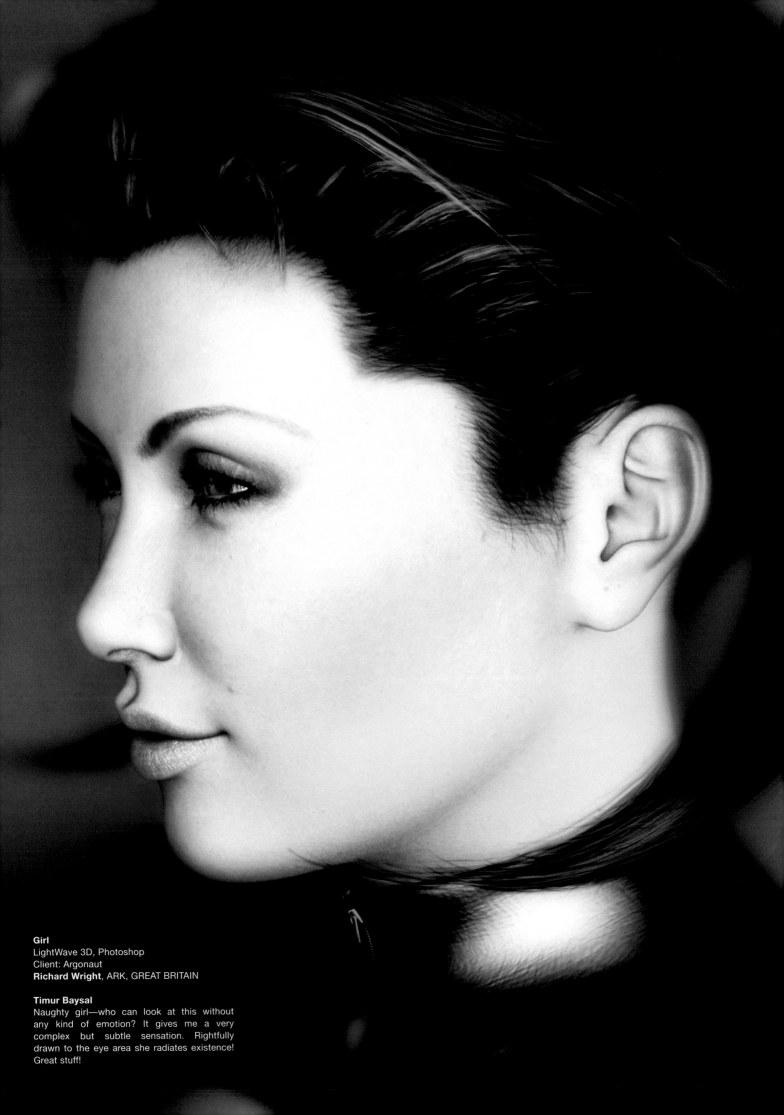

Girl
LightWave 3D, Photoshop
Client: Argonaut
Richard Wright, ARK, GREAT BRITAIN

Timur Baysal
Naughty girl—who can look at this without any kind of emotion? It gives me a very complex but subtle sensation. Rightfully drawn to the eye area she radiates existence! Great stuff!

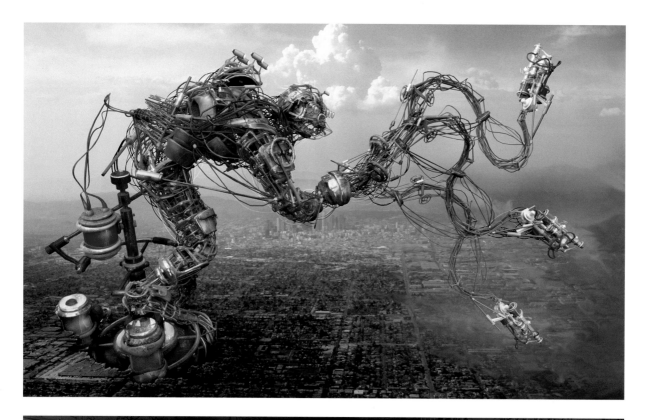

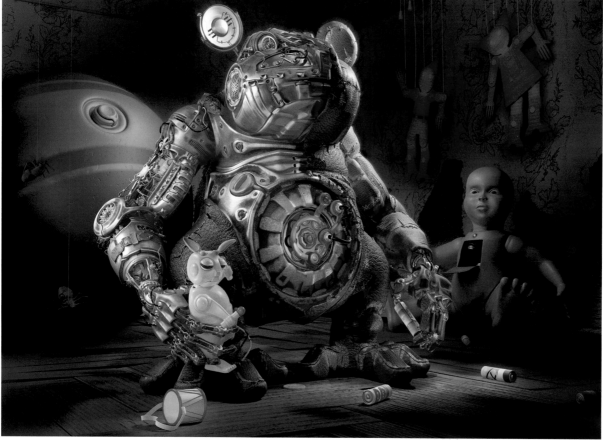

Metals
ZBrush, Photoshop
Meats Meier, USA
[top]

Timur Baysal
Playfully surreal, yet oddly confident, this image shows the ever present uniqueness of Meats' style—I always want to reach in there with pliers and cut some cables. What's great here is that you can't quite tell whether this robot destroys or creates.

Meh Gorilazzz
3ds Max
Juliy Trub, International Art Found, RUSSIA
[above]

Timur Baysal
What a neat kind of inspiring complexity and strength. I find this image very compelling and almost relaxing to look at. It's the nightmare of a child after having watched too many commercials between a 'Twilight Zone' episode.

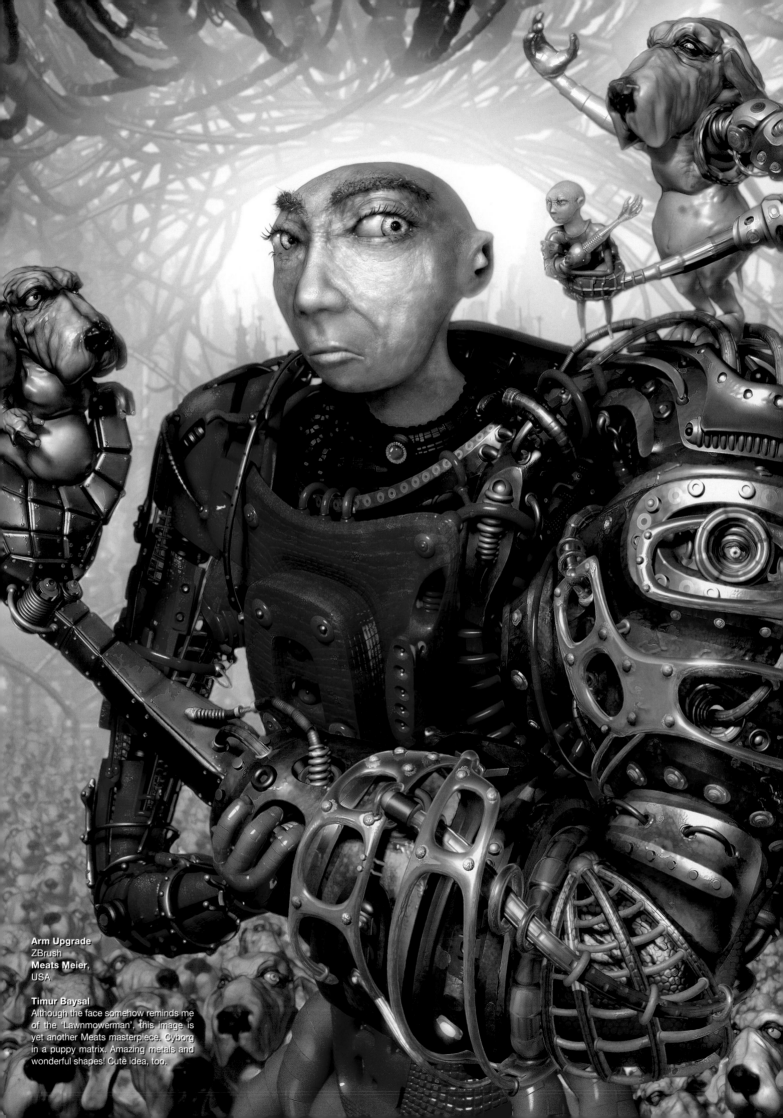

Arm Upgrade
ZBrush
Meats Meier,
USA

Timur Baysal
Although the face somehow reminds me
of the 'Lawnmowerman', this image is
yet another Meats masterpiece. Cyborg
in a puppy matrix. Amazing metals and
wonderful shapes! Cute idea, too.

ZACK PETROC

Zack Petroc has a Bachelor of Fine Arts degree from the Cleveland Institute of Art with a major in Sculpture and dual minor in Drawing and Digital Media. Additionally, he studied anatomy at Case School of Medicine and figure sculpture in Florence, Italy. Zack uses his strong design background as the foundation for both his traditional and digital work. Zack is currently working as a freelance Art Director and Concept Designer for feature film and games. He is also a member of the Art Director's Guild Technology Committee and author of several training DVDs from The Gnomon Workshop.

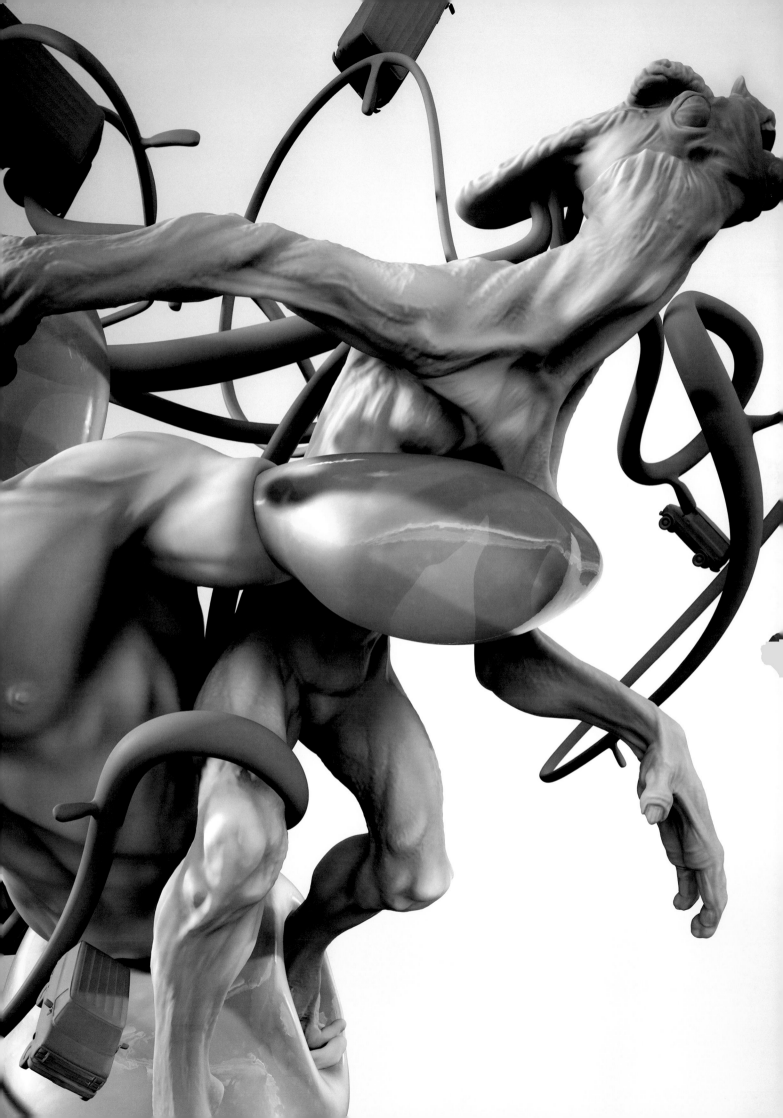

CONTENTS

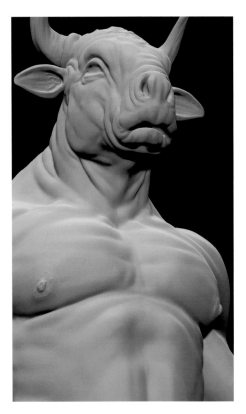

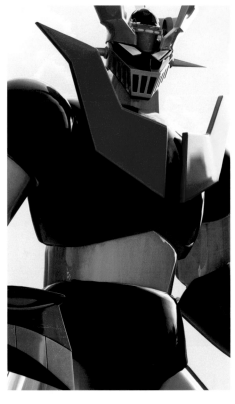

**Zack Petroc
Gallery**

134

**Zack Petroc
Tutorials**

142

**Zack Petroc
Invited Artist Gallery**

170

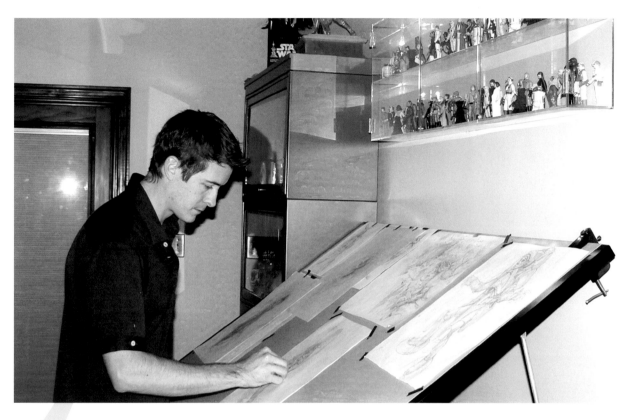

Background

I don't remember a time when I did not love to create. In the beginning, it was drawing. The pictures I made depicted the standard array of scenery your brain finds awe inspiring at a young age. No pretensions about the subject matter here: Star Wars, superheros, miscellaneous alien landscapes, and epic battles. The only point to note about my art at that age might be that my desire to create was omnipresent. It's arguable whether or not some are born with innate skills that will make them accomplished artists; at least in the traditional sense of drawing, painting, and sculpting. I'm of the opinion that your desire to create, not an innate skill, is what truly determines how accomplished your art will become. The stronger your desire to understand the inner workings of any discipline, the more likely you are to stay committed to mastering it. So, what I am truly thankful for is my desire to create art, not my perceived skill at creating it.

During grade school, I transitioned into set building. This was of course on a micro scale. These first attempts at creating worlds and backdrops for my characters (at the time action figures) and narratives would evolve into a life long endeavor. A vast number of Star Wars sagas played out in our rural home and around our yard. Rotted trees with moss placed upon a giant boulder became Endor landscapes, while long winters made it possible to transport an entire armada of Snow Troopers to Hoth. I also had a guinea pig until one abnormally cold February day when my Luke in Hoth gear needed to be kept warm while I built a shelter. You know how that story ends. Actually, the guinea pig was fine, but many men were lost during those epic battles. The little vintage four-inch bastards that I now have to pay hundreds of dollars to replace. In my studio today, it's nice to look up from my monitor or

drawing table to see those same exact symbolic characters, now behind glass, reminding me not to take my own art too seriously. I'm here to entertain, maybe to teach, and hopefully to inspire.

Building on an education

I've said this before but its worth repeating, "I went to Art School to get an education, not a job." For me, a large part of any education is about opportunities and choices. Gaining an understanding of what your school has to offer and creating new opportunities for yourself is an invaluable part of your education. Sure, any good school will offer you opportunities such as inspirational visiting artists or internships for applied arts positions, but you may have to dig deeper to find the ones that best suit you. The influential opportunities I had to discover ranged from cadaver anatomy labs at adjunct schools to developing new internships that gave me access to new digital software.

Opportunities

You'll need to explore and be creative to find opportunities. The way I like to think of it is all the opportunities that will help you achieve your goals already exist. You just need to find a way to envision them. There have been several times when I've defined a goal on paper, as improbable as it seemed at the time, then listed out every possible opportunity that might help me achieve it. If you keep your mind open to the idea, you'll be amazed at the answers you can find, or rather funnel, into your brain. After all, they already exist just waiting to be utilized. All you need to do is go find the appropriate ones to help you achieve your goals. The more you understand what your goals are, the easier it becomes to make the appropriate choices to help you achieve them. There are other choices to make

beyond which opportunities to accept. These choices go back to your level of desire to create. Choosing when your creative day begins and ends is often more difficult than it sounds. As a student, I remember being in my studio from 9:00am to 12:00am (closing time), Monday through Saturday. On Sunday I left at around 8:00pm. The hours were long, but in many ways, being a student provided the quintessential working environment. Somehow, working a much shorter forty- to fifty-hour work week for someone else is much more draining than a ninety-hour work week as a student. After graduation, the difficult part is focusing on your own art after a long workday, when your creativity and energy are completely drained. I believe the answer is 80%. The question: "How many

graduates with fine arts degrees abandon all forms of personal art after graduation?" It's your choice. It's difficult to envision what you would like your life to be. Envisioning the success is fairly easy, but I think I always bypassed the part about understanding the commitment it took to get there. The best approach is not to find a career you think will suite you, but to find a person that has already positioned themselves where you think you would like to be. What will help is to understand what that person's life now entails on a daily basis. How many hours do they spend doing the things they love to do? How many hours are spent managing a situation? Are they creating content for themselves or for someone else? How would that effect you? How much time do they actually spend with their

family? Is that important to you? So, in essence, if you can envision the life of that person, not the career, I think you'll be in a much better position to decide what you really want your life to become. The simple definition of success for me is having control over the choices I make in my life. From choosing the projects I'd like to work on, to choosing when I'd like to spend more time with my family. The more control I have over these choices, the more successful and fulfilled I feel. So, hopefully for you, capitalizing on good opportunities will lead to more freedom in the choices you will have to make.

Transition to a digital media

What can one say about the joys of how your eyes feel after staring at a computer screen for hours on end. Transitioning to a

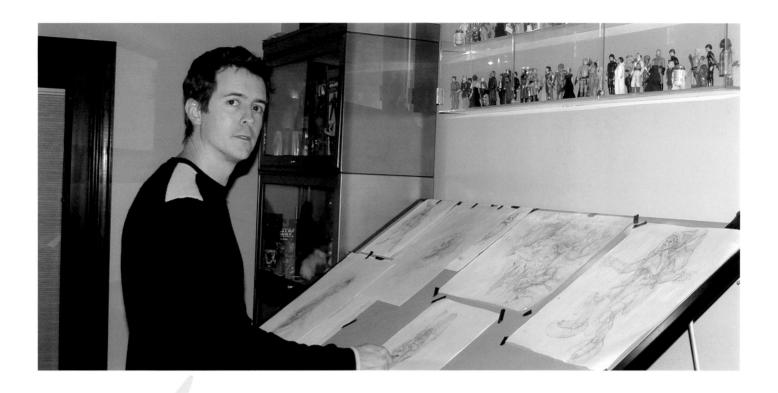

digital medium was not easy for me. It reminds me of those old cliché stories your dad would tell you about walking to school when he was a kid. As the story goes, "It was up hill both ways, through a rocky mountain pass with a rattle snake latched onto his coin-purse." When I was making the transition, there were no online forums, training DVDs, focused education programs, or even teachers for that matter. Just hard work and rattle snakes. Damn it was tough. One of the main reasons why I agreed to spend time creating content for Ballistic was so others could avoid those frustrations. Seeking out technical information necessary to operate a software makes you a better technician, not a better artist. The appeal for me to use digital media was obvious. My work had always been about creating characters and

worlds that revolved around a narrative. I was not focused on materials (wood, clay, metal) or the spaces my sculptures would occupy. A digital solution was my most liberating choice. To clarify the point about sculpture that truly utilizes material and space I would suggest looking into the artists Noble and Webster. Look at the materials they use and how that effects the interpretation of their work. Look for the way they use light and shadow to make the entire space surrounding the sculpture become part of the work. Also, look for the rats. Today with software like ZBrush and Mudbox, the pathway into a digital workflow is extremely accessible. My only caution would be to first make sure it's the right choice for your work. There is an expected pull towards digital media today that stems from their sheer novelty.

If you can first make sure a digital medium is the right choice for your art, then you'll know that investing the necessary time into understanding the software will be well worth the payoff.

The smaller is to the greater as the greater is to the whole

I can't discuss this topic without first mentioning Richard Fiorelli, my second year design teacher at CIA for introducing me to this invaluable concept. This simple principle is often the corner stone of a great design. It refers to how parts of an object relate to the entire object, and how that entire object relates back to its surroundings. A simplified example in terms of art direction would be to think of a character in costume, riding on a creature through a city. Look at the character's costume to see how it relates to the harness on the creature, then examine how

the costume and harness as a whole relate to the city backdrop. If you separate the character from the creature would you be able to visually connect them again? Should you be able to? We can also use this costume example to explore how the language of visual design can help tell our story. If the costume of the character looks disjointed from his surroundings it can immediately inform the audience that he is a visitor, not an inhabitant, even before he speaks. "Hello, me Grignak, you tell how get go Hollywood and Vine?" Yes, this must be a visitor. As the visual disconnect between the character's appearance and their surroundings grows, the greater the amount of perceived tension and foreboding. There are many nuances and exceptions to this rule, but its always a great starting point to help you tune-in your own designs.

Rhythm and proportion

Let's subtitle this section "Avoiding a meat-tube creation". When I'm asked to critique an individual's work, one of the first things that strikes me is their understanding of rhythm and proportion. First, there are many rules about proportion. How many heads high by the 4th of July and so on. I like to think of proportions in terms of how they relate to a character's design. For instance, what do the following proportions of a character say about his personality? The size of the head, the width of the shoulders, and length of the arms are all proportions that evoke specific sensibilities. A smaller head with broad shoulders can make a character seem taller, while larger hands and feet can have the opposite effect. If the choices for specific proportions don't match the

character's personality it can detract from the overall design. The rhythm can be described as the sweeping gesture that flows through a character. There are natural curves and flowing lines that transition across a character creating a sense of rhythmic weight and balance. This is directly tied to the gesture and can help establish a sense of animation or movement even in a static pose. Without the elements of rhythm and proportion your character or creature can look like a grouping of generic meat-tubes devoid of life and personality. If that happens someone might put ketchup on that bitch and serve it up with baked beans. In a nutshell, the more you understand about these two concepts the less likely you are to create a lifeless design.

Defining a few roles

The roles of an Art Director and Production Designer vary from live action, to animation, to game projects. Typically, on a live action project the Production Designer is at the top of the visual food chain. He or she represents one point of the creative triangle, with the Director and Director of Photography (DP) representing the remaining two. A live action production can have several Art Directors under the Production Designer who are responsible for a variety of tasks. The focus of an Art Director can vary from concept creation to the production of sets and costumes. In animation, the top visual seat can be titled either Art Director or Production Designer. It's only a matter of semantics. In both cases, some of the main responsibilities focus on overall mood and

tone of the film through color, light and design (akin to the responsibilities of a live action Production Designer). One of the main contributions of the person holding this title is the color script. A visual color diary of the film that echoes and adds to the narrative. In gaming, these creative titles and roles are still fleshing themselves out. More and more game studios are adding Art Directors to their staff in an effort to get one step closer to usurping film design. Due to the fluidity of these various hierarchies it can take a while to wrap your head around all of the intricacies of who does what; particularly since each project will tend to divide responsibilities differently. I hope this helps you define what role you might be interested in achieving, and perhaps lets you attach a potential title to a career goal.

Sculpture: Two larger then life size figures created for Zack's BFA show at the Cleveland Institute of Art.

Digital art direction

As an Art Director in the entertainment industry today, it's hard, if not impossible, to work on a project that does not contain a digital representation of one of your designs, at least in the Action Adventure or Sci-Fi genres. Established Production Designers are becoming more aware of new digital tools, while up and coming Art Directors will most likely look at digital tools and software as their native media. The fundamental asset of an Art Director or Production Designer is their sense of design. Whether it be for characters, sets, or colors. As you've heard before, these new digital tools are still nothing more then new digital tools. They don't teach or improve design. For me, the only poignant aspect of this entire "digital revolution" is this: I don't have to be an accomplished user of any of these new tools, but I do need to understand their potential. When this happens, my designs will be uninhibited.

2D to 3D disconnect

If there is a hurdle in the design processes of creating content for the entertainment industry it would be the disconnect between a 2D concept and its 3D counterpart. The translation from 2D to 3D is rarely direct. The more stylized the design intentions become the more difficult the translation can be. Part of the difficulty lies in the fact that the stylization often happens in a 2D medium which has many different properties and often less limitations than 3D. This has fueled the rise of 2D-3D collaborative design. Although paper is still the most viable starting point for content creation, Production Designers and Art Directors are turning to 3D at a much earlier stage. A 2D hard-edge or architectural design can now be quickly blocked out in 3D using a variety of software. With the advent of programs like ZBrush and Mudbox this process is even applicable to complex organic shapes. At this stage, a tangential process occurs where the 2D and 3D designs can begin to inform each other. This allows the design to live and evolve in its native world of 3D. When this occurs the creative decisions that are made in 2D are done so with a greater understanding of how they will shape the final 3D product.

Joie de vivre

Working as an Art Director in the fluid industries of feature films and games has afforded me the opportunity to meet many talented artists with different areas of expertise. Just when you're feeling like you have a good grasp on what is achievable in a specific area of design you meet someone that forces you to re-calibrate your standards. For this reason, I love the project-based nature of these industries. It forces me to evolve as an artist to keep my skill sets viable. I enjoy projects that need to define a global sense of design, from an entirely new world, to a completely different take on an existing genre. It's great to meet other artists with the same level of desire to create something worthwhile. Working with these types of teams on great projects is where my current interests lie.

Froad concept sketch
Pencil
This drawing depicts the part frog, part toad animal for my 'Art Directing a Digital Maquette' Gnomon training DVD. For me, these quick drawings are still the fastest way to work through design iterations and initial concepts.
[far left]

Froad half pose
Mudbox, ZBrush
I enjoyed discovering "who" this character was. Once I decided what physical characteristics constituted a Froad, I was able to further define the character by focusing on what his specific personality traits might be. It's during this phase of design, be it 2D or 3D, that the real character begins to show.
[left]

Creature drawing
Pencil
This is a design iteration of the animatronic creature that gets strapped onto the Froad's head. It shows one of several head variations that eventually materialized into the more bird-like iteration shown in the adjacent screen capture. The juxtaposition of bird forms in the creature, to the amphibious forms of the Froad, worked well within this character's background story.
[far left]

Creature full pose
Mudbox, ZBrush
When developing any design there is an interesting back and forth that can happen when one incarnation of the design in 2D or 3D begins to influence the other. The advent of intuitive, accessible digital sculpting software like Mudbox and ZBrush have made this dynamic even more beneficial to the design process.
[left]

Froad full pose
Mudbox, ZBrush
In this image, I've taken the Froad from its initial half pose and translated it into a full pose. Starting with a half pose allows me to take advantage of symmetrical sculpting while I develop the forms and rhythms of the character. It also allows me to make more informed decisions when creating the full pose.
[right]

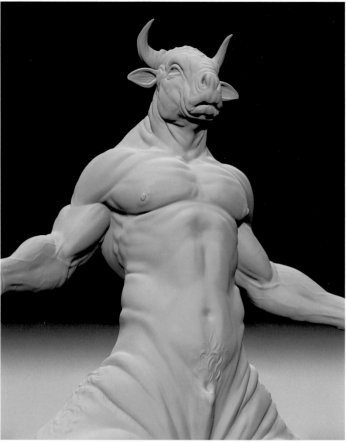

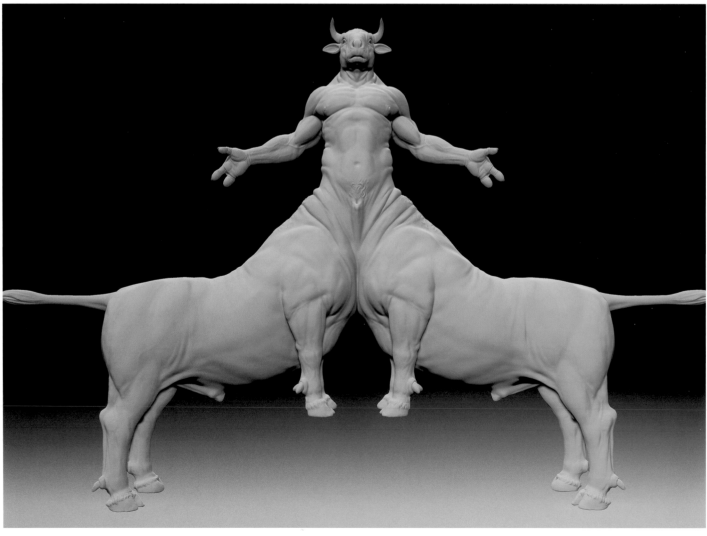

Male anatomy study
ZBrush, Maya
This image showcases the Box Mesh workflow. The Box Mesh approach to digital sculpting was a natural evolution that allowed me to make decisions based on creative choices as opposed to technical factors. I was developing my Box Mesh workflow while simultaneously recording the Gnomon 'Human Anatomy' training DVD. In that respect these training materials can be a great catalyst for solidifying your own techniques.
[far left]

Double-muscled heffer: torso
ZBrush, Maya
The inspiration for this piece came from my love of mythology as a storytelling genre. I've always been intrigued by man's first thoughts of what creatures and beasts would look like. They were often combinations of animals or humans with animal parts; some of history's first super-villains.
[left]

Double-muscled heffer
ZBrush, Maya
Using the thoughts of what a mythological character embodies as a starting point, I found an appropriate and modern twist to that principle in genetically-engineered creations. Those two completely different starting points lead to many of the same design solutions for this character.
[left]

ZBrush banner
ZBrush, Maya
This was a digital sculpture commissioned by Pixologic. The fact that they sought out a commissioned piece with no constraints is a testament to their commitment to developing ZBrush with art and the artist in mind.
[right]

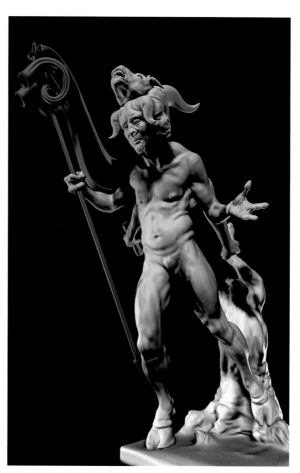

Adam and Eve
ZBrush, FreeForm, Maya
This is a statue design from Totenkopf's gallery in 'Sky Captain & the World of Tomorrow'. I created the piece during our transition to ZBrush so the path to its final completion was a bit convoluted. First, the design sculpt was done in FreeForm, then redefined in Maya, and finally finished in ZBrush. Not many people know that Adam was a "baller" and could rebound like a "mofo". Actually, now that I think about it that might have been a globe in his right hand.
[far left]

Devil statue
ZBrush, FreeForm, Maya
The multi-faced devil statue was my first venture into the world of ZBrush. At the time, I remember being amazed at the level of detail I thought I was achieving. My modeling team said: "Silly American, just wait to see what the future holds."
[left]

Mythological shaman
ZBrush, Maya
The inspiration for this character originated with the mythology of the Native American Indian tribes that were indigenous to the area where I grew up. I enjoyed hearing about their stories of creatures and world origins. From these, I began to question the difference between mythology and religion.
[left]

Black and white corpse
ZBrush, Maya
This was one of my first experiences with completing an entire digital image from design to modeling, texturing, lighting and final render. Note the disjointed ulna, and stitches on his leg from a previous surgery. The flap of pectoralis muscle folded across the upper arm replicates one of my memories from my studies in the cadaver labs at Case.
[right]

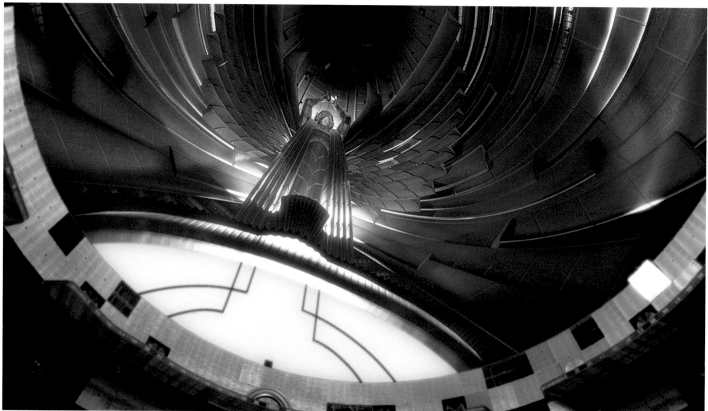

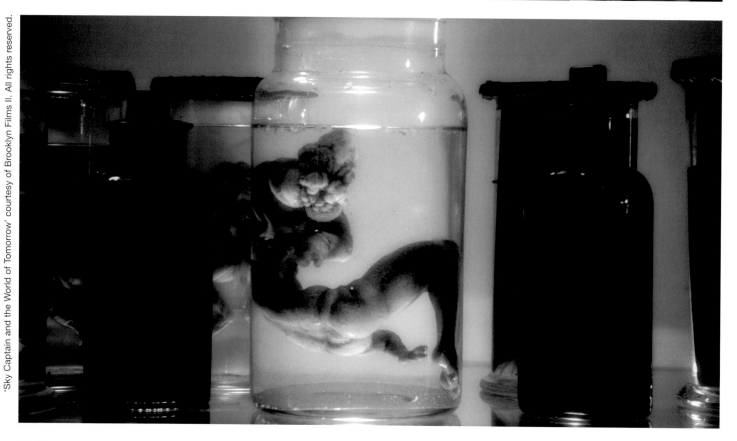

Art deco statue
Zbrush, Maya

The upper recesses of the rocket ship in the final sequence of 'Sky Captain' housed one of the most technically involved figurative models of the production. Creating the interlocking hands that grasped the sword became even more difficult when Kevin Conran, our mastermind Production Designer, came up with the idea of having individual steel panels break away from the statue as the rocket ship careened into outer space.
[top]

Underdeveloped creature
FreeForm

When looking back at this piece, one of the most intriguing aspects was the fact that it was designed as a digital property first, then output as a practical prop to be used on set. This workflow is much more common place now but at the time designing a character digitally then sending it off to a 3D printer was something that even amazed us when it actually worked.
[above]

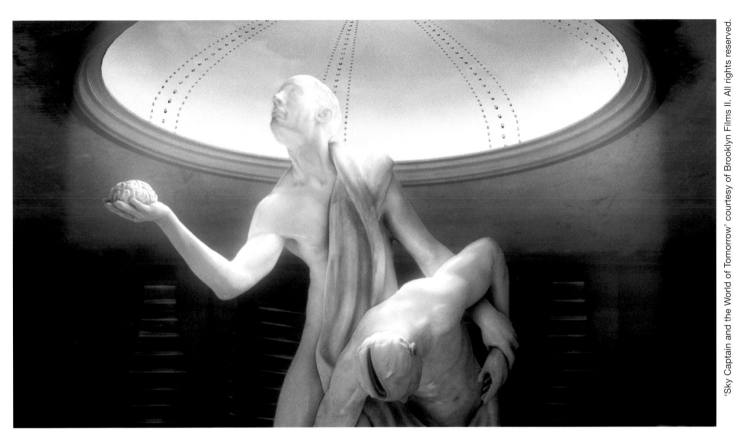

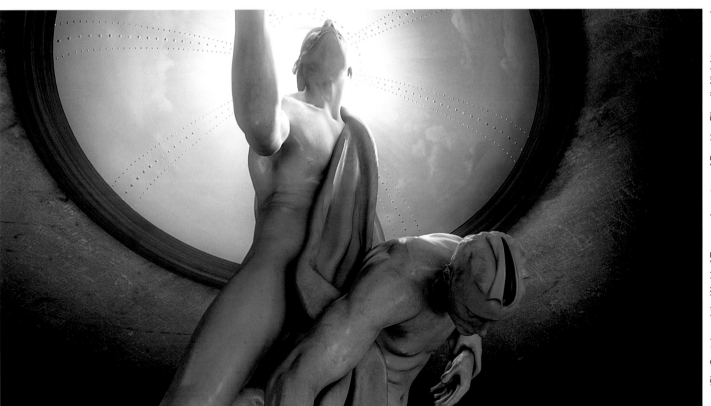

Totenkopf office statue

ZBrush, FreeForm, Maya

Kevin and Kerry Conran had been developing 'Sky Captain' for five years before pre-production began at WOT Inc. headquarters in Van Nuys, CA. With that much time and energy invested, it's hard to believe how willing they were to welcome the creative involvement of others. After reading the script, I asked Kerry if he thought a statue that spoke to the personality of Totenkopf would be appropriate for the yet to be designed office set. I described what I had in mind and his belief in creating opportunities for others set things in motion. WOT Inc. was a rare creative environment that immediately broke down the barriers between the art department and the production team. This freedom allowed us to create an exorbitant amount of assets while maintaining a high level of design integrity. Kerry and Kevin's generosity also inspired a sense of ownership within the entire crew. [above series]

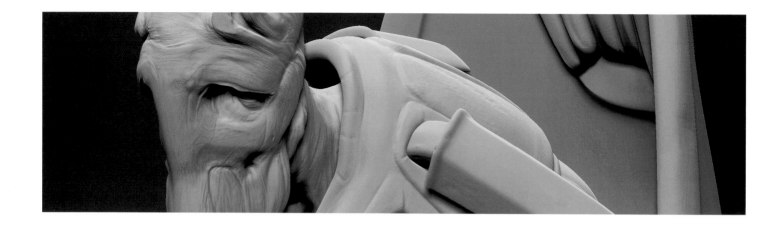

CHARACTER MODELING: CHARACTER CREATION

Starting Point

The narrative is always the starting point for my work. As an Art Director, one of my main responsibilities is to develop a visual language that complements the story. From color to character design, I try to make creative choices with an understanding of how they will impact the story. Before I begin any design, I gather as much information as possible about the world in which it exists. It is important that I consider not only how the environment will impact the design, but also how the design will impact the environment. Defining these parameters, even in the simplest terms, provides a foundation against which I can judge the validity of my design choices.

The story

In order to allow more time to focus on technique, I wanted to keep the narrative driving this design simple. A disease is causing rapid deterioration in a character's health, and he is searching for a cure. It is a simple plot that establishes character motivation and a starting point for the form development of his overall design. His story can also inform his posture, final pose, and accessory design.

Techniques and tools

My approach for creating a design sculpt is to start with a rough representation of the form and gradually refine the details

and design. I find the gesture and rhythms first, then refine the proportions. A large percentage of my sculpting will be done with the Scratch brush in Mudbox. I set the strength to a low level in the beginning and decrease the strength as I incrementally divide the mesh. Throughout the process I use a combination of the Move, Push, Pull, and Smooth tools to manipulate the form. As a general rule of thumb, I use Scratch to sculpt, and Move to reposition the topology. I also use Pinch and Bulge to accentuate creases and folds.

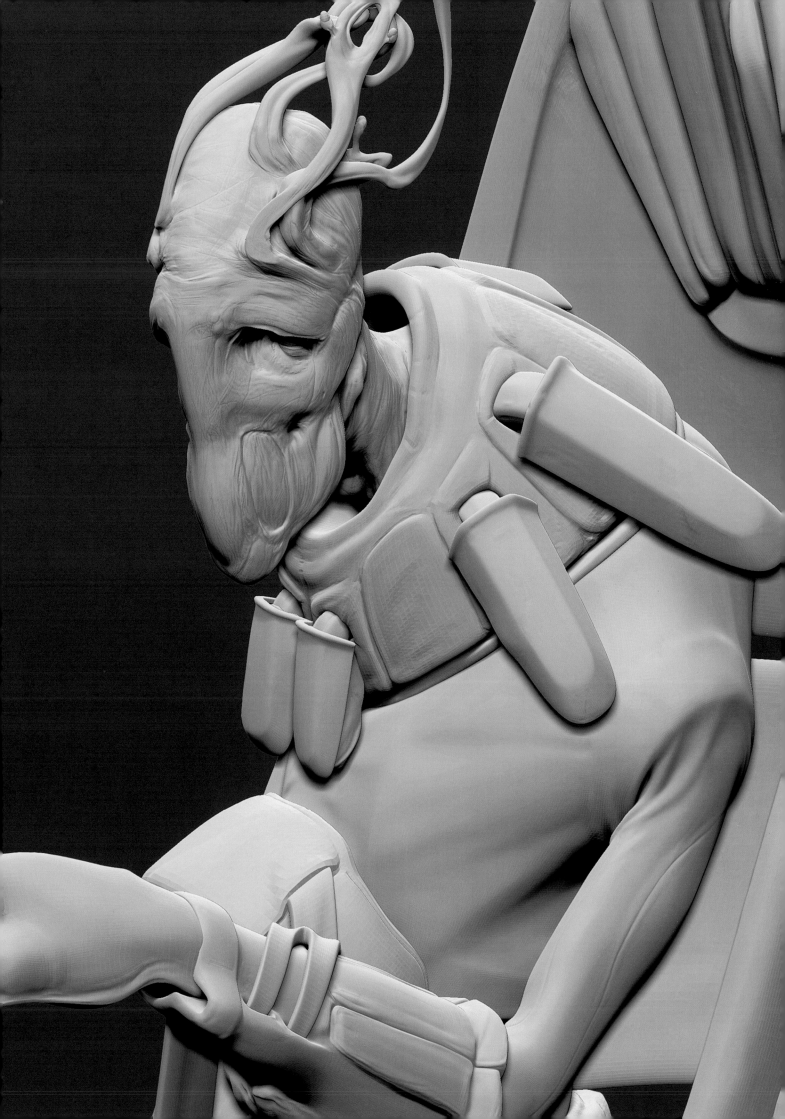

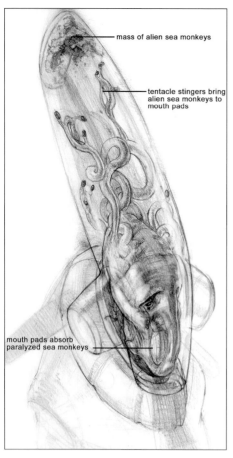

Concept sketch

For me, paper is still the fastest way to work through design iterations. I begin by creating several rough sketches that represent a variety of design potentials. Next, I create a more detailed sketch that refines a direction. In this example, I wanted something that conveyed more subtle personality traits as opposed to over the top emotion. I also incorporated cloth and other materials into the design to showcase a variety of challenges you might encounter when creating a design sculpt. I also use the 2D concept stage to illustrate specific ideas about how parts of the character might function. Due to the "alien" nature of this character, I wanted to clarify what is happening within his helmet. When possible, I like to have a few design variations to pull from while I am creating the sculpt. Therefore, the head in this sketch was a slightly different design.

Blocking in the base mesh

I block in the base mesh by creating low-resolution shapes that will become high-resolution objects during the Mudbox sculpting phase. In some cases, like the collar, the low-resolution objects act only as a place holder while I refine the design.

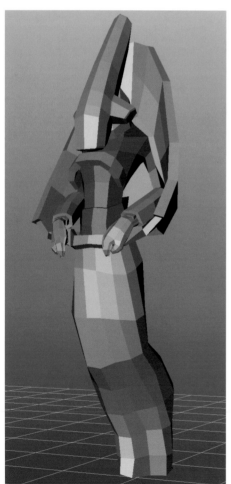

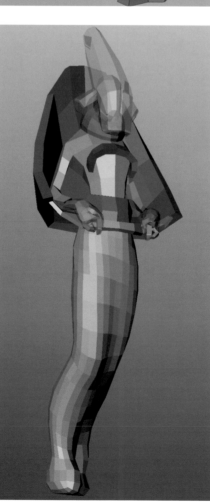

The half pose

Instead of starting with a rig-friendly pose for the concept sculpt, I tend to start with a half pose. The half pose is a symmetrical pose that captures as much of the character's personality as possible. This allows me to take advantage of symmetrical sculpting while getting a better sense of how the emotion of the character is reading. Note the transparent material added to the helmet and gloves.

The gesture pass

During the gesture pass I try to focus on the entire form. When a character has multiple costume pieces I evaluate how they flow together to create an overall shape.

Rough in the torso

Building on the gesture, I begin to pull out the muscle masses and supports that define the overall silhouette of the character's upper body. I liked the idea of having a small frail torso surrounded by supports that made him appear broader at first glance. The cloth of his suit stretches over the supports.

Rough in the head and hands

For me, the key to getting good results when I sculpt heads and hands is not to divide the meshes too quickly. Staying at a lower level of subdivision allows me to focus on the forms as a whole and how they relate to the body. Often, the placement and size of the head can often tell more about a character than its features.

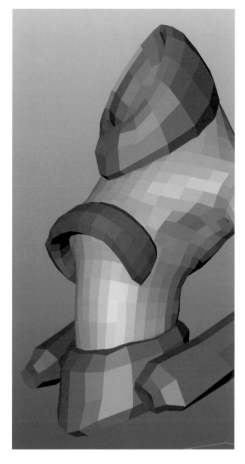 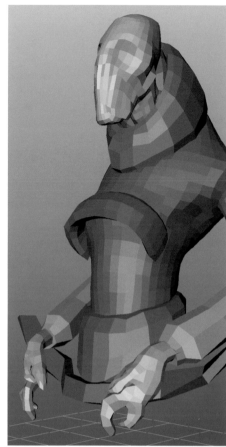

Rough in the gloves

The gloves consist of two parts, the upper ridged form and the lower flexible material that cover the hands. I wanted the lower flexible material to remain round and full to make the character's grasp seem less intrusive. At this stage, I used the upper form mesh as a place holder. I wanted to explore size and proportion to see how the glove related to the arm and fit in the floating back support. I didn't want to look at any details yet, so I kept the subdivision level low while I explored the form development.

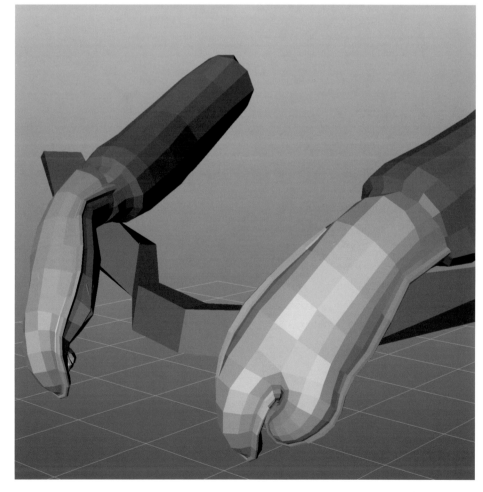

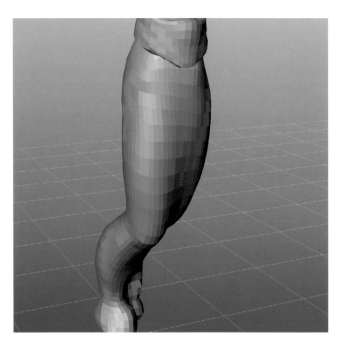

Rough in the legs

To add a different challenge, the leg mass was intended to be an abstract material. I wanted it to have the sensibilities of a heavy flowing gas mixed with the properties of cloth. I also wanted it to have forms that suggested anatomical landmarks of legs and feet. Whenever I deal with a new form like this one, it inevitably takes a few iterations, during both the sketch and sculpt phases, to arrive at the appropriate solution.

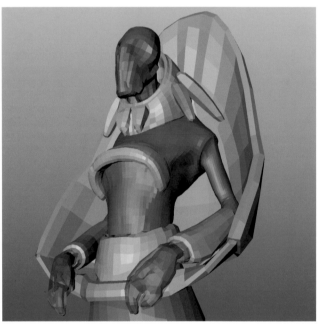

The miscellaneous accessories

In an effort to keep all parts of the model at the same level of development, I roughed in the collar, collar attachments, back support, and chest plate. When the individual parts are at different levels of development, it can be difficult to evaluate how they relate to one another.

Who is the character?

Once I define what the character is, I can move on to the more important question. Who is the character? Who the character is refers to their specific personality type. It is not how they are perceived, but how they perceive things. The answers to those questions will definitely add to the development of my character. To help define who this character is I wanted to think of him in a routine situation. Thinking about the types of objects he might interact with helped me create a more complex understanding of his personality. In this case, he had a thermos filled with chicken soup and maybe space crackers.

Add the tentacles

As opposed to the rest of the head, the tentacles needed to be asymmetrical from the beginning. I added them as a separate object so I could continue to sculpt in symmetry as I developed the rest of the head.

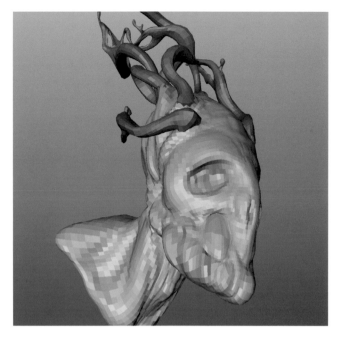

Combine the tentacles and head

When I arrived at a comfortable state with the overall design of the head, I was ready to start asymmetrical sculpting. At this stage, I combined the head mesh with the tentacle mesh to refine the transition between them. For further technical details on this topic refer to my next tutorial. I am always amazed at how much you can change a face before the asymmetry is noticeable. I changed the bone structure, jawline form and superficial skin details in this example. I might need to change it even more before I'm finished.

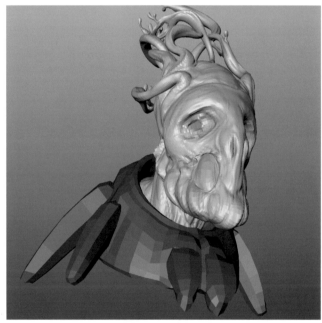

Adding the eyes and stingers

First, I exported a high-resolution version of the head from Mudbox. Next, I imported it into Maya to use as placement reference for the eyes and stingers. The eyes and stingers were combined respectively to create two meshes. Fewer meshes keep the Mudbox scene more manageable.

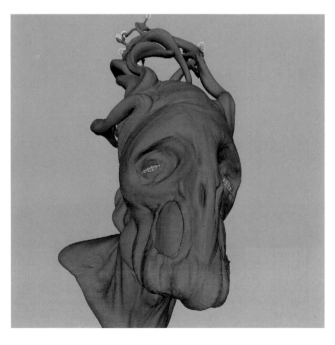

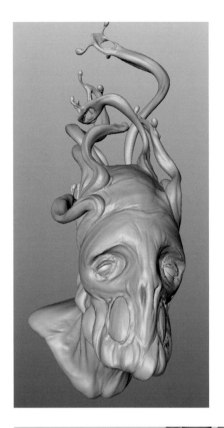

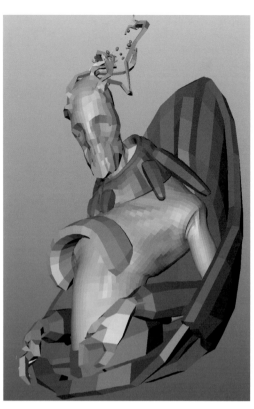

Import eyes and stingers as new objects

With the eyes and tentacle stingers in place, I now had all the necessary elements to judge the face's design. Again, understanding who this character is will play the largest role in critiquing the effectiveness of the design.

Pose the head

Learning when to use functions that only digital sculpting affords and when those same functions are limiting your creativity is an invaluable lesson. I began sculpting the head centered around the x-axis and looking straight ahead to take advantage of symmetrical sculpting. With the symmetrical sculpting phase of the head complete, I needed to rotate and translate the head to add to the gesture of the half pose.

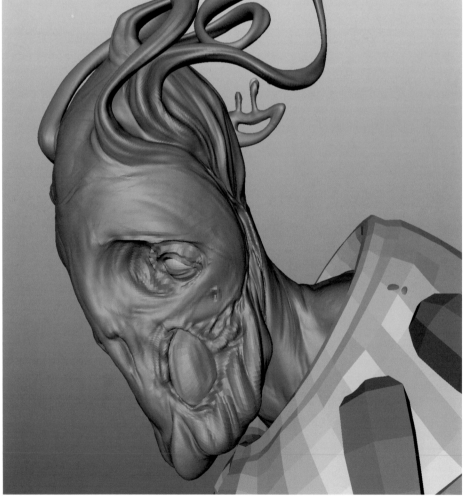

Skin over bone and cartilage

Skin over bone can be very similar to cloth stretched over a ridged object. In this example, notice how the skin stretches out over the large occipital bone. Where the bone ends, the skin tends to wrinkle and fold back onto itself.

Refine the torso and stretched cloth

When sculpting cloth and creating the illusion of an understructure, one of first things I need to determine is the cloth's thickness and how tautly it is stretched over a surface. After determining these two factors, I begin by defining the boundaries of the supporting understructure and other contact points.

Creating the illusion of supports

The second step in creating the illusion of a support structure under cloth is to define the creases and folds. Subtle creases were created between the shoulder, and neck supports and folds were developed under the arms.

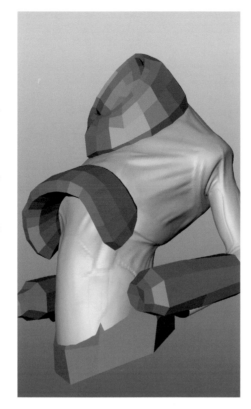 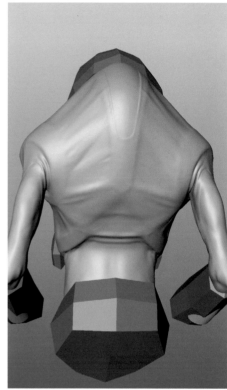

Refine the miscellaneous accessories

In a very free-form way, I have begun to define the details on some of the miscellaneous accessories. Notice how the topology on the chest plate conformed to the design intentions by creating clean lines and forms. In contrast, the collar, and gloves will need to be rebuilt.

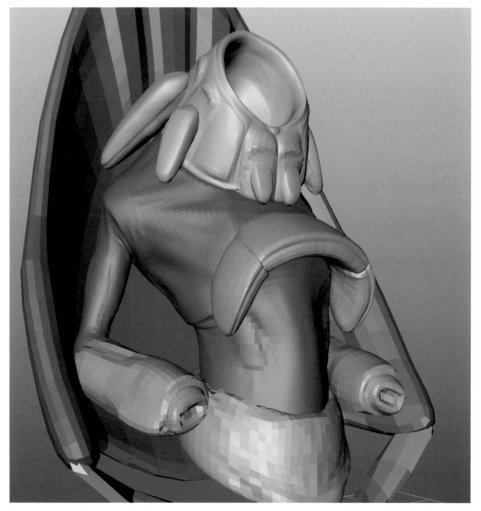

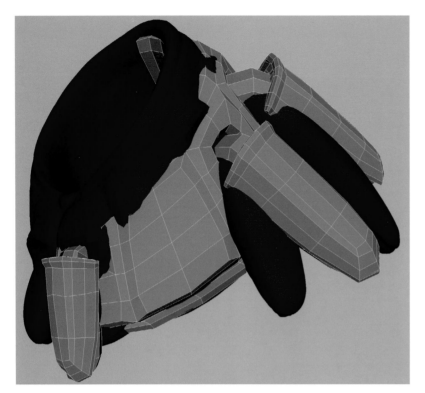

Re-topologize the collar and attachments

I exported the high-resolution collar to use as a template (shown in blue) for the creation of the organized mesh. I rebuilt the mesh with simple edge loops that helped me define the details when I brought it back into Mudbox.

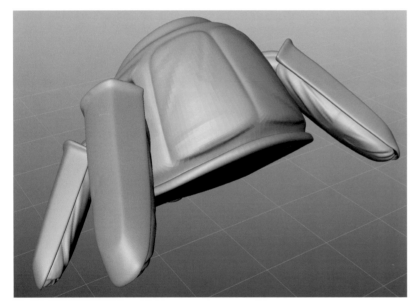

Collar details

Here is an image of the final collar details sculpted onto the organized collar mesh. This is a quick workflow that allows me to explore the form development with an undefined low-resolution mesh, then re-topologize the mesh to take advantage of the edge loops as the design becomes final.

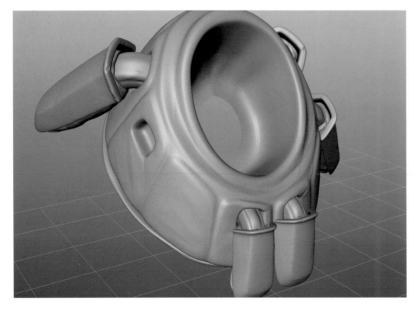

Re-topologize the gloves

I used the same re-topologizing approach on the gloves as I did for the collar. I also wanted to emphasize the frailty of the arms so I added larger pads at the back of the upper glove form. This accentuated the thinness of the forearms. I also brought a low-resolution version of the hands into Maya for glove placement reference.

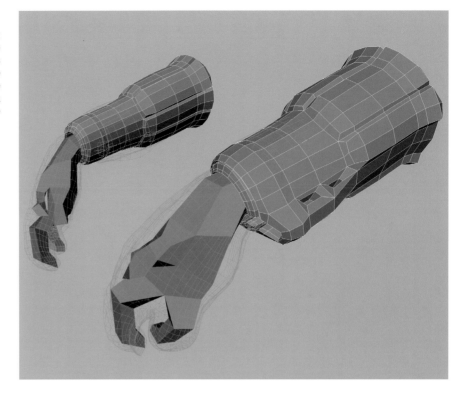

Glove details

This image shows the final detailing of the gloves. I added and defined a channel at the end of the upper form that will accept the lower flexible portion of the glove.

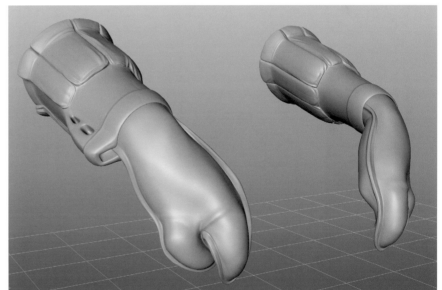

Add a design element

After seeing the character roughed-out in 3D, I decided to add a design element in the form of an arm support that stretched down from the chest plate and attached to the gloves. The freedom to add elements to your design sculpt allows the 3D version to inform your original 2D concept. This gives your concept additional freedom to grow.

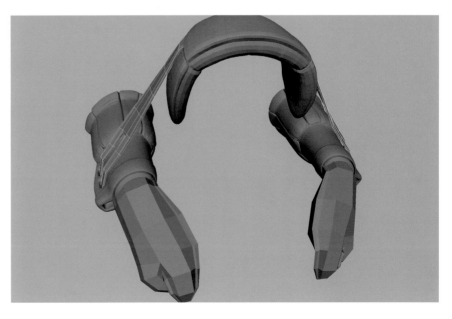

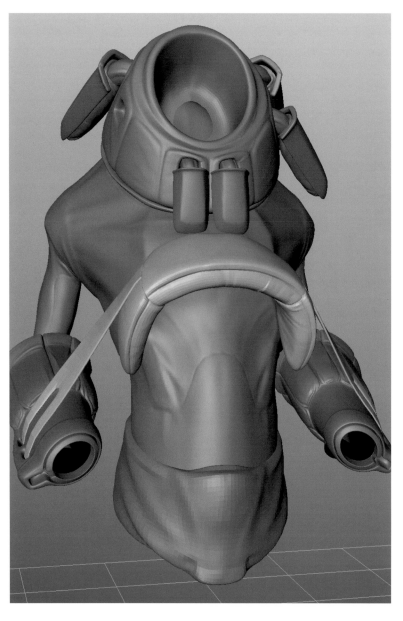

Chest plate details

The existing topology on the chest plate conformed to the design intention which allowed me to bypass the re-topologizing stage. I integrated the new arm supports by adding insertion points under the chest plate's center pad on either side.

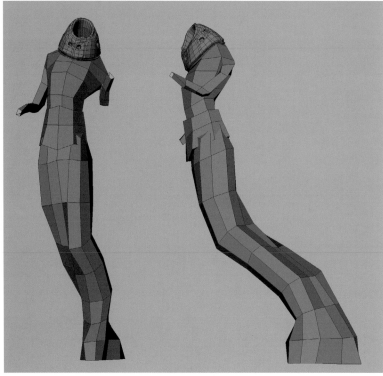

Pose the base mesh

After all of the major elements were defined, I began the posing stage of the concept sculpt. The first step was to establish the core of the pose. This included the torso, hips, and leg mass. I used Maya for this stage because it allowed me to rotate portions of the individual meshes. For example, the lower part of the torso needed to rotate in the opposite direction of the upper part.

Evaluate the core pose

When a figure's shoulders slant in one direction, the pelvis slants in the opposite direction to balance out the weight. This is called contrapposto. Notice how the character's right shoulder is up, and the right side of his pelvis is down.

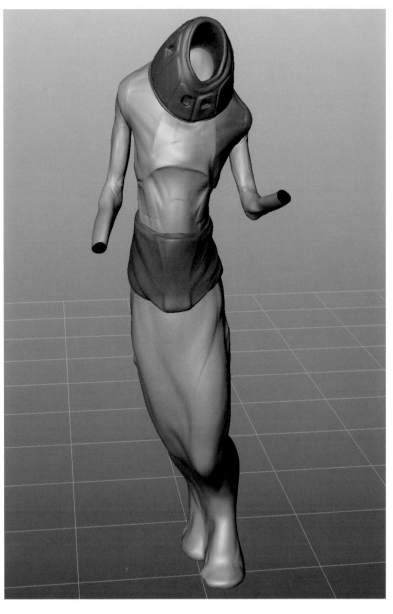

Add the head, gloves and hands

With the core pose complete its a fairly straightforward process to add the head, gloves, and hands. I used Maya for this stage as well so that I could rotate one side of the glove and hand meshes independent from the other side.

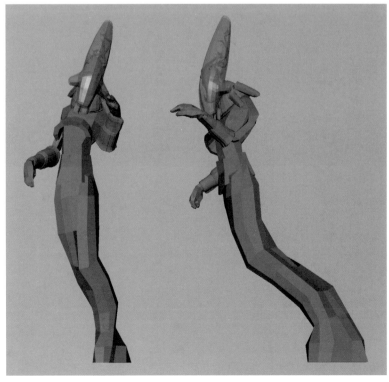

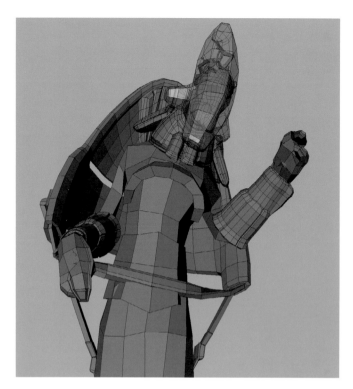

Finished initial pose and accessories

I placed the remaining accessories to accentuate and balance the flow of the pose. In this case, the back support was slightly angled to the left which balances the shift in the character's pelvis.

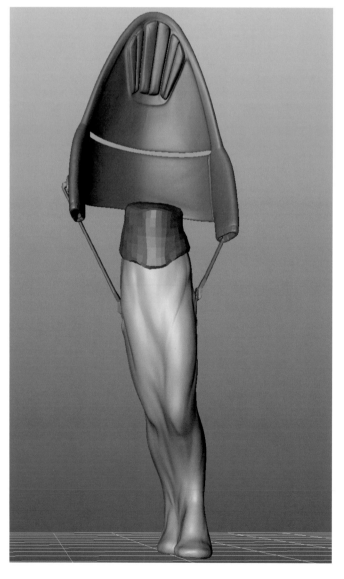

Refine the leg mass

Because of the organic nature of the leg mass, I wanted to wait until the pose was set before I defined the final details. The sweeping lines that flow throughout the form should echo the overall gesture.

Stretching the cloth

I chose to emphasize folds and creases in the cloth that would help accentuate the pose. Using the support structure under the cloth as a starting point, I looked for long angled creases along the character's back that ran parallel to the angle of the shoulders.

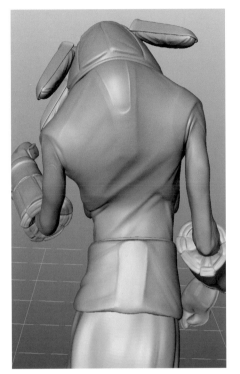 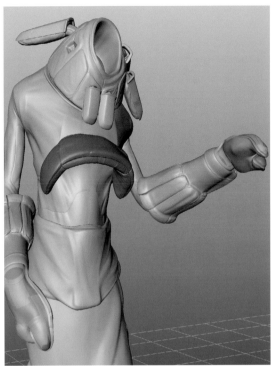

Redefined arm supports

To conform to the pose, the left arm support was redefined in Maya. I chose to make them a thick, somewhat elastic material which meant that folds and other detail would be minimal.

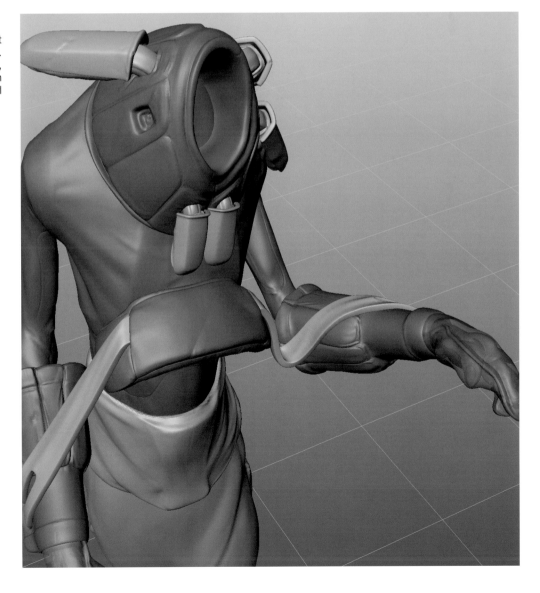

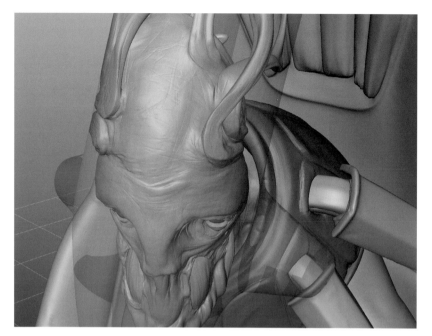

Interaction of surfaces

I like to find areas of a concept sculpt that can showcase interaction of the forms and materials. From the cloth stretching over supports to the arm supports draping over the form of the glove, these were opportunities to add character to my sculpt. In this image, I flattened out areas of the tentacles where they were pressing up against the helmet.

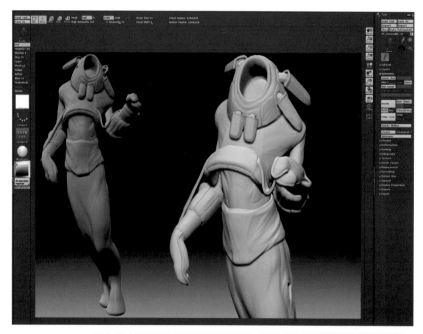

Analyze the body in ZBrush

The ability to analyze a design with real-time lighting and shading is another digital sculpting revolution from the folks at Pixologic. The first step was to select the body meshes and export them as .objs from Mudbox. Next, using the Import option under the Tool palette, I was able to import the body to review the design in real-time.

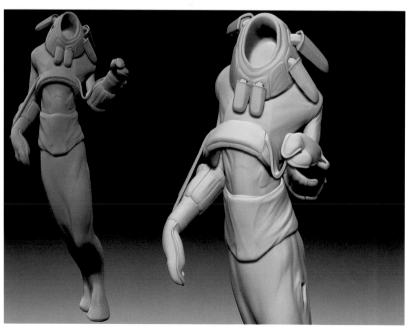

Analyze the head in ZBrush

By selecting specific areas of your mesh and exporting as .obj from Mudbox, you can review isolated areas of your sculpt in ZBrush. After reviewing the head I decided to try a slightly different version to see how it would affect the design.

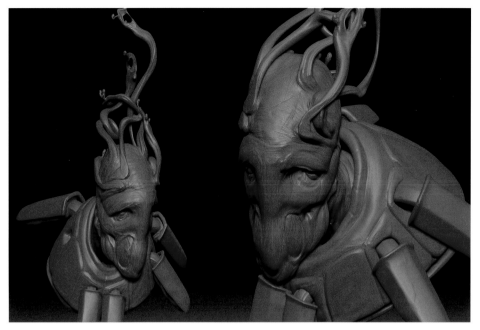

Revised head painting

A common occurrence when creating a design sculpt is to go back and forth from 2D to 3D. This is typically done by two different individuals but if you can develop your skills in both disciplines, you'll posses a powerful pairing that can inform one another and help create a better design.

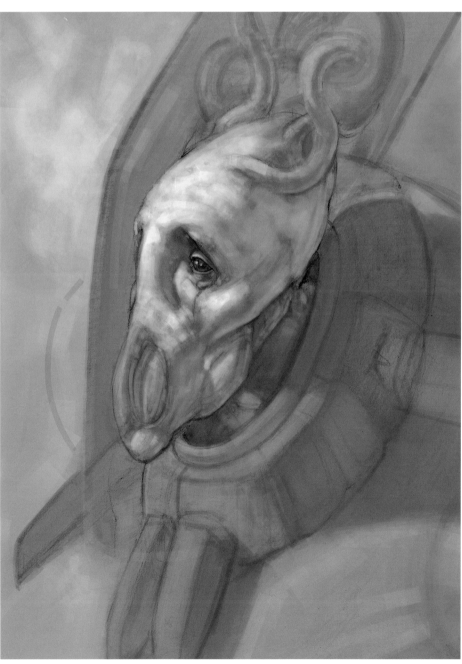

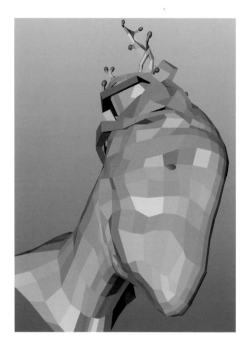
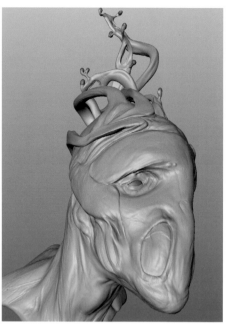

Changing the sculpt (low-res large changes)

After I decided on a slightly different direction for the head, I was ready to implement the changes on my Mudbox mesh. I went to the lowest level of division first which allowed me to focus on the global structural changes of the face.

Changing the sculpt (high-res small changes)

I gradually stepped up through the levels of division, working on the changes from a macro to micro approach. The finite details stayed largely the same which helped to expedite the process.

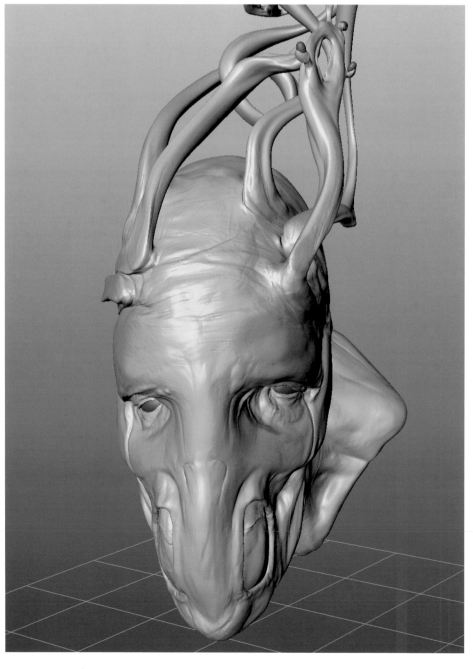

Compare the head designs

There are several ways to compare the two head designs. The most obvious is to import a version as a different mesh and move it off to one side for side-by-side evaluation. To use Mudbox to its full advantage I like to import the mesh as a layer and use the Transparency slider bar under the Layers tab to transition back and forth between the meshes. To do this I began by exporting the new version of the head at its highest level of division.

Import as Layer

The next step was to open the file containing the first head version. The designs were created from the same base mesh which means their point orders are still identical. I used this to my advantage and imported the second head design mesh as a layer on top of the first head design mesh. I could then use the Transparency slider bar to transition back and forth between the two for evaluation. Don't forget to make sure the mesh you are importing onto is set to the same level of division as the mesh you are importing. For further technical details on this topic, refer to my next tutorial.

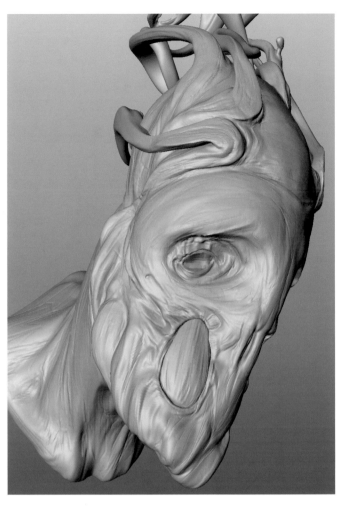

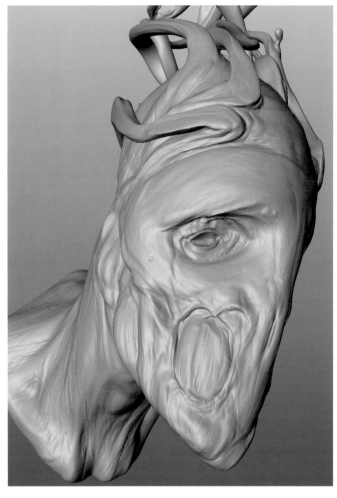

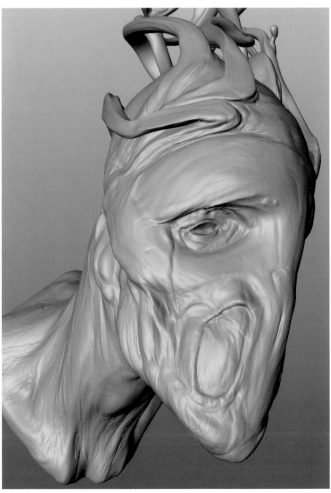

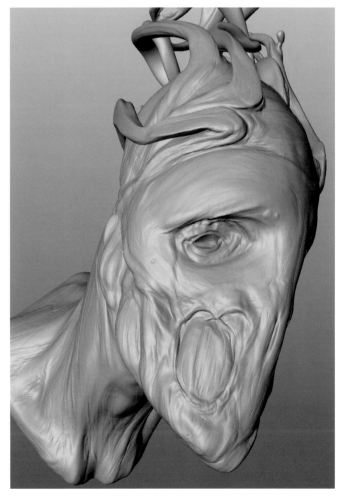

Back to ZBrush

The final step was to review the sculpt in ZBrush with real-time lighting and shading. To do this, I selected the entire mesh in Mudbox and exported a single .obj object. As in previous steps, I imported the .obj and applied a few different shader materials for final evaluation.

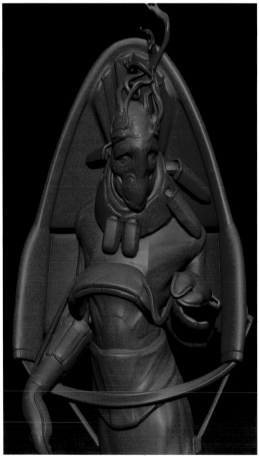

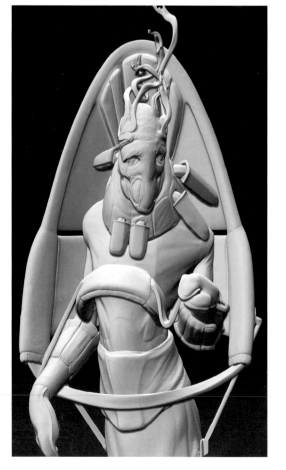

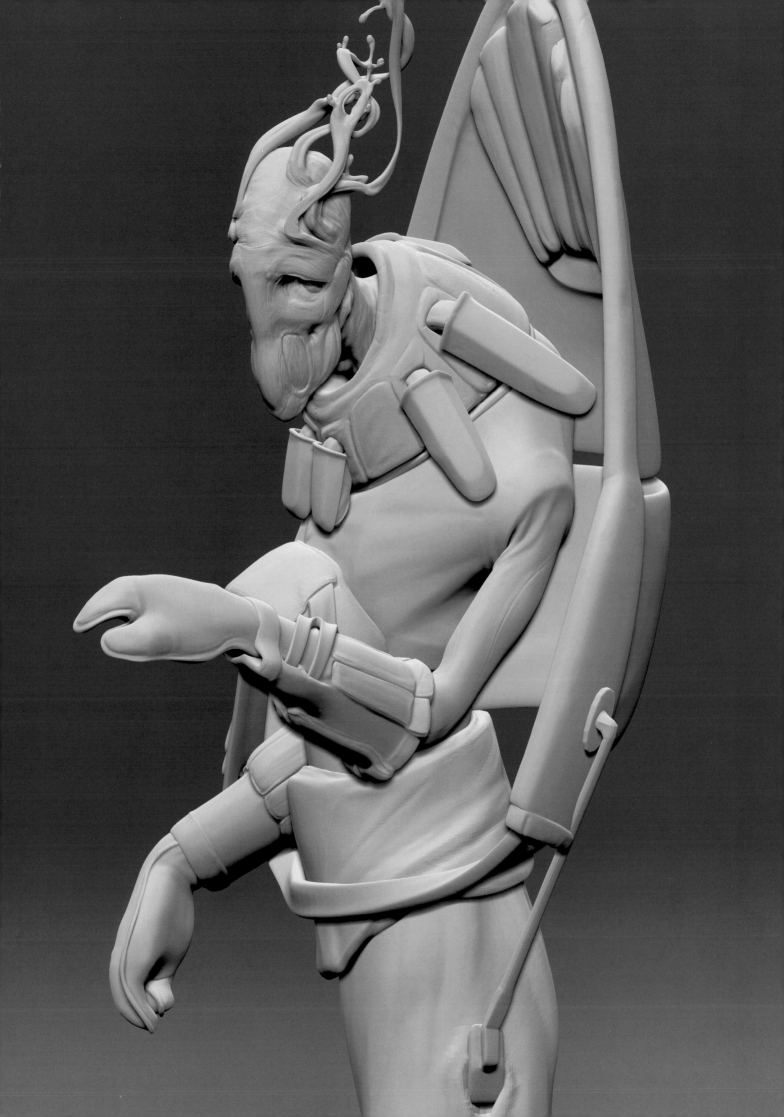

CHARACTER MODELING: WORKAROUNDS

Technical limitations

With any new technology, there are limitations. Overcoming these limitations can mean the difference between a design that represents your complete vision and a design that was compromised. I chose to present these technical tutorials separate from the character creation tutorial to allow for a more focused look at the individual steps.

Leveraging software

One of the best things that has happened to ZBrush is Mudbox. The friendly competition between these two applications will prove to be a key factor in the evolution of high-poly sculpting. They are both great programs that represent different and effective approaches to high-poly sculpting.

Due to the nature of their beginnings, each possesses a drastically different interface and overall approach to digital sculpting. Each excels in its own way and offers unique toolsets to accomplish creative visions. As with all of my endeavors, I came across these techniques that utilize both programs, in an effort to facilitate a more creative workflow. I tend to only come across these new solutions when I run into a technical roadblock that inhibits my design. In this case, necessity breeds solutions. The following tutorial presents techniques for circumventing specific limitations when creating a design sculpt, but also contains the steps to take a model from Mudbox to ZBrush and back. A general tip to bear in mind when

transversing these two applications is that, although it might not be visually apparent, they often do things in slightly different ways. For example, when dividing a mesh ZBrush orders the new points in a different way than Mudbox. This explains why dividing the same mesh in ZBrush and in Mudbox, the same number of times, will not create a compatible mesh. Using the UV information is one work around to this limitation and is presented here.

Terminology

In the following tutorials I refer to the "detailed mesh". This is the divided, sculpted mesh in Mudbox.

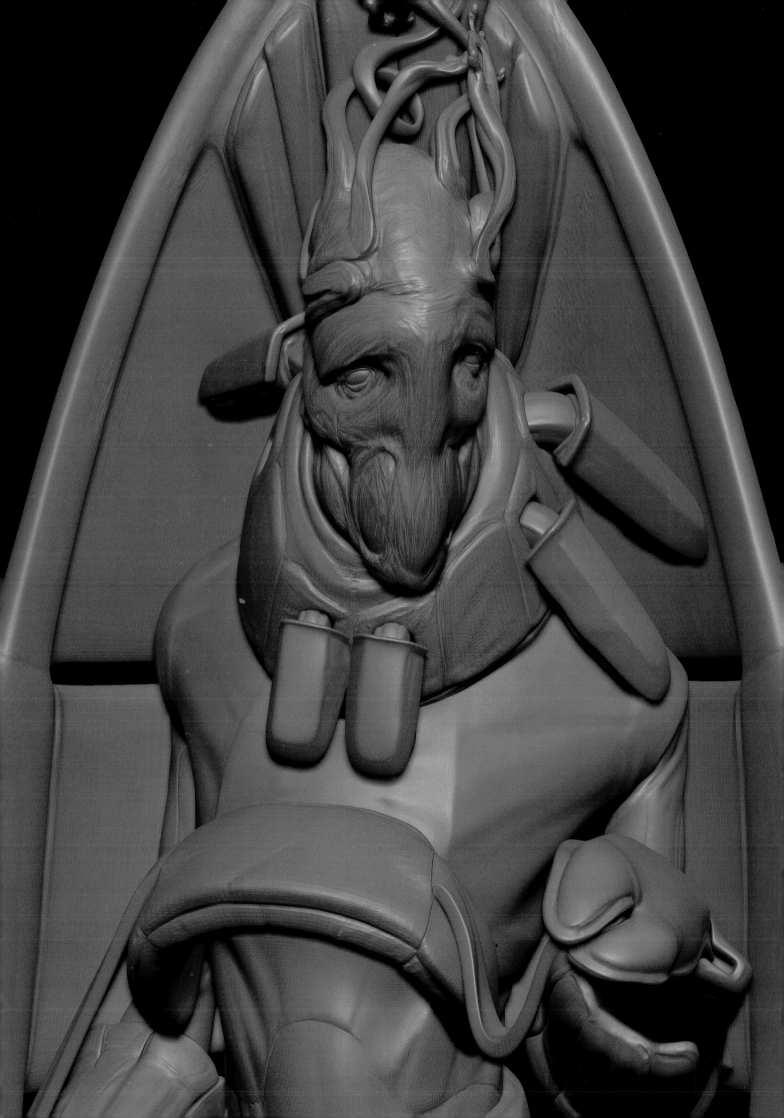

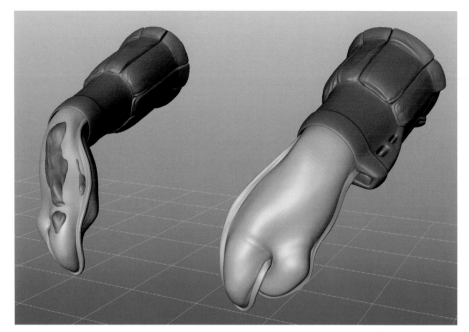

Mirror on non-connected meshes

I have come across several situations where I needed to mirror a mesh that was not connected at the center line. In this example, the glove on the right side of my character has become deformed and penetrates the hand. I have sculpted details on my left glove that I want to apply to the right glove but cannot mirror across the center line on unconnected meshes. The following is a work around to this problem. The only limitation is the file size your poly editing software can handle.

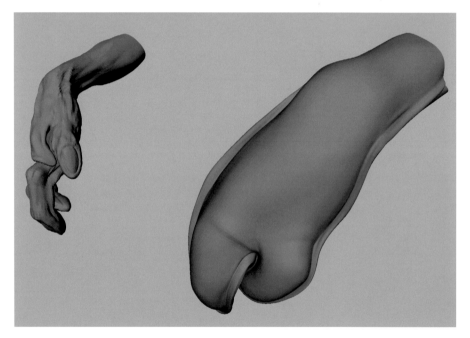

Get rid of the problem (delete bad half)

The first step is to export the gloves from Mudbox at their highest level of division as an .obj mesh. After Importing the high resolution .obj mesh into Maya, I separate the pieces and delete the bad half. For this example, I also imported a medium resolution version of the hand mesh to check for intersection while creating the new glove.

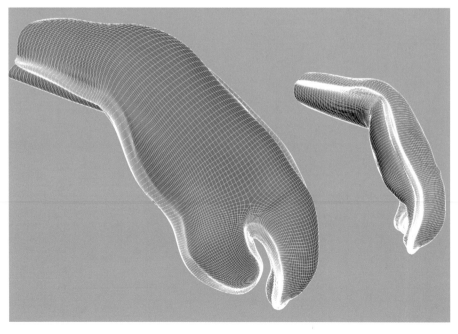

Re-mirror the glove

I mirror the good glove across the x-axis and use Poly Combine to create a single mesh. With the hand mesh in place I can visually check for penetration with the new glove mesh.

Use ZBrush to create new assets

Export the new high resolution mesh from Maya as an obj. then import that mesh into ZBrush. In ZBrush, under the Tool palette, expand the Geometry tab and select Reconstruct Subdiv Surface. Take the mesh down to sDiv1 (the lowest division level) and under the Tool palette expand the Texture tab and select AUVTiles. Export the mesh at both its lowest level of division and at its highest level division. You now have a low-resolution mesh and a high-resolution mesh with matching UVs. Take note of the poly count on the high resolution mesh. You will need this information in the next step.

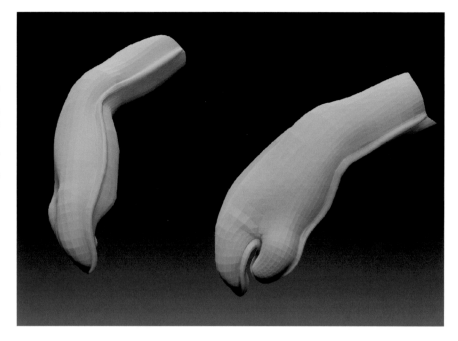

Import the low mesh with UVs into Mudbox

In Mudbox, delete the old gloves then import the lowest level mesh you exported from ZBrush in the previous step. Divide that mesh until it matches the poly count on the highest mesh you exported from ZBrush. In this example, I needed to subdivide the mesh four times. Select the mesh then under the Mesh tab, select Recreate Level UVs. You should now have a smooth, high-resolution mesh with UVs.

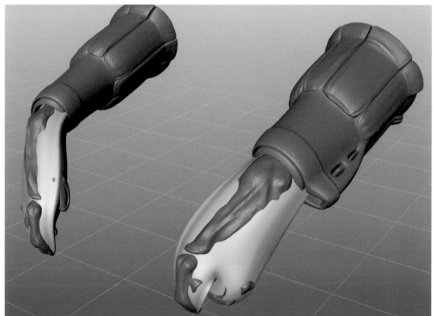

Import Hi UVed as Layer

Select the gloves then under the File tab, select the Import as Layer option. Import the highest level mesh you exported from ZBrush previously. When the Import Options dialog box appears, select the UV Position option and select OK. This will use the UV information on the mesh, as opposed to the point order, to re-create the detail. The mesh should now be symmetrical and correct.

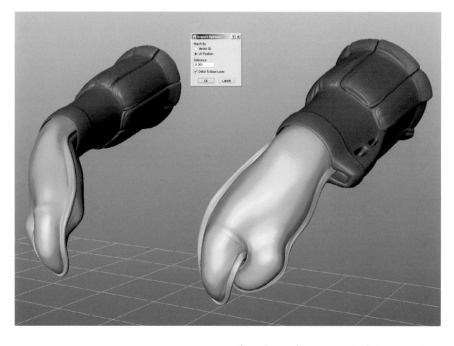

Combining meshes (head and tentacles)

The ability to combine low-resolution meshes and retain their high-resolution detail has many advantages. In this example, I sculpted with symmetry to define the face then combined the face with the asymmetrical tentacles at a later stage.

Creating UVs on the meshes

The first step is to create UVs on the head and tentacles. I begin by exporting the meshes separately from Mudbox. Because the UVs will be temporary, I often apply them in ZBrush by using the AUV Tiles button under the Texture tab, or in Maya by using Automatic Mapping.

Scale UVs in 0-1 space

Before you transfer the UVs onto the detailed Mudbox meshes make sure the UVs do not overlap in 0-1 UV space. To check the UV placement I imported the head and tentacle meshes into Maya, selected them, and opened the UV Texture Editor window. The tentacle UVs were created in Maya using Automatic Mapping, scaled down, and moved to the upper right hand corner in the 0-1 texture space. The head UVs were created in ZBrush and can be seen in the 0-1 texture space laid out in a grid-like pattern originating in the lower left corner of the 0-1 UV texture space.

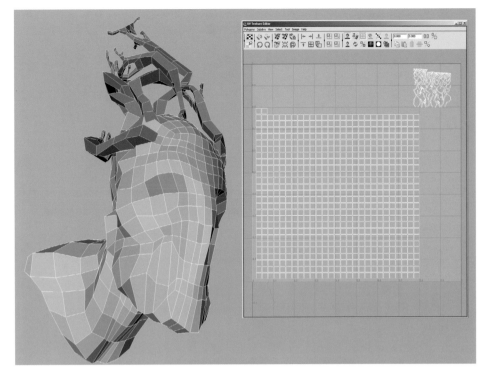

Export original meshes

In Mudbox, step up to the highest level of division on your head mesh. Select the mesh and under the File tab and choose Export Selection. Repeat this process for the tentacles. In the next step, I'll use these meshes to re-apply the sculpted details to the meshes that have UVs.

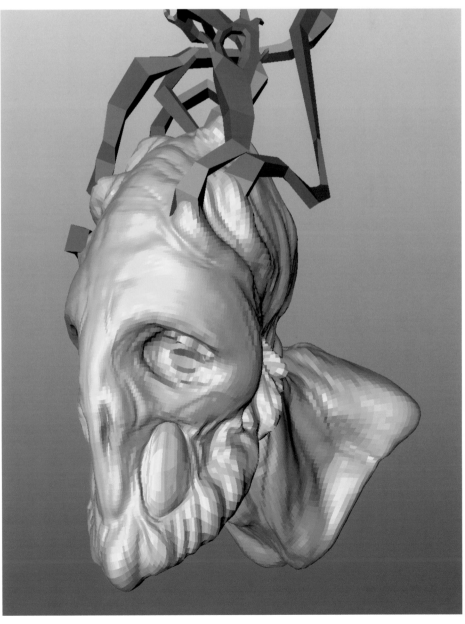

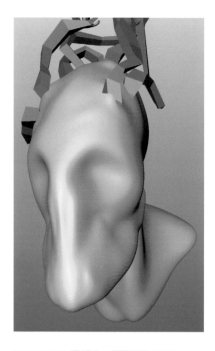

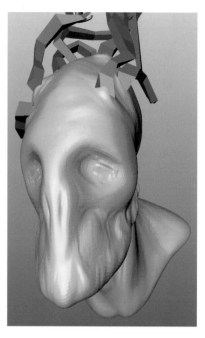

Re-apply the details

Delete the old meshes then import the low resolution head and tentacle meshes that have the new UVs. Take each low-resolution mesh and divide it to a level that corresponds with the number of divisions on the original high-resolution meshes. Select the head mesh, then under File select the Import as Layer option. Import the original high level head you exported from Mudbox in the previous step. Repeat for the tentacles. The meshes should now contain UVs. Export these new high-resolution meshes separately and save them as .obj files. I typically overwrite my previously exported high-resolution meshes to avoid confusion.

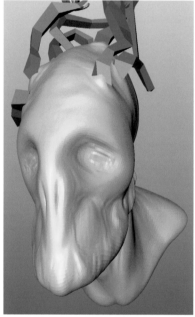

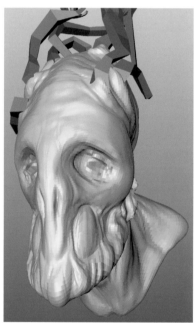

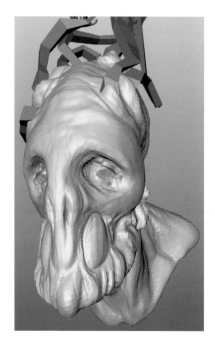

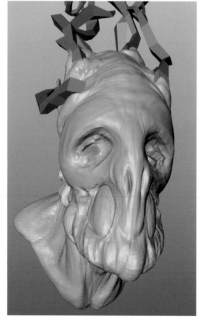

Merge the meshes

In Maya, delete the appropriate faces, snap the vertexes together, and combine the head and tentacle meshes. After combining, don't forget to weld the vertexes between the head and tentacles so the result is one continuous mesh. To achieve a better fit between the tentacles and head, I used the level zero division of the tentacles, and the level three division of the head. This mesh will now be my level zero division in Mudbox. Export this mesh from Maya as an .obj.

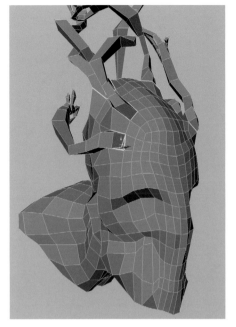
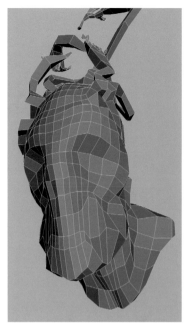

Re-apply details to the combined mesh

In Mudbox, import the combined mesh from the previous step. Divide it to match the number of division levels in the previously exported detailed head. You should now have a smooth, high resolution mesh with non-overlapping UVs. Select the new head mesh and under the File tab and choose Import as Layer. In the Import File box select the detailed head mesh you previously exported from Mudbox. When the Import Options dialog box appears, select the UV Position option and select OK. The head details will import and apply to the new head mesh. The tentacles should stay in place and remain smooth. Make sure the new head mesh is still selected and import the detailed tentacle mesh you previously exported. Use the UV Position option and select OK.

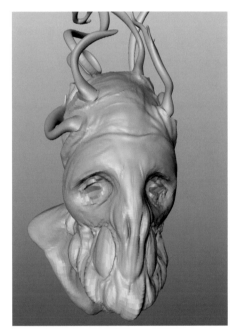
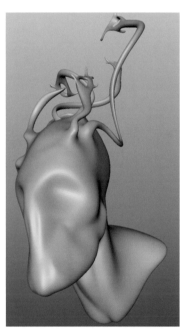

Final combined mesh

The new mesh should now contain the head and tentacle details. If not, I feel your pain. This can be a difficult, unforgiving process to properly execute. The key to its success is in the UVs. Make sure to apply and scale them at the appropriate step. Also take a moment to evaluate their layout and check for overlapping areas in the 0-1 UV space.

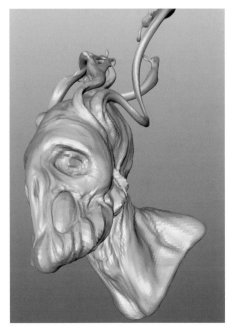
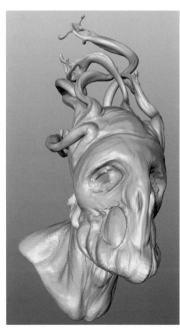

Birdman
3ds Max, ZBrush, Photoshop
Jeff McAteer, USA

Zack Petroc
There are many qualities of Jeff's work that I enjoy. What really pulls me in is his craftsmanship. I admire the way he develops his broader forms then adds subtle accents like skin folds.

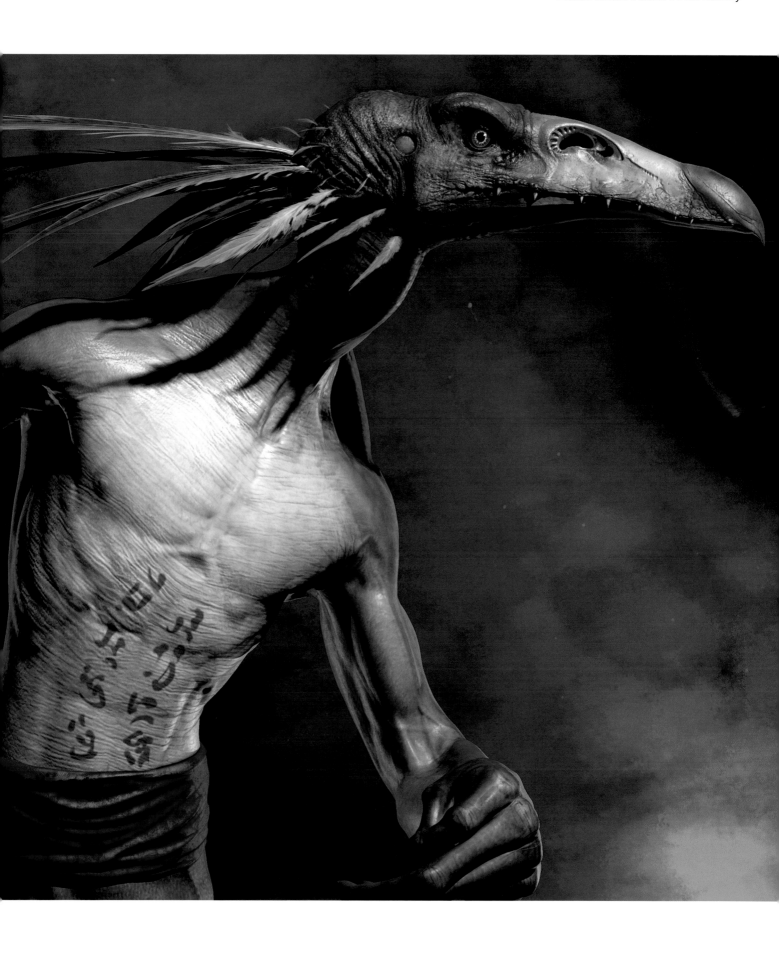

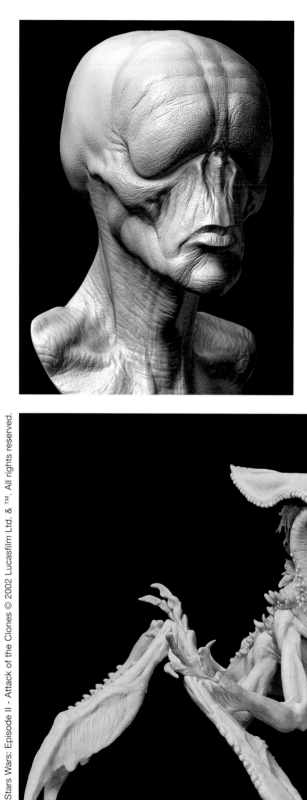

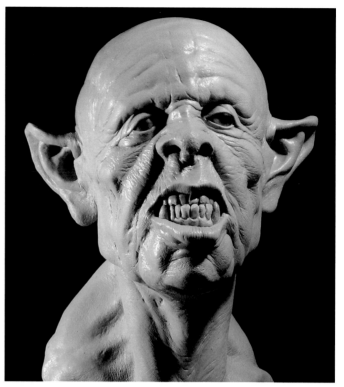

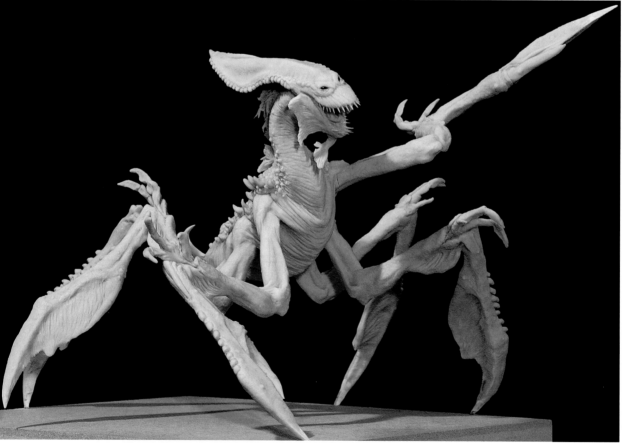

Blind Alien
ZBrush
Scott Spencer, USA
[top]

Zack Petroc
Scott's work has a well-developed sense of structure. This a good example of how invented shapes and forms still find logical places to integrate into the rest of the anatomy.

Acklay: Final design sculpture
Clay
Courtesy of Lucasfilm Ltd.
Robert E. Barnes, USA [above]

Zack Petroc
To invent anatomy of unique origins, while also conveying emotion and action is something Robert does better than anyone I know. Simply put, it is what you want a design sculpt to be.

The Sorrowful Ogre: character bust
Water-based clay
Scott Spencer, USA
[top]

Zack Petroc
This sculpt shows how Scott structures his forms. I can see where his studies are directly influencing his creative decisions as muscles originate and disappear into their insertion points.

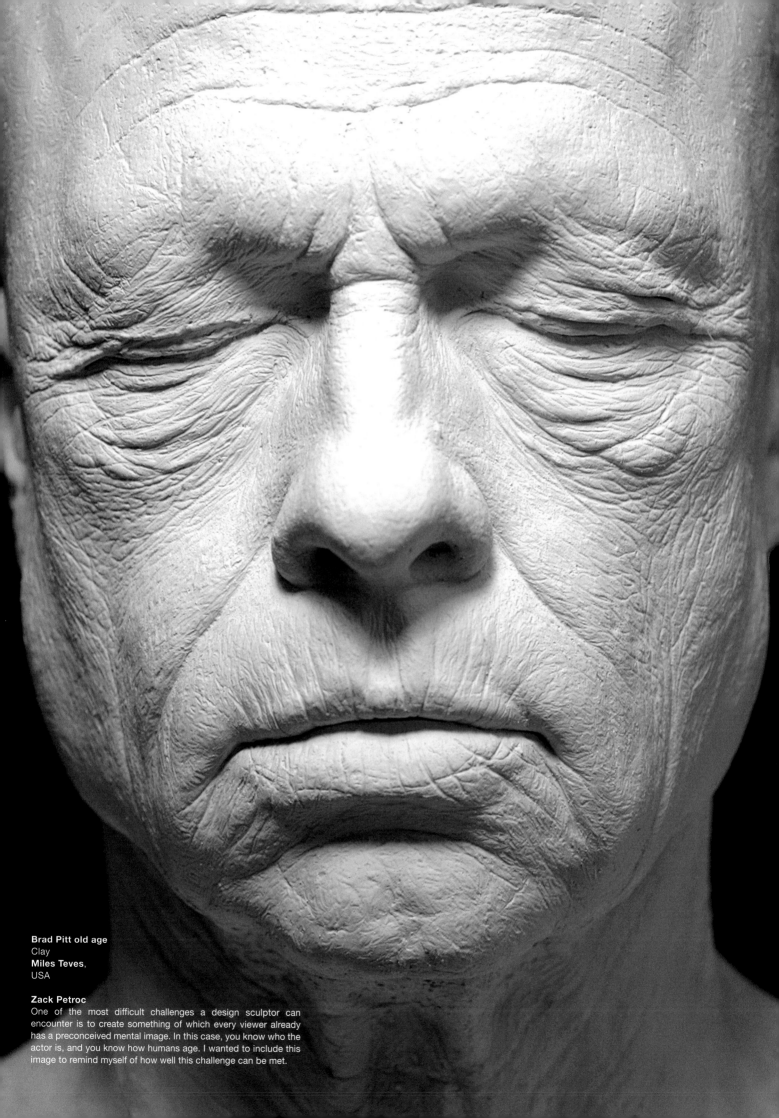

Brad Pitt old age
Clay
Miles Teves,
USA

Zack Petroc
One of the most difficult challenges a design sculptor can encounter is to create something of which every viewer already has a preconceived mental image. In this case, you know who the actor is, and you know how humans age. I wanted to include this image to remind myself of how well this challenge can be met.

Scary Toons
ZBrush, Maya, Photoshop
Ralf Stumpf, GERMANY
[above series]

Zack Petroc
These characters have a great whimsical sense, and
the shear amount of variation in the designs is inspiring.
Their proportions tell you exactly what size they would
be if they were turned into practical sculpts.

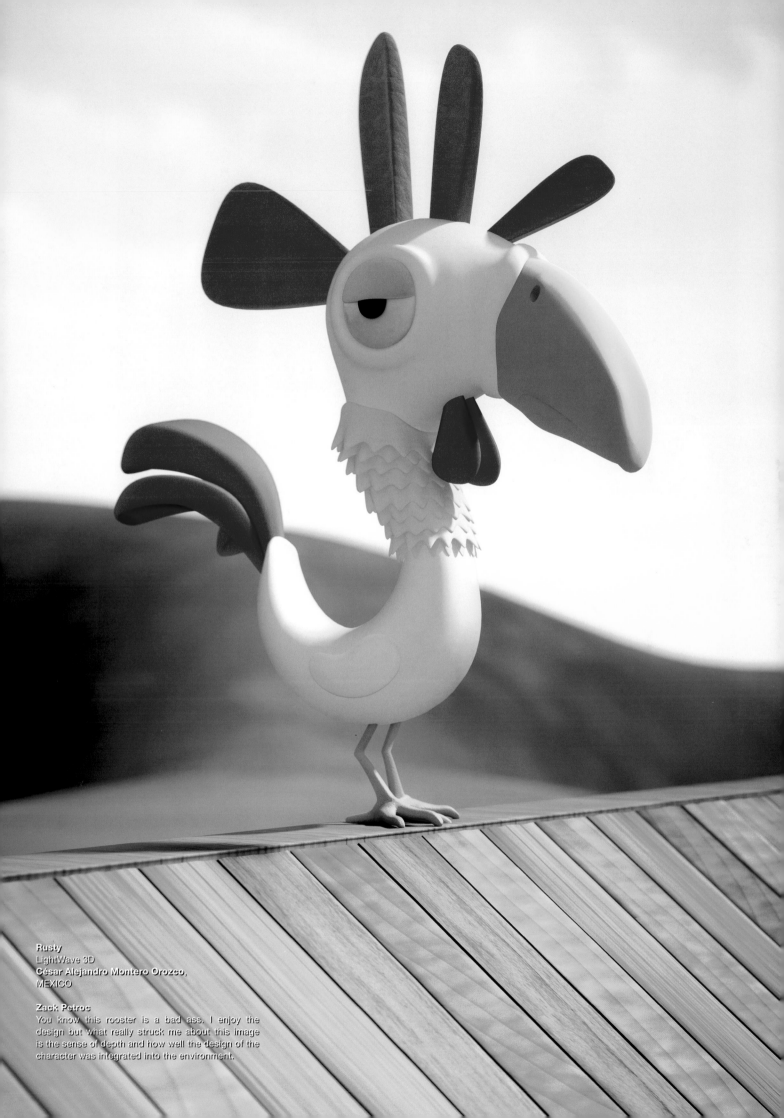

Rusty
LightWave 3D
César Alejandro Montero Orozco,
MEXICO

Zack Petroc
You know this rooster is a bad ass. I enjoy the design but what really struck me about this image is the sense of depth and how well the design of the character was integrated into the environment.

White teeth
3ds Max, mental ray, Photoshop
Jonathan Simard, CANADA
[top left]

Zack Petroc
I liked the intentional repetition of the crescent moon that filled this composition. The arch of the character is accentuated by the straight line of the hanging bell.

The Hoplite Tireless Warrior: Winter Storm
LightWave 3D, Poser, Painter, Photoshop
Jacques Martel, FRANCE
[above]

Zack Petroc
What caught my attention in this piece was the intentional use of a limited color palette. It serves the story well, acting as an additional dynamic to set the mood of the piece.

The warrior king is alone
3ds Max, finalRender, Photoshop
Marco Lazzarini, ITALY
[top right]

Zack Petroc
It was nice to see an image of a character that was not rendered from a dead-on, front view. The angle of the camera helps add to the story of who this character really is.

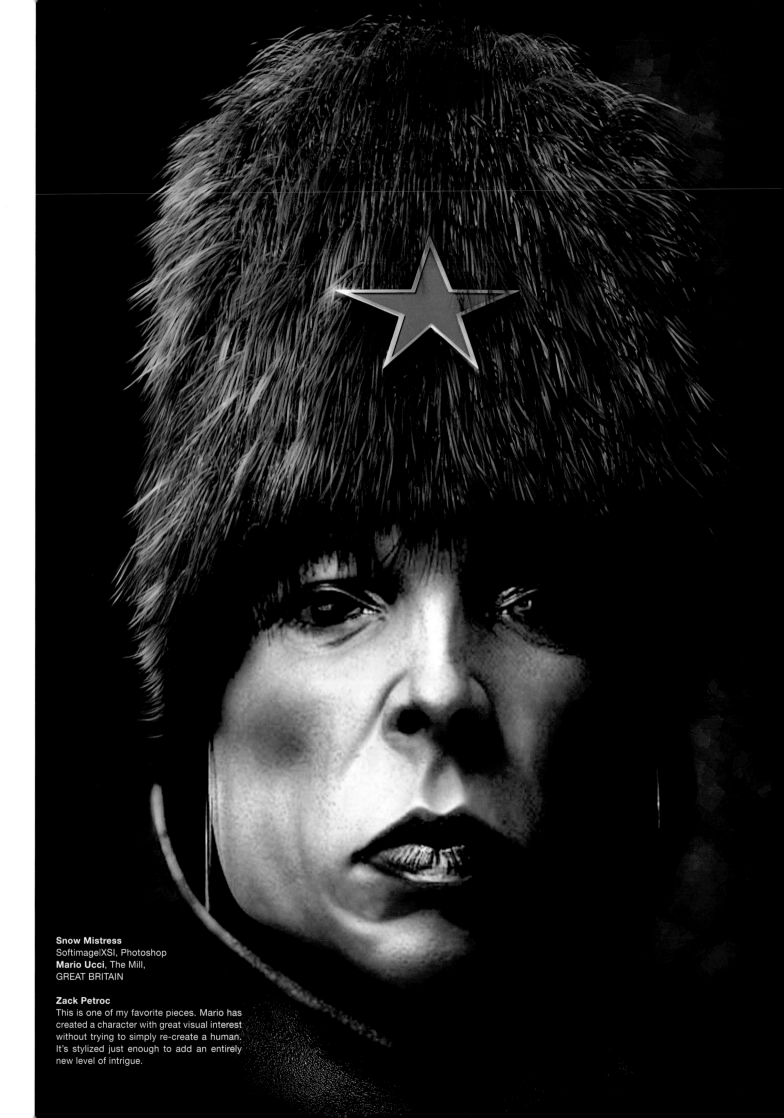

Snow Mistress
Softimage|XSI, Photoshop
Mario Ucci, The Mill,
GREAT BRITAIN

Zack Petroc
This is one of my favorite pieces. Mario has
created a character with great visual interest
without trying to simply re-create a human.
It's stylized just enough to add an entirely
new level of intrigue.

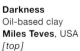

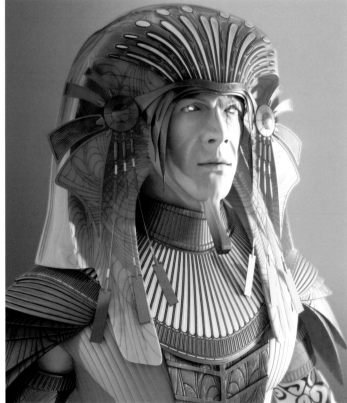

Darkness
Oil-based clay
Miles Teves, USA
[top]

Zack Petroc
Few careers let you create iconic creatures that become part of the sub-culture. This inspired me when I was too young to watch the film in the VHS case.

Mant bust
Water-based clay
James McPherson, USA
[above]

Zack Petroc
I love the genre that influenced this design sculpt. The single surface mask feeling sets an immediate tone for the world in which this creature might live.

Pharao
3ds Max, Photoshop
Thibaut Claeys, NarvalArt, BELGIUM
[above]

Zack Petroc
The costume details precisely convey the artist's intentions. The ridged, symmetrical forms seem like a design template ready to be turned into a real-world costume.

Darkness: closeup
Oil-based clay
Miles Teves, USA
[top]

Zack Petroc
Notice the subtlety in each fold resulting from the character's grimace as they begin and then transition back into the broader, more relaxed areas of the face.

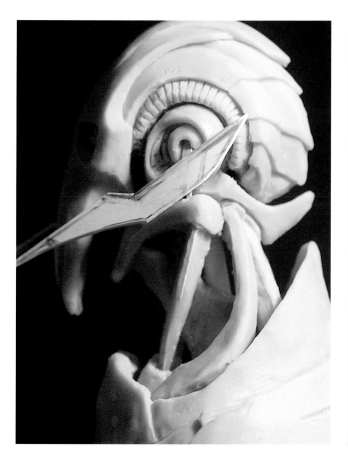

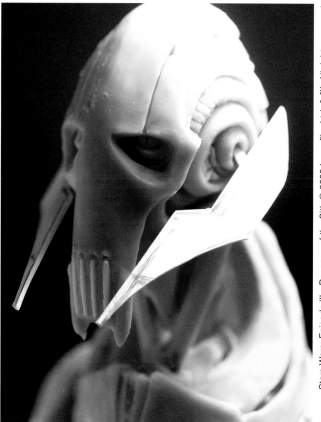

General Grievous: Head design sculpture
Clay
Courtesy of Lucasfilm Ltd.
Robert E. Barnes, USA *[top series]*

Zack Petroc
I love the free-formed hard-edge surfaces in this sculpt. With digital hard-edge modeling, we have come to expect exact edges and flawless surfaces. There is something so much nicer about this sculpt because it conveys every surface change but retains the gesture and fluidity of the form development.

Boga: Head design sculpture
Clay
Courtesy of Lucasfilm Ltd.
Robert E. Barnes, USA *[above]*

Zack Petroc
In this sculpt, the weight and volume of the Boga's neck is a real inspiration. The folds of loose skin on the underside of the surface accentuate the mass and add a great sense of scale. It also shows beautifully executed detail with a purpose.

Sooperman
Maya, mental ray, Photoshop
Bryan Ballinger, USA
[left]

Zack Petroc
The simplified style of the face, the swirl at the end of the cape, the three dimensional clouds, what's not to love about this piece? Great execution from character design, to pose, to integration into the background.

Mazinger Z
LightWave 3D, Photoshop
Inspired by Go Nagai
Angel Nieves, USA
[right]

Zack Petroc
It was nice to see a robot with simplistic form development in a great pose that really conveys personality. This piece also does a great job of portraying scale.

Character © Sandy Frank Film Syndication Inc.

Tiny
3ds Max, ZBrush, mental ray, Photoshop
Inspired by: Battle of the Planets
Chih-Han Hsu, AUSTRALIA
[left]

Zack Petroc
This is another one of my favorite images; the iconic hero pose with the somewhat overweight and seemingly out of shape superhero. I also like all of the finishing details from the gesture of the cape to the rim light on his shoulders.

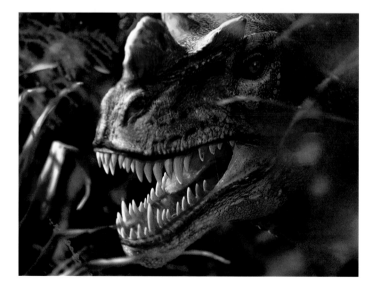

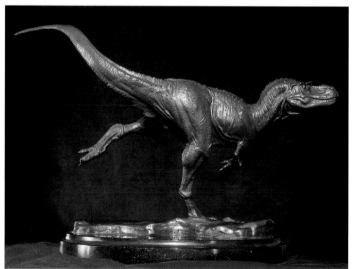

Massif: concept design sculpture
Clay & Acrylic paint
Courtesy of Lucasfilm Ltd.
Robert E. Barnes, USA *[top]*

Ceratosaurus
ZBrush, Photoshop
David Krentz, USA
[above]

Judith
Clay cast in bronze
David Krentz, USA
[above]

Rex Mundi
Clay cast in bronze
David Krentz, USA
[right]

Zack Petroc
Merging of existing animal influences and invented forms work incredibly well in this sculpt. From the rhino-like plates on its back to the crocodile jaw, it is a nice balance of animal and alien influences that work well to create a new character.

Zack Petroc
I love to look at the work of an artist who is obviously passionate. To see David's work is to experience that passion and one individual's devotion to developing their craft.

Zack Petroc
This piece has a phenomenal gesture that carries through from the tip of the snout to the end of the tail. It has a perfectly executed balance of weight and sense of movement.

Zack Petroc
It would be hard to find a better example of textured skin folding and stretching across a muscular form. This piece showcases how the layers of bone, muscle, and skin combine to make a complete statement.

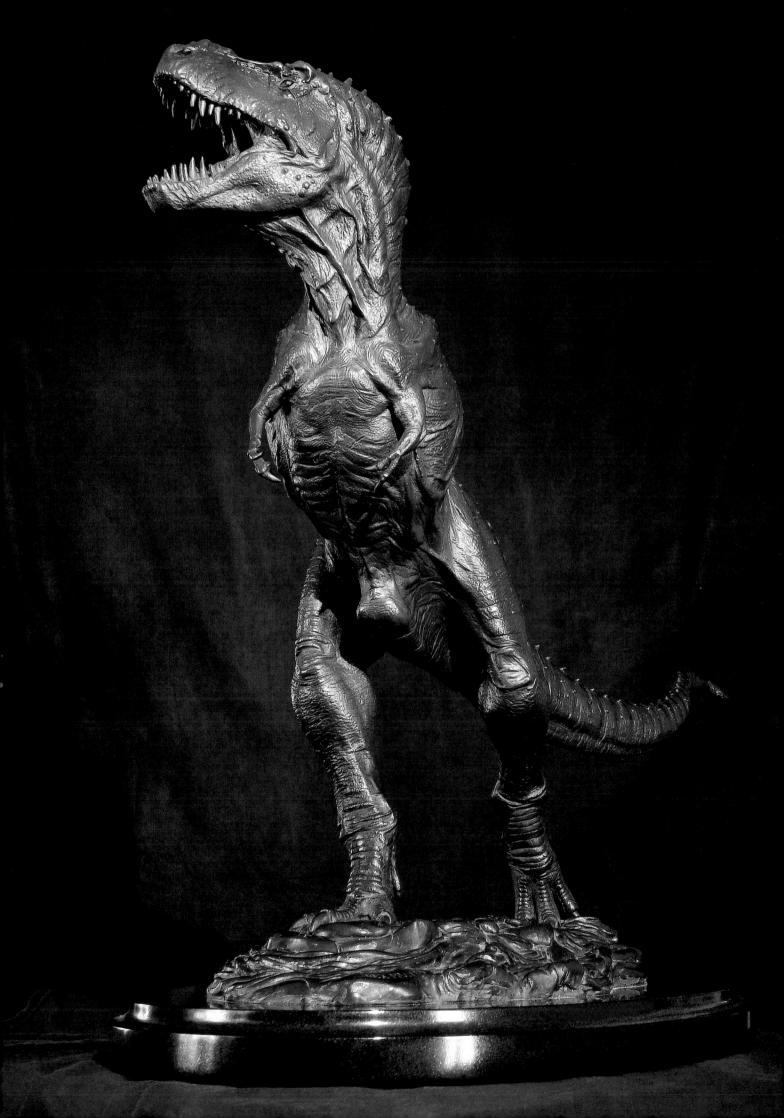

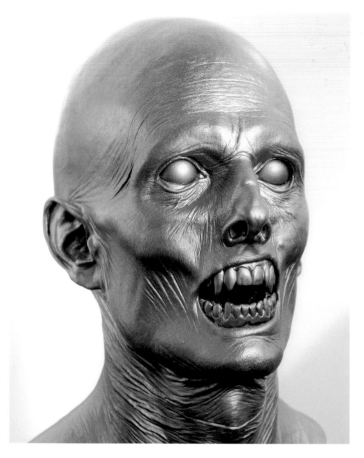

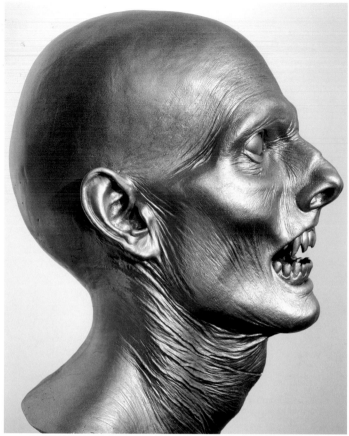

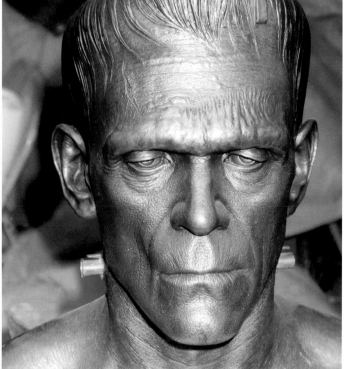

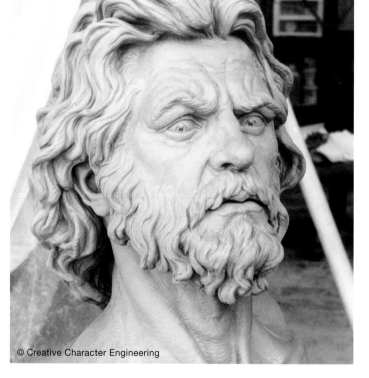

© Creative Character Engineering

Lestat
Oil-based clay
Miles Teves, USA
[top]

Zack Petroc
The most noteworthy point here is the skin treatment. The balance of where it stretches and where it begins to sag works perfectly to accent the skull structure—like delicate paper that could be torn from the surface with little effort.

Frankenstein bronze
Clay cast in bronze
Miles Teves, USA
[above]

Zack Petroc
The emotion conveyed by the face of this Frankenstein sculpt is what draws me to the piece. I also enjoy the attention to details like the intentional sculpting that defines the edge of the prosthetic brow line.

Zeus bust
Water-based clay
James McPherson, USA
[above]

Zack Petroc
I like the classical stylization of the hair, brow, and eyes in this sculpt. Even the expression created by the downward gaze and furrowed brow is a perfect choice for this genre adding to the overall impact of the piece.

Lestat-46
Oil-based clay
Miles Teves, USA
[top]

Zack Petroc
As well as the skin over the skeletal forms, there are many subtle design choices in this piece. The lower eyelids folding down and the uneven curling back of the lips show the thought process that furthered this design.

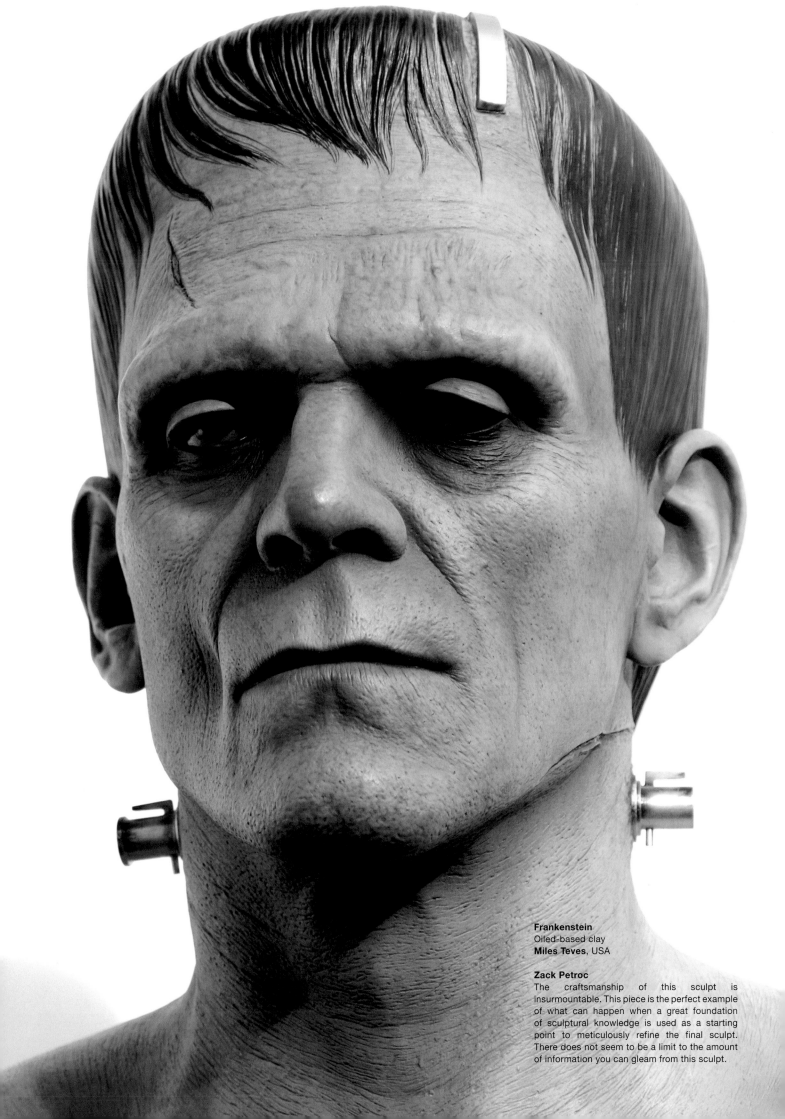

Frankenstein
Oiled-based clay
Miles Teves, USA

Zack Petroc
The craftsmanship of this sculpt is insurmountable. This piece is the perfect example of what can happen when a great foundation of sculptural knowledge is used as a starting point to meticulously refine the final sculpt. There does not seem to be a limit to the amount of information you can gleam from this sculpt.

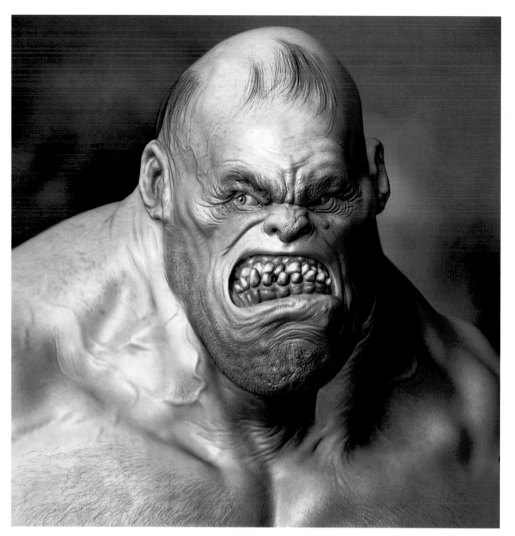

Hyde
SoftimagelXSI, ZBrush, Photoshop
Alex Oliver, BRAZIL
[left]

Zack Petroc
There are a lot of nice things starting to develop with this sculpt. The shifting of the facial proportions serve the character design well.

Crossed Paths
SoftimagelXSI, ZBrush, Photoshop
Inspired by Aaron St.Goddard
Pierre Bourgeot, CANADA
[right]

Zack Petroc
The design choices in the proportions of this character are what drew me to the image. The bulk in the legs obviously grounds the character but I also liked the way the mass added to the forearms begins to tie all the forms together.

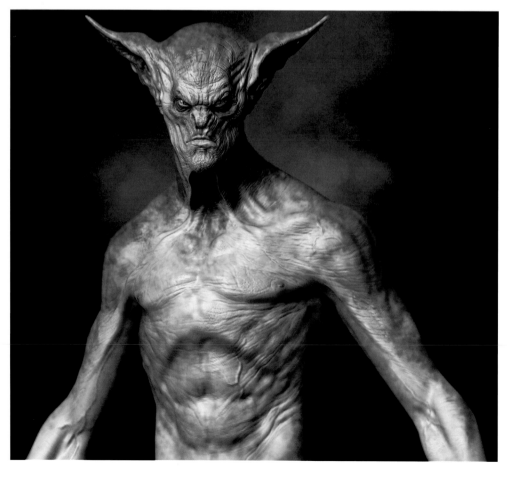

Vampire
SoftimagelXSI, ZBrush, Photoshop
Alex Oliver, BRAZIL
[left]

Zack Petroc
The ribcage area of this character is a great example of layered structure. There is an understanding of anatomy and surface change dictated by the underlying forms that add an inspirational level of complexity to this sculpt.

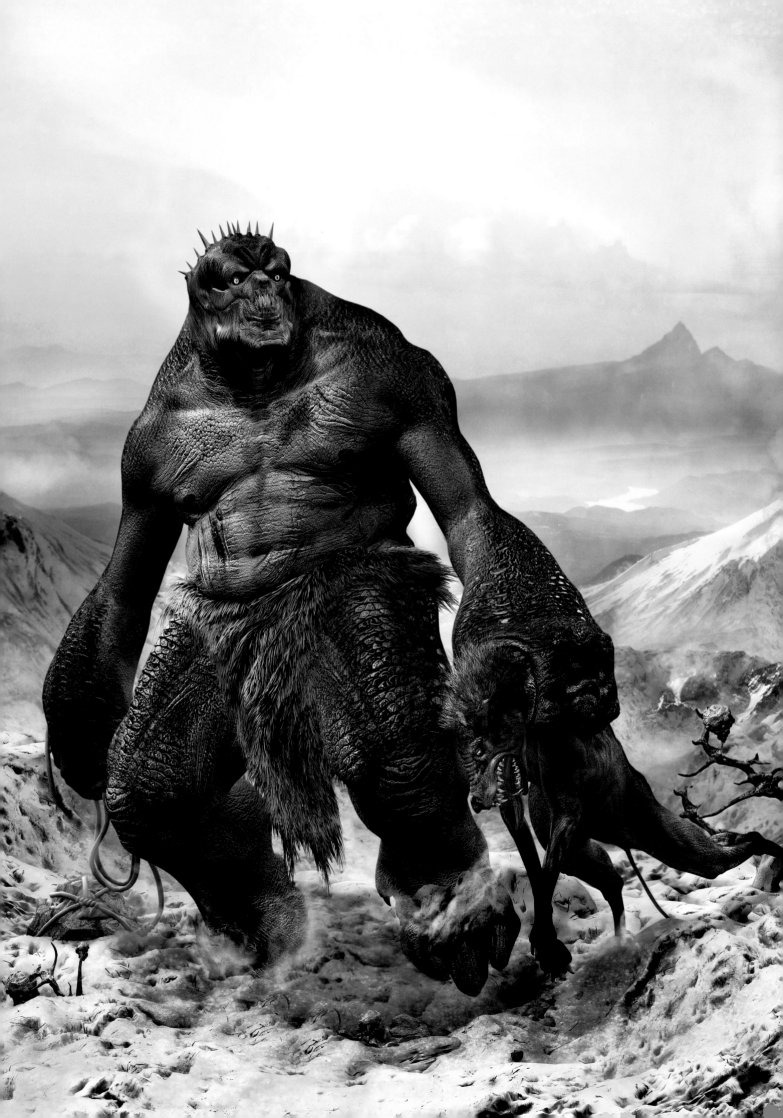

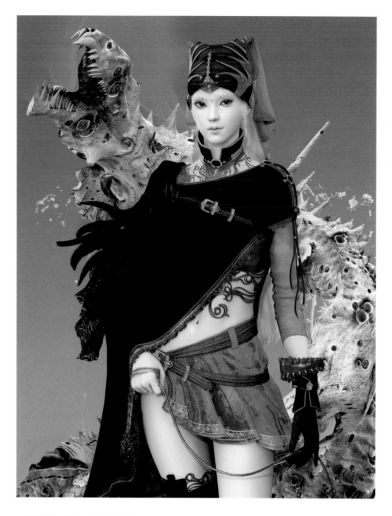

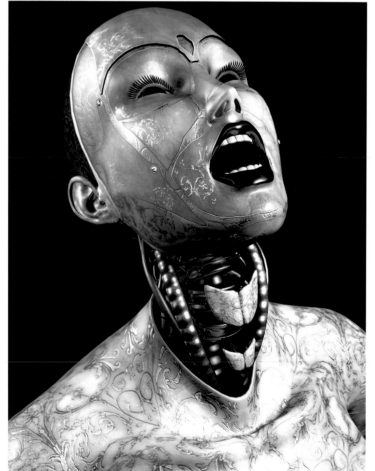

Invader commander
3ds Max, Brazil r/s, HDRShop,
Photoshop
Eun-hee Choi, KOREA
[above left]

Zack Petroc
This is a great example of how the
stylized creature in the background
can accentuate and inform the
costume of the character in the
foreground. Additionally, the graphic
and two dimensional nature of the
creature creates a nice transition
to the foreground 3D character.

Lona
Maya, Photoshop
Christoffer Green,
SWEDEN
[above]

Zack Petroc
There is a nice simple gesture to
this character that seems to speak
to her personality. I've always found
a base to be an interesting choice
for a digital character.

Robot face
Maya, Photoshop
Jim Seize,
CANADA
[left]

Zack Petroc
Domo Arigato Miss Roboto. I really
admire the textured detail on the
surface and how it emotes a sense
of actual material, not just color.
I also like the juxtaposition of the
ornate details being applied to
a cold robotic surface. Kind of like
what might happen if RoboCop
made it with a Fabergé egg.

Nurenda
ZBrush, Maya, Photoshop
Sebastien Legrain,
CANADA
[right]

Zack Petroc
Creating a digital portrait of
a realistic character is very
difficult to do well. This image
comes very close to overcoming
those limitations.

Index

A

Murat Afsar
Istanbul,
TURKEY
kazmamurat@hotmail.com
68

Steve Argyle
Orem, UT,
USA
steveargyle@gmail.com
steveargyle.com
70

B

Bryan Ballinger
Huntington, IN,
USA
bryan@bryanballinger.com
www.bryanballinger.com
180

Wesclei Barbosa
Rio de Janeiro, RJ,
BRAZIL
wesclei@hotmail.com
www.wesclei3d.com
122

Robert E. Barnes
Petaluma, CA,
USA
rebarnz@aol.com
172, 179, 182

Fred Bastide
Montreux, Vaud,
SWITZERLAND
fredbastide@vtxnet.ch
112

Timur 'Taron' Baysal
Santa Monica, CA
USA
www.taron.de
76-107

Andrea Bertaccini
Tredistudio,
Forlí,
ITALY
andrea.bertaccini@tredistudio.com
www.tredistudio.com
116

Eugene Beskhodarny
Saratov,
RUSSIA
zhenyabes@yandex.ru
113

Pascal Blanché
UBISOFT
Montreal, QC,
CANADA
lobo971@yahoo.com
www.3dluvr.com/pascalb
74

Fabrizio Bortolussi
Padova,
ITALY
www.digitalfreaky.com
120

Pierre Bourgeot
Vancouver, BC,
CANADA
me@pierrebourgeot.com
www.pierrebourgeot.com
187

Ken Brilliant
Newbury Park, CA,
USA
ken@brilliant-creations.com
www.brilliant-creations.com
114

Ryan Brucks
Epic Games, Inc.
Cary, NC,
USA
7, 11, 17, 19

C

Damien Canderle
Lyon,
FRANCE
www.maddamart.com
60

Shane Caudle
Epic Games, Inc.
Cary, NC,
USA
shane@planetshane.com
www.planetshane.com
52-53, 72

Eun-hee Choi
Yong-in, Kyong-gi,
KOREA
hi97bzo@hotmail.com
www.kjun.org
188

Thibaut Claeys
NarvalArt
Vedrin, Namur,
BELGIUM
bito@sevarna.com
www.sevarnya.com
178

D

Antje Darling
Geronimo, OK,
USA
antje@sunnet.net
www.antjesgraphics.com
74

Scott Dossett
Epic Games, Inc.
Cary, NC,
USA
7, 15, 19, 50-51, 58, 59

G

Dani Garcia
Barcelona,
CATALONIA
woody@woodys3d.com
www.woodys3d.com
118

Jason Gary
Driftwood, TX
USA
jgary@austin.rr.com
70

Christoffer Green
Kävlinge,
SWEDEN
christoffer.green.googlepages.com
188

Olivier Gros
Montpellier,
FRANCE
realkooala@hotmail.com
110

H

Matt Hancy
Epic Games, Inc.
Cary, NC
USA
59

James Hawkins
Epic Games, Inc.
Cary, NC,
USA
7, 10, 11, 12, 13, 14, 15, 16, 18, 19,
[Front cover: Soft Cover edition]

Pete Hayes
Epic Games, Inc.
Cary, NC,
USA
7, 12, 15, 19, 50-51, 58, [Front cover:
Soft Cover edition]

Avinash Hegde
Mumbai, Maharashtra,
INDIA
avinash3ds@yahoo.com
www.avinash3ds.blogspot.com
114

Aaron Herzog
Epic Games, Inc.
Cary, NC,
USA
7, 10, 11, 15, 17, 19, 50-51, 58,
[Front cover: Soft Cover edition]

Peter Hofmann
Weilheim,
GERMANY
www.peXel.de
71

Jay Holsfelt
Epic Games, Inc.
Cary, NC,
USA
7, 10, 11, 15, 17, 19, 50-51, 58, 59,
[Front cover: Soft Cover edition]

Chih-Han Hsu
Brisbane, QLD,
AUSTRALIA
hhssuu@gmail.com
180

Alex Huguet
Barcelona,
SPAIN
54

K

Zubuyer Kaolin
Dhaka,
BANGLADESH
overcontrast@yahoo.com
www.linesmakeimages.com
61

David Krentz
Pasadena, CA
USA
david@krentzpresentz.com
www.davidkrentz.com
www.krentzpresentz.com
182, 183

L

Kevin Lanning
Epic Games, Inc.
Cary, NC,
USA
www.epicgames.com
6-49, 50-51, 58, 59, [Front cover:
Soft Cover edition]

Marco Lazzarini
Siracusa,
ITALY
info@3dlink.it
www.3dlink.it
176

Jinwoo Lee
San Francisco, CA,
USA
jermain72@dreamwiz.com
www.3dmodeler.wo.to
66

Sebastien Legrain
Montreal, QC
CANADA
sebcesoir@hotmail.com
sebleg.free.fr
116, 189

Sunghun 'Ryan' Lim
Bioware Corp.,
Edmunton, AB
CANADA
sunghunlim@hotmail.com
www.ryan3d.com
111

M

Abner Marín
Torreagúera, Murcia,
SPAIN
abner@faraguay3d.net
www.faraguay3d.net
70, 118

Jacques Martel
Pontenx les Forges,
FRANCE
www.virtuhall.com
176

Jeff McAteer
Edmonds, WA,
USA
jeff@jeffmcateer.com
170-171

James McPherson
Burbank, CA,
USA
www.jimmcpherson.com
178, 184

Meats Meier
Los Angeles, CA,
USA
meats@sketchovision.com
124, 125

Maurizio Memoli
Napoli,
ITALY
mau.memoli@libero.it
122

Marco Menco
Civitanova Marche,
ITALY
drummermenco@yahoo.it
drummer.cgsociety.org
116

César Alejandro Montero Orozco
Zapopan, Jalisco,
MEXICO
montero@archeidos.com
www.archeidos.com
175

Maury Mountain
Epic Games, Inc.
Cary, NC,
USA
7, 15, 19, 58, *[Front cover: Soft Cover edition]*

Denisa Mrackova
Praha 10,
CZECH REPUBLIC
mrackovadenisa@seznam.cz
75

N

Angel Nieves
Buford, GA,
USA
angeln@vertexangel.com
www.vertexangel.com
181

O

Jerry O'Flaherty
Epic Games, Inc.
Cary, NC,
USA
15, *[Front cover: Soft Cover edition]*

Alex Oliver
Sao Paulo,
BRAZIL
mail@alexoliver.art.br
www.alexoliver.art.br
186

P

Jung-won Park
NCSOFT,
Kangnam-gu, Seoul,
KOREA
jwpark@jwillust.com
www.jwillust.com
56

Chris Perna
Epic Games, Inc.
Cary, NC,
USA
chris.perna@epicgames.com
www.myspace.com/gearsartlead
7, 10, 11, 15, 17, 19, 50-51, 54, 58,
59, *[Front cover: Soft Cover edition]*

Zack Petroc
Studio City, CA
USA
www.zackpetroc.com
126-169

Laurent Pierlot
Blur Studio Inc.,
Venice, CA,
USA
laurent@blur.com
108

Zoltán Pogonyi
Budapest, Pest,
HUNGARY
z.pogonyi@chello.hu
piktor.uw.hu
119

R

Luiz Fernando Rohenkohl
Marechal Candido Rondon, Paraná,
BRAZIL
www.reptu.com
121

S

Jacob Saariaho
Boston, MA
USA
cpt.jack1@mac.com
112

Sergio Santos
Madrid,
SPAIN
sergio_ssn@yahoo.es
www.sergio3d.com
66

Rod Seffen
Magherafelt, Londonderry,
NORTHERN IRELAND
odditycg@gmail.com
110

Jim Seize
Montreal, QC,
CANADA
jimseize@hotmail.com
www.trajectons.com/seize
188

Charli Siebert
Huntington Beach, CA,
USA
unimaginative82@hotmail.com
www.unimaginative.org
69

Jonathan Simard
Montreal, QC,
CANADA
capitaine_star@hotmail.com
pikmin.cgsociety.org/gallery
176

Sebastien Sonet
Valdoie,
FRANCE
xxeb@publink.fr
www.publink.fr
68, 109, 120

Michael Sormann
Vienna,
AUSTRIA
michael@sormann3d.com
www.sormann3d.com
119

Scott Spencer
Burbank, CA,
USA
scott@scottspencer.com
172

Ralf Stumpf
Mülheim Ruhr,
GERMANY
stumpf3d@arcor.de
174

T

Miles Teves
Woodland Hills, CA
USA
miles@milesteves.com
www.milesteves.com
173, 178, 184, 185

Juliy Trub
International Art Found,
Moscow,
RUSSIA
comboja@bk.ru
124

U

Mario Ucci
GREAT BRITAIN
ucci@cgsalad.com
www.cgsalad.com
54, 177

V

Corrado Vanelli
Casaletto Ceredano (CR),
ITALY
cvanelli75@libero.it
115

David Munoz Velazquez
Barcelona,
SPAIN
munozvelazquez@gmail.com
www.munozvelazquez.com
60

Cyril Verrier
Gouvieux,
FRANCE
www.quadpilot.com
64, 68

W

Chris Wells
Epic Games,
Morrisville, NC,
USA
c11wells@hotmail.com
63

Brent Wong
Fountain Valley, CA,
USA
superbeez@gmail.com
www.brentwong3d.com
122

Richard Wright
ARK
Sheffield, Yorkshire,
GREAT BRITAIN
rich@arkvfx.net
www.arkvfx.net
123

Z

Yang Zhang
YiChang, HuBei,
CHINA
zhangyangshaoyu99520@hotmail.com
57

Loïc Zimmermann
Troyes, Aube,
FRANCE
info@e338.com
www.e338.com
55, 67, *[Cover: Limited Edition]*

Peter Zoppi
Los Angeles, CA,
USA
pzoppi@gmail.com
www.zopfx.com
62, 64, 65, 66, 72, 73, *[Back cover: Soft Cover edition]*

SOFTWARE INDEX

Products credited by popular name in this book are listed alphabetically here by company.

Company	Product	Website	
Adobe	After Effects, Photoshop	www.adobe.com	
Autodesk	3ds Max, Combustion, Maya	www.autodesk.com	
Cebas GmbH	finalRender	www.cebas.de	
Chaos Group	VRay	www.vrayrender.com	
Corel	Painter	www.corel.com	
CuriousLabs	Poser	www.curiouslabs.com	
Luxology	modo	www.luxology.com	
MAXON	Body Paint 3D, CINEMA 4D	www.maxon.com	
Mentalimages	mental ray	www.mentalimages.com	
NewTek	LightWave 3D	www.newtek.com	
Paul Debevec	HDRShop	www.hdrshop.com	
Pixology	ZBrush	www.pixology.com	
Skymatter	Mudbox	www.mudbox3d.com	
Softimage	Softimage	XSI	www.softimage.com
Splutterfish	Brazil r/s	www.splutterfish.com	
Taronite	ZBorn Toy	www.taron.de	
Epic Games	Unreal Engine 3	www.epicgames.com	